THE FALLEN

A PHOTOGRAPHIC JOURNEY THROUGH THE WAR CEMETERIES
AND MEMORIALS OF THE GREAT WAR, 1914–18

JOHN GARFIELD

First published 1990
This edition published 2014
by Spellmount, an imprint of

The History Press
The Mill, Brimscombe Port
Stroud, Gloucestershire, GL5 2QG
www.thehistorypress.co.uk

British Library Cataloguing in Publication Data.
A catalogue record for this book is available from the British Library.

ISBN 978 0 7509 5204 0

Typesetting and origination by The History Press
Printed in India

CONTENTS

FOREWORD BY KATHARINE WHITEHORN

Here dead we lie
Because we did not choose
To live and shame the land
From which we sprung.

Life, to be sure,
Is nothing much to lose
But young men think it is,
And we were young.

<div align="right">A.E. Housman</div>

The First World War somehow still fascinates us; we dwell on it even more than we do on the far larger Second World War; the graves of the soldiers still speak to us of a sense of glory, different in many ways from the thinking that drove Britain to fight again two decades later. It is expressed in the hymn 'I vow to thee my country all earthly things above', patriotism is assumed to be a virtue, and a homesick affection for England or Scotland – or indeed the Empire – seems far stronger than any hatred of the Hun. The men may have joined up from a sense of duty, or some notion of adventure, excitement even; and, of course, some were conscripted. The prevailing class system was reproduced exactly in the armed forces, but the idealistic patriotism was real enough at every level. For men of that generation, there was an assumption that loving your country and being good in a religious sense were all part of the same commitment; those of different convictions – my Presbyterian father, for example, who was a conscientious objector – were assumed to be cowards or traitors, scorned and given white feathers in the street. The virtue and bravery of fighting for your country and the 'glory' of dying heroically are as old as civilisation, though easier to portray with a white horse and a sword than with mud and guns.

Even if Wilfred Owen's poem spoke of 'those who die as cattle', Rupert Brooke in 'The Soldier' wrote that his grave would be 'forever England', his heart would 'give somewhere back to the thoughts by England given'. And a hundred years ago it was such written words – not pictures or broadcasts or radio – that expressed the prevailing atmosphere. There is an inescapable poignancy in the contrast between the strength of the soldiers' emotions – for their comrades, for the country they were defending, for the notion of glory – and the horror of the trenches: filthy, cold with water, vile with blood and fear, the grim expectation of 'going over the top' never far away. The tombs of these men reflect the pathos: many graves were made to look somehow like the gardens of home, and the words express the faith that their sacrifice had been valuable; that even the men too mauled to be identified were 'Known unto God'. For these men – and their mothers and sweethearts back home – bravery, patriotism, the love of home, God and the Church seemed all part of the same belief; their graves reflect it.

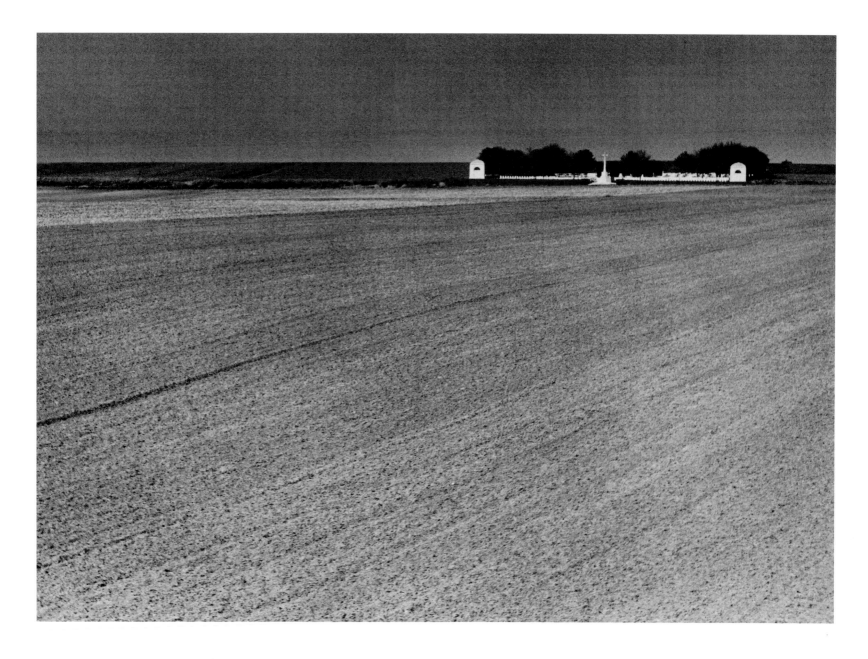

INTRODUCTION BY GAVIN STAMP

The terrible history of the twentieth century can be read on tombstones and monuments. That is one good reason for preserving and maintaining the thousands of war cemeteries that lie all over the world. Some think that is a waste of money; others that it is morbid to spend time studying the artefacts of death. Both are dangerously wrong: with war ignorance is not bliss but a menace. For the health of civilization it is necessary constantly to be reminded of what human beings can do to each other. As King George V observed, at the end of his pilgrimage to the war cemeteries of the Western Front in 1922, 'I have many times asked myself whether there can be more potent advocates of peace upon earth through the years to come, than this massed multitude of silent witnesses to the desolation of war.'

Many will not listen to those witnesses, as the essential failure of the War to End War demonstrated after only two decades. Yet it is the cemeteries and memorials of the Great War that remain the most poignantly eloquent. The slaughter was so huge and yet the reason so dubious. That makes the inspection of the tombstones recording the brief lives of so many soldiers so harrowing, and anger-making. But at least, as far as this country is concerned, subsequent wars have not used up young lives quite so prodigally.

Over the long period he has devoted to making powerful modern images from the cemeteries of the Great War, John Garfield has travelled to remote and difficult places where ordinary men died while doing their best to slaughter each other: to the Tirol and Macedonia, and to Gallipoli. I have not yet been to those places to see the work of the talented British architects who raised stone monuments there for the Imperial War Graves Commission, yet I have visited one telling spot where, I think, the remarkable surgeon-cum-photographer has yet to penetrate.

High up in the Carpathians between Sinaia and Brasov along what used to be the frontier between Rumania and the Austro-Hungarian Empire are many little cemeteries from the Great War, even in anonymous death, nationality is distinct: the unknown Rumanian soldiers have white crosses, the Hungarians curious little grey pyramids for tombstones and the Germans rugged Maltese crosses. All lie next to each other in poignant reflection of the complex history of Transylvania. They also emphasise how all Europe was the unhappy legatee of that war, and of the peace that was imposed afterwards – something that contemporary events in Eastern Europe only emphasise. Historical mistakes will not go away, even when the names of men who died are long forgotten.

On the Western Front, the graves of former enemies can lie in similarly poignant juxtaposition, as at the St Symphorien Cemetery outside Mons where John Garfield's camera has caught British and German tombstones side by side. Such things serve to emphasise the apparent futility of that monumental conflict – but, of course, sentimental musings should be tempered by realism. Revisionist historians rightly remind us of Imperial Germany's ruthless war aims in 1914, and the St Symphorien graves are a consequence of the great crime of invading neutral Belgium. But need it have taken four brutal years to counter those war aims? Every great power in 1914 seemed possessed by an unpleasantly arrogant nationalist fervour: the British Empire not least. And all nation states, whether monarchies or democracies, in the legitimate defence of national interests, felt able to consign their citizens to the slaughter with absolute ruthlessness. Peace was not to be had at any price.

That slaughter was further assisted by a military technology that was almost out of control – certainly out of the control of politicians and high ranking generals. The result was those 'intolerably nameless names' – the terrifying walls of elegant Roman lettering designed by Macdonald Gill on the walls of the British Memorials to the Missing, or the raised Gothic names densely grouped on bronze plates around the concentrated mass-graves in German cemeteries. European civilization willingly destroyed itself with abandon.

One fascination of war cemeteries is to see how each nation accom-modated itself to the loss. The French seem almost to have been unable to cope: just huge seas of white crosses and an architecture of painfully confused character. The Germans, long skilled in the architecture of death, created haunting war cemeteries in France and Belgium of a marked Teutonic character: dark rough crosses, granite slabs, tough but subtle buildings of rugged stone and fine craftsmenship – all designed by Robert Tichler – in sacred groves of oak trees imbued with folk memories of Thor, God of War. A painfully beautiful one, photographed by Mr Garfield, is a Vladslo near Ypres where figures of grieving parents by Kathe Kollwitz kneel by a carpet of grave slabs. The Belgian tombstones,

in contrast, seem over elaborate and fussy, incorporating enamelled national colours and attempting to defuse the painful linguistic battle between French and Flemish that emerged during the conflict. The Italian cemeteries are among the most powerful architecturally, reflecting the austere Neo-Classical romanticism of Mussolini's post-war state.

And then there are the British cemeteries, which tell, not by their scale but by the number of them: over nine hundred along the Western Front; some tiny, but all so carefully and individually designed for their site: and all so beautifully landscaped and planted. This is no accident. The terrible task of the Imperial War Graves Commission was undertaken at the height of a great flowering of English garden design, and Gertrude Jekyll herself advised the Commission on planting. But the remarkable quality of the cemeteries is not only the result of a happy combination of trees, plants and the contrasting textures of masonry – to which Mr Garfield is so sensitive. They are also fine as architecture, for the Commission's work benefited from the Edwardian revival of Classicism, of the Grand Manner, which evolved into an austere and creative monumentality in the hands of talented architects. At no other time ironically, could the Commission have produced such fine work. For, after the Second World War, all the Commission could do was to continue with the tradition established in the First – but diluted to a greater or lesser degree.

That British officialdom succeeded in commissioning artists of great talent was extraordinary, almost unique. This triumph over conventional mediocrity was due to the vision and dedication of the founder of the War Graves Commission, Sir Fabian Ware. The best architects were employed: Sir Edward Lutyens, Sir Herbert Baker, Sir Reginald Blomfield and Charles Holden as Principal Architect for France and Belgium; Sir Robert Lorimer for North Italy and Macedonia and Sir John Burnet for Gallipoli and Palestine. All produced some of their finest work for the Commission. Above all, perhaps, there was Lutyens, creator of the Cenotaph in Whitehall, who had such a strong influence on the character of all the Commission's work and who, in his Memorial to the Missing, evolved his own abstracted 'Elemental Mode' of monumental, humanist Classicism which rose to the occasion so powerfully, and poignantly.

The letter Lutyens wrote to his wife in 1917 on an exploratory visit to France says much about the mood of the time and his own intentions: 'What humanity can endure, suffer, is beyond belief. The battfields – the obliteration of human endeavour, achievement, and the human achievement of destruction, is bettered by the poppies and the wild flowers – that are as friendly to an unexploded shell as they are to the leg of a garden seat in Surrey. It is all a sense of wonderment how can such things be . . . The grave-yards, haphazard from the needs of much to do and little time for thought – and then a ribbon of isolated graves like a milky way across miles of country, where men were tucked in where they fell – ribbons of little crosses each touching each across a cemetery – set in a wilderness of annuals – and where one sort of flower has grown the effect is charming, easy, and oh so pathetic, that one thinks no other monument is needed. Evanescent, but for the moment perfect – and how misleading, I surmise, is this emotion, and how some love to sermonize. But the only monument can be one in which the endeavour is sincere to make such a monument permanent – a solid ball of bronze!'

The interest of official British war cemeteries is quite different from that of country churchyards back home. There is no variety in craftsmanship, no curiosities of the monumental mason's art, no charmingly naïve or vulgar effigies. All is uniform, and disciplined by an austere conception of architecture, humanised by nature and by subtle landscaping. Sentimentality, and the over-emotionally figurative in art, were rigorously suppressed by common consent. As Blomfield later wrote, 'Many of us had seen terrible examples of war memorials in France and were haunted by the fear of winged angels in various sentimental attitudes.' But, above all, the unique quality of the British cemeteries comes from the repetition of standard, secular headstones. Here the Commission prevailed over the wishes of distressed relatives, for it was established that no bodies would be taken home for reburial (a principle betrayed by Margaret Thatcher after the Falklands War), that all ranks should have stones of equal size, and that this standard headstone should not be a cross (although a cross, or other religious symbols, together with a regimental badge, could be carved on it).

Such a secular character seems appropriate in commemorating mass, mecha-nised slaughter. It was also necessary after a war in which British casualties included Hindus, Muslims, Buddhists and Jews in addition to all denominations of Christians and none. So in the British cemeteries there are not those painful moments when the repetitive sequence of crosses is broken by the shape of a Star of David. Equality in death was maintained 'irrespective of creed or caste' as Lutyens wished. In this there was some difference of opinion between the architects. Holden, like Lutyens, wanted pure architectural forms and was 'in favour of eliminating everything that is of only temporary interest', while Baker favoured a more literal symbolism and revelled in heraldry and literary references. Lutyens had his way by designing the Great War Stone, those Pagan monoliths so subtly proportioned which, bearing the quotation from Ecclesiastes chosen by Kipling, stands as a focus in almost every cemetery. But official, Anglican England fought back and achieved the compromise of the free-standing Cross of Sacrifice in every cemetery: a rather sentimental design by Blomfield.

Here, perhaps, was an expression of the more repellent side of Edwardian Britain, of the complacent, unimaginative, unbending establishment which

had sent so many off to the trenches to die. Siegfried Sassoon, who knew what the reality of war was, dismissed Blomfield's Menin Gate at Ypres as 'a pile of peace complacent stone' – 'Well might the Dead who struggled in the slime / Rise and deride this sepulchre of crime.' But, almost seventy years later, the official British war cemeteries and memorials of the Great War do not seem merely cynical. Rather, in their resonant, emotionally-charged monumentality, they seem perfectly to express loss and sacrifice. They are not remote or irrelevant, but have so much to tell about ourselves and our unhappy history. For we suffer still from the fracture of early twentieth-century European civilization – a civilization so adept at killing on a grand scale but one which still thought worthwhile the commemoration of every single life lost.

The irony is that, for Britain at any rate, some of the finest artistic expressions of the period in terms of architecture and landscape gardening are to be found in France and Belgium and on other far-flung battlefields in cemeteries and memorials. The purpose of these was to commemorate the dead; now they also serve as a memorial to the civilization that engendered such quality, and which was yet so damaged in the conflict. Surely no one with an eye and a heart and a tragic sense of history can fail to be moved by these places. One such is John Garfield. The images he has made from the graveyards of the Great War and the tombstones of men and many different nationalities are of a powerful beauty. They ought also to be didactic and salutary.

CHRONOLOGY OF EVENTS

1882 The Triple Alliance: Germany, Austria-Hungary and Italy

1894 Alliance between France and Russia

1904 Entente Cordiale between Great Britain and France

1907 Rejection of disarmament schemes by Germany

1907 Triple Entente: Britain, France and Russia

1908 Austria-Hungary annexes Bosnia-Herzegovina

1912 Serbia, Montenegro, Greece and Bulgaria from the Balkan League against Turkey

1913 Serbs and Greeks from Alliance against Bulgaria

1914 28 June – Archduke Francis Ferdinand of Austria-Hungary assassinated at Sarajevo by Gavrilo Princip

1914 23 July – Austria-Hungary sends ultimatum to Serbia demanding suppression of Slav anti-Austrian activities, and demanding Austrian presence at inquiry into assassination

1914 28 July – Austria-Hungary declares war on Serbia

1914 30 July – Russia mobilizes

1914 1 August – Germany declares war on Russia

1914 3 August – Germany invades Belgium; declares war on France

1914 4 August – Britain declares war on Germany

THE WAR

1914 August – Turkey closes the Dardanelles

14–24 August – French retreat in Alsace-Lorraine. British retreat from Mons

5–9 September – First Battle of the Marne

14 September – Falkenhayn becomes German Commander-in-Chief replacing Moltke

October – First Battle of Ypres

November – Austrian invasion of Serbia fails

1915 18 March – British and French warships fail to force the passage of the Dardanelles

April–May – Second Battle of Ypres

25 April – Allied landings at Gallipoli

May–June – Battles in Artois

23 May – Italy declares war on Germany and Austria

25 September – Battle of Loos

October – Allied force lands at Salonika

December – Evacuation from Gallipoli begins

1916 21 February – Germans attack Verdun

May – Italians defeated at Asiago

1 July – Opening of the Battle of the Somme

September–October – First Allied attacks in Salonika

1917 March – Russian Revolution

April – British attacks in Artois. French attacks in Champagne

6 April – United States declares war on Germany

April – Battle of Arras, and Vimy Ridge

31 July – Opening of 3rd Battle of Ypres, later attacks on Passchendaele

October – Italian defeat at Caporetto

1918 21 March – Opening of final German offensive on the Somme

May–June – Final German offensive on Marne and Aisne

June – Italians repulse Austrians on the Piave

July – Successful Allied attacks on Aisne and Marne

September – German retreat in the west

October – Austrians defeated by Italians at Vittorio Veneto

4 November – Armistice on Italian Front

11 November – Armistice on Western Front

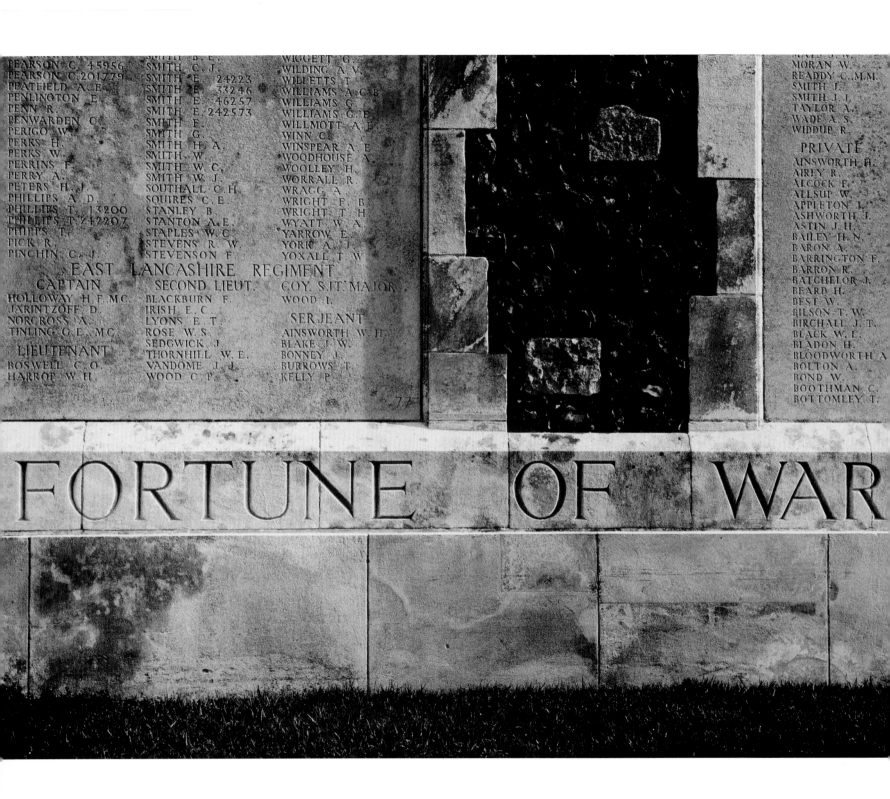

PEARSON C. 45956
PEARSON C. 201779
PEATFIELD A. E.
PENLINGTON E.
PENN R.
PENWARDEN C.
PERIGO W.
PERKS H.
PERKS W.
PERRINS F.
PERRY A.
PETERS H. J.
PHILLIPS A. D.
PHILLIPS T. 13200
PHILLIPS T. 242207
PHIPPS T.
PICK R.
PINCHIN C. J.

SMITH B. E.
SMITH C. J.
SMITH E. 24223
SMITH E. 33246
SMITH E. 46257
SMITH E. 242573
SMITH F.
SMITH G.
SMITH H. A.
SMITH W.
SMITH W. C.
SMITH W. J.
SOUTHALL C. H.
SQUIRES C. E.
STANLEY B.
STANTON A. E.
STAPLES W. C.
STEVENS R. W.
STEVENSON F.

WIGGETT G.
WILDING A. V.
WILLETTS T.
WILLIAMS A. C. B.
WILLIAMS G.
WILLIAMS G. E.
WILLMOTT A. E.
WINN C.
WINSPEAR A. E.
WOODHOUSE A.
WOOLLEY H.
WORRALL R.
WRAGG A.
WRIGHT E. B.
WRIGHT T. H.
WYATT W. A.
YARROW E.
YORK A. J.
YOXALL T. W.

EAST LANCASHIRE REGIMENT

CAPTAIN
HOLLOWAY H. F. M.C.
JARINTZOFF D.
NORCROSS A.
TINLING G. E. M.C.

LIEUTENANT
BOSWELL C. O.
HARROP W. H.

SECOND LIEUT.
BLACKBURN F.
IRISH E. C.
LYONS E. T.
ROSE W. S.
SEDGWICK J.
THORNHILL W. E.
VANDOME J. J.
WOOD C. P.

COY. SJT. MAJOR
WOOD I.

SERJEANT
AINSWORTH W. H.
BLAKE J. W.
BONNEY J.
BURROWS T.
KELLY P.

MATE J. W.
MORAN W.
READDY C. M.M.
SMITH J.
SMITH J. J.
TAYLOR A.
WADE A. S.
WIDDUP R.

PRIVATE
AINSWORTH H.
AIREY R.
ALCOCK E.
ALLSUP W.
APPLETON L.
ASHWORTH J.
ASTIN J. H.
BAILEY H. N.
BARON A.
BARRINGTON F.
BARRON R.
BATCHELOR J.
BEARD H.
BEST W.
BILSON T. W.
BIRCHALL J. T.
BLACK W. L.
BLADON H.
BLOODWORTH A.
BOLTON A.
BOND W.
BOOTHMAN C.
BOTTOMLEY T.

FORTUNE OF WAR

THE GREAT WAR

	KILLED OR DIED OF WOUNDS	TOTAL CASUALTIES
BRITISH EMPIRE	908,000	3,190,235
FRANCE	1,363,000	6,160,800
ITALY	460,000	2,197,000
RUSSIA	1,700,000	9,150,000
UNITED STATES	115,000	321,350
	4,546,000	21,019,385

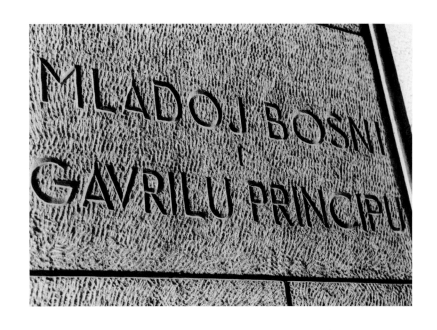

	KILLED OR DIED OF WOUNDS	TOTAL CASUALTIES
AUSTRIA-HUNGARY	1,200,000	7,020,000
GERMANY	1,774,000	7,142,000
TURKEY	325,000	975,000
BULGARIA	101,000	253,000
	3,400,000	15,390,000

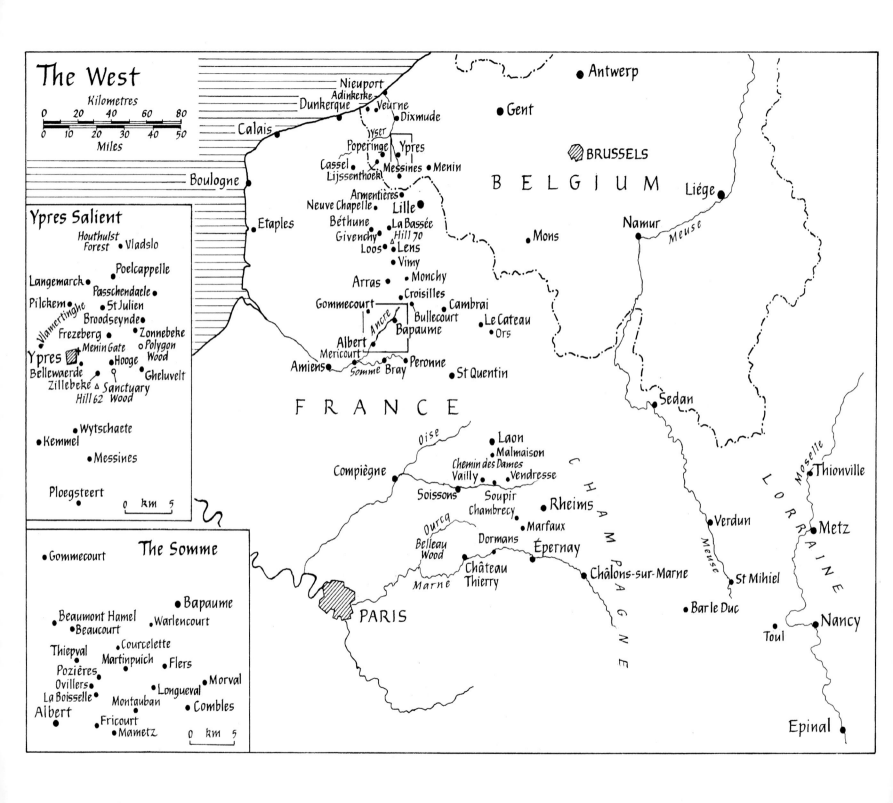

FLANDERS 1914

The conscience of civilised peoples, since Christianity began, has never reached a lower ebb than when the first gas-cloud was emitted. The wretched Turcos upon whom it principally fell – troops brave enough in the face of tangible danger – broke and fled gasping all down the road to Vlamertinghe, shrieking that the devil was indeed behind them.

P.B. CLAYTON *Plain Tales from Flanders*

For many years the German plan for the rapid defeat of France had been based upon a major thrust through Belgium, continuing through northern France, thereby outflanking the main French forces. Once far enough west, the German Armies would then swing south beyond Paris. This vast 'left wheel' would encircle the main French Armies, which at the same time would be occupied in resisting the frontal German attack from Alsace-Lorraine. Finding themselves surrounded within a few weeks, or at most months, of the outbreak of War, with Paris threatened from the west, and their armies divided, France would capitulate. The Germans hoped that final victory would be achieved before the relatively small British Expeditionary Force could cross the Channel, let alone be deployed.

The plan was the work of Field-Marshal Count Alfred von Schlieffen. Born in 1833, Schlieffen was Chief of the Prussian General Staff from 1891 to 1905. As early as 1897, when Germany was evolving its *Weltpolitik*, the first plan for attacking Belgium without a Declaration of War was written. The first Moroccan Crisis of 1905 stimulated further German thoughts of 'aggressive self-defence', and the Schlieffen Plan appeared in 1905. After his retirement, the Field-Marshal continued to develop his plan, which was fully described in 1909 in his book *Der Kriege in der Gegenwart*. Although the plan was later modified by Moltke, Chief of the General Staff after Schlieffen, it remained the basis of the German attacks in 1914. Its success depended upon the efficient and early mobilization of the German forces. Germany had some 87 divisions already mobilized, a well-trained and highly efficient army, irrespective of the 49 less dependable divisions of Austria-Hungary. France faced Germany with 62 divisions, but not all were as disciplined and efficient as the Germans, and the French military doctrine of attack often left the logistics of war to chance.

The diminutive BEF of only six divisions was unlikely to halt the massed German advance, even if it could be deployed in time. Belgium's six divisions, however bravely they fought on their own territory, had neither the training nor the material sufficient for a modern war of movement and firepower. To the German advantage of military superiority, the Schlieffen Plan added the element of surprise by the instant violation of Belgian neutrality without warning, a neutrality which, although proclaimed by Belgium and supported by Britain, had prevented any strengthening of Belgium by her allies. The French position regarding Belgium was ambivalent and no more than a reflection of the delicate relationship between those two countries. If Belgium had not been insistent upon the major powers, including France, 'respecting' her territory, she would not have denied herself the support of a mobilized French Army positioned on Belgian soil, which might have halted the Germans in 1914. The Schlieffen Plan was no secret and the hope that Belgium's 'neutrality' would deter the Germans was forlorn. German troops moved into Luxembourg on 1 August, 1914, some seventy-two hours before war was declared at midnight on 4 August. King Albert of the Belgians, despite knowing only too well his country's perilous situation, refused the Germans free passage through his country. The forts of Liège, Namur and Antwerp did not fall without fierce resistance, which certainly delayed the main thrust of the Schlieffen Plan. Although the retreat towards France was inevitable from mid-August onwards, the Belgian line finally held on the left bank of the River Yser, from Nieuport on the coast to Dixmude, and thence to the northern end of the Ypres Salient. The halting of the Germans on the most northerly section of the front between Dixmude and Nieuport probably determined the outcome of the War. Had that line not been held by bitter fighting and flooding of the land, the Germans would have raced to Calais and Boulogne, the BEF would have been cut off from all supplies, the French would have been attacked from the rear and Paris would have fallen in 1914.

As von Kluck's 1st Army approached the French border it squandered the one opportunity to outflank, towards the sea, the main French force and four divisions of the BEF. The British had reached Mons, 80 miles from the Channel coast. But von Kluck, under order from Bulow, Commander of the German 2nd Army, was diverted from the crucial out-flanking

VLAMERTINGHE MILITARY CEMETERY. IDENTIFIED BURIALS 1,157. UNIDENTIFIED 18

movement and turned inland; in so doing he met with the BEF. The Germans belief, fostered by Moltke, that the BEF could be rapidly destroyed, and at least one of the Allies eliminated from the Western Front, proved to be far from the reality. On Sunday 23 August, 1914, the Germans learnt, at great cost, of the extraordinary fire power of the British musketry. Such was its rapidity and accuracy that wave after wave of German troops were mown down by what they believed to be machine guns, but which were no more than superbly handled Lee-Enfield rifles. The BEF suffered losses in men, but none in guns, and, having halted the German advance, might yet have stood their ground on the line of the Mons–Condé canal, or at least a few miles south of it. But the French 5th Army on their right was withdrawing, the position of the BEF was threatened on three sides, and Sir John French, Chief of the Imperial General Staff, had no choice but to order a withdrawal.

Thus began for the British, in the heat of August, the dusty retreat towards Le Cateau, and beyond that to St Quentin, a march in which the realities of foot-slogging were never more brutally brought home. In six days the 2nd Corps marched 75 miles and fought two general actions. At Le Cateau on 26 August, the anniversary of the Battle of Crécy, the British turned and fought again, their musketry, this time with more artillery, temporarily halting the Germans, but their losses were 7,800. The retreat from Mons altogether occupied thirteen days, the distance covered being at least 200 miles.

As the line of the French retreat approached Paris, one possible historical verdict is that the Germans were, at least geographically, on the verge of victory within four months of the outbreak of war. But the logistics tell a different story.

The Belgian Army, although decimated, held the crucial northern line from Dixmude to Nieuport. The French Armies in the west were largely intact. The BEF had survived brilliantly at Mons, and more bloodily at Le Cateau. In the east Verdun, sacred to the French, held, and the Germans had failed to exploit their earlier advances from the Moselle. Further west the Allies were gathering forces which would create the battlefields of the Somme.

The losses in the BEF in 1914 were heavy in relation to its size. At Mons it consisted of two Army Corps, each about 32,000 strong, and a Cavalry Division. The losses were 16,000 killed, wounded and missing. Many lie in the cemeteries of St Symphorien, Mons, Frameries, and in Le Cateau.

For the French their losses were a foretaste of the later horrors of Verdun and the Aisne. For the Germans their heavy losses contributed to the final failure of the only fast-moving phase of the War – which might have brought them a dramatic victory.

Brandhoek New British Cemetery

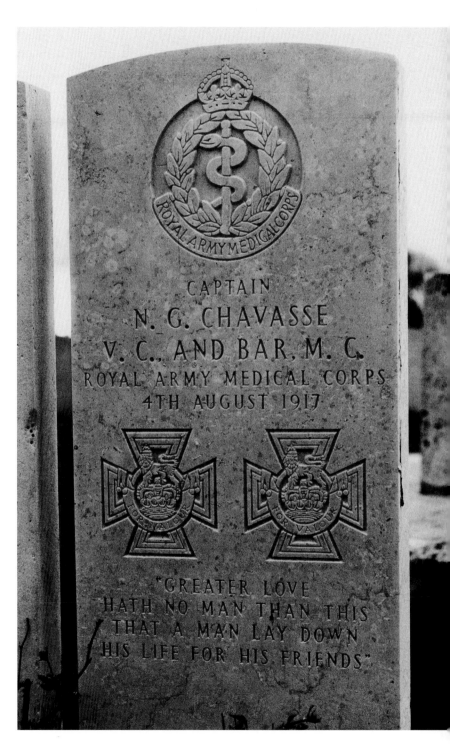

Left and below: Nieuport, British Memorial to the Missing. 566 names.
Opposite: Adinkerke Churchyard Extension

NIEUPORT, MEMORIAL TO KING ALBERT OF THE BELGIANS

But what he has suffered, what he suffers day by day, only those can understand who have had the privilege of access to this hero, the most sensitive and gentlest of men, silent and reserved.

MAURICE MAETERLINCK *The Wrack of the Storm*

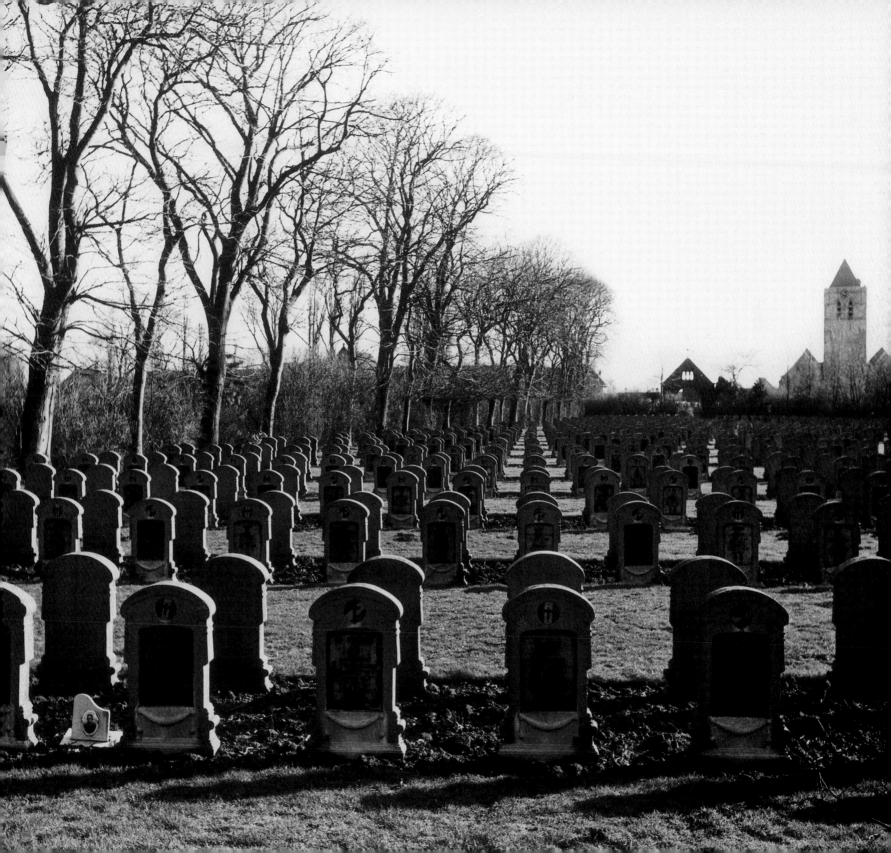

In Bruges was born the son of Jean Swalue, who died for his native land. Only a last shred of territory beyond the Yser was left for him to defend; he died in its defence. His body, so like a big fair haired boy's, rests somewhere in the cemetery of Adinkerke.

HENRI DAVIGNON *A Book of Belgium's Gratitude*

ST SYMPHORIEN MILITARY CEMETERY, MONS. IDENTIFIED BURIALS 164. UNIDENTIFIED 65

Opposite and right: *St Symphorien Military Cemetery, Mons*
Below left: *Le Cateau German Cemetery*
Below right: *Le Cateau British Military Cemetery*

LE CATEAU

I do not doubt that mankind will survive even this War, but I know for certain that for me and my contemporaries, the World will never again be a happy place. It is too hideous. And the saddest thing about it is that it is exactly the way we should have expected people to behave from our knowledge of psychoanalysis.

SIGMUND FREUD, letter to Lou Andreas-Salomé; 'Sigmund Freud'

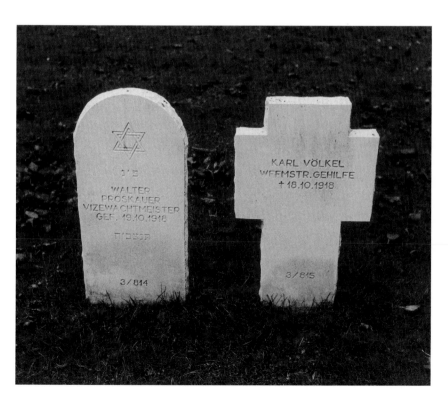

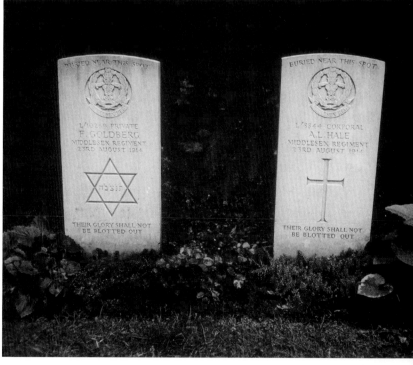

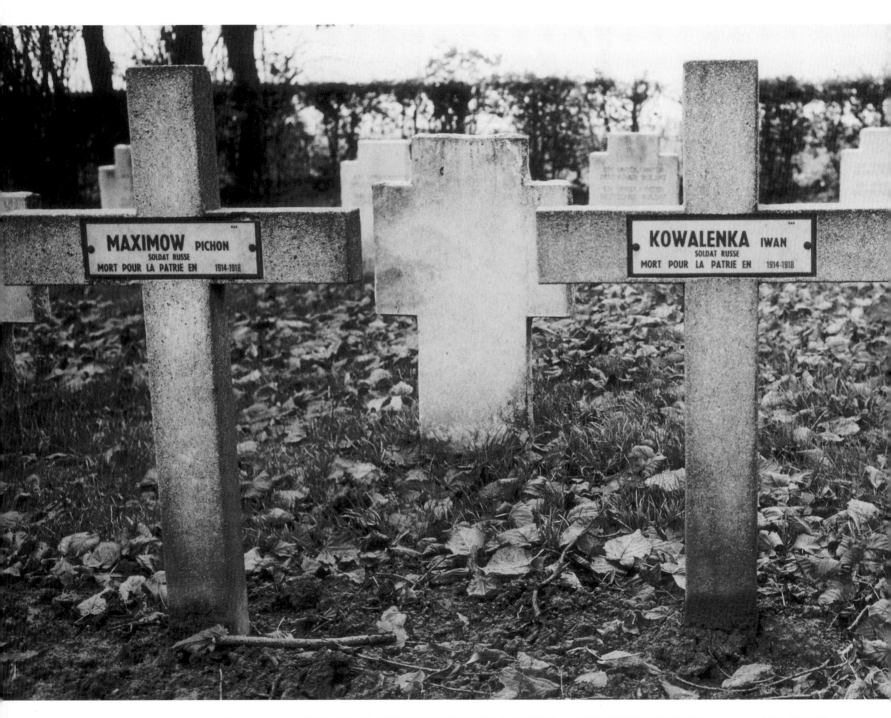

LE CATEAU GERMAN CEMETERY. HEADSTONES OF RUSSIAN PRISONERS OF WAR. INDIVIDUAL BURIALS 5,381 MASS GRAVE 141

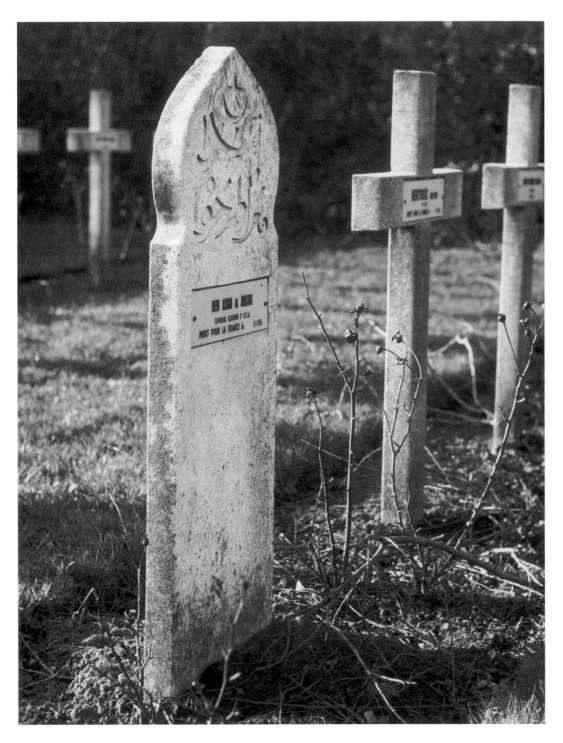

FURNES

That courtyard in the convent at Furnes will always haunt my mind as the scene of a grim drama. Sometimes, standing there alone in the darkness, by the side of an ambulance I used to look up at the stars and wonder what God might think of all this work if there were any truth in old faiths.

PHILIP GIBBS *The Soul of the War*

During the two days that followed, the convent at Furnes was overcrowded with the wounded. All day long and late into the night they were brought back by the Belgian ambulances from the zone of fire, and hardly an hour passed without a bang at the great wooden gates in the courtyard, which were flung open to let in another tide of human wreckage.

PHILIP GIBBS *The Soul of the War*

Verne (Furnes) Communal Cemetery Extension

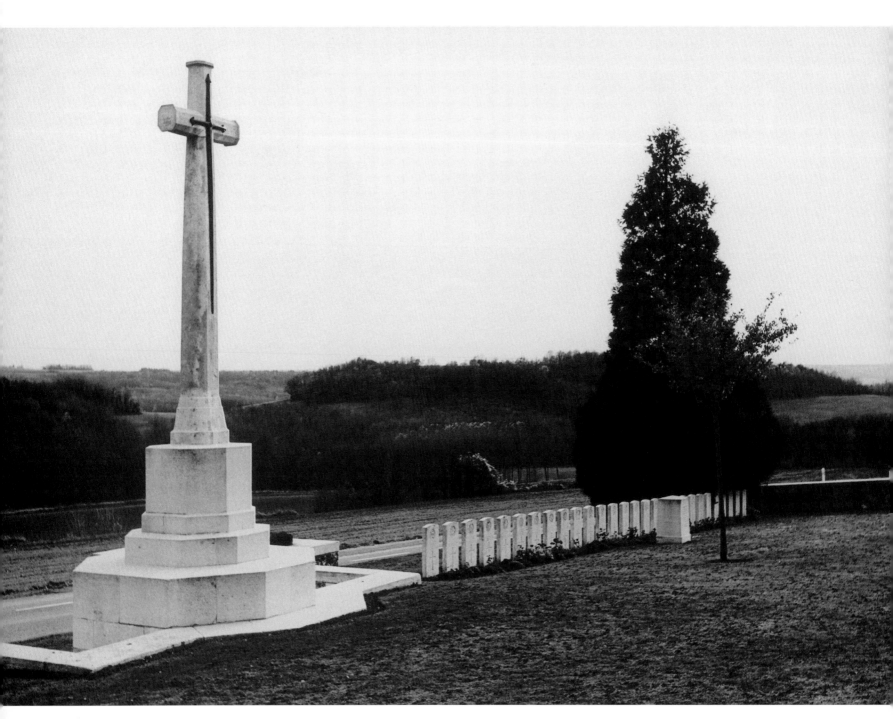

VENDRESSE BRITISH CEMETERY. IDENTIFIED BURIALS 327. UNIDENTIFIED 401

THE MARNE AND THE AISNE

He fell in October 1918 on a day that was so quiet and still on the whole front that the army report confined itself to the single sentence: 'All quiet on the Western Front'.

ERICH REMARQUE *All Quiet on The Western Front*

The Battles and the campaigns of the Marne and the Aisne marked the fortunes and disasters of the Allies from 1914 until the final success of 1918. When Paris was threatened, within a month of the opening of the War, the Allied counter-attacks on the Marne finally halted the Germans, and it was on the banks of the Marne and on the plateau above it, in the summer of 1918, that the full power of the American forces, with the French and the British, caused the Germans to pay the price for having lines of communications which they could not sustain. Between these phases of dogged defence and successful attack came the costly failure of the Nivelle Offensive of 1917, when so many lives were lost on the slopes of the historic Chemin des Dames, that beautiful ridge above the Aisne.

The original Schlieffen Plan, with its rapid right-flanking movement through Belgium and French Flanders, should have led to the virtual encirclement of Paris after the final southern thrust took the Germans across the Seine to the west of the capital. As the French fell back from Flanders, von Kluck and von Bulow, with Moltke's approval, changed their southward thrust from the west to the east of Paris. Thus by 5 September, 1914, the German 2nd and 3rd Armies had reached some 20 miles south of the Marne below Epernay and Châlons, while the extreme right wing formed by the German 1st Army was on the Marne west of Château Thierry, and over the Ourcq south of Villers-Cotterêts.

This was the setting for the first battles of the Marne and the Ourcq in September, 1914, with the BEF and the French 5th Army counter-attacking northwards across the Marne, between the German 1st and 2nd Armies. The Germans fell back from their west and south flanks to the Aisne after fierce fighting, especially with the French. Moltke was replaced as Chief of the General Staff by Falkenhayn on 14 September and the attempts by each side to outflank the other to the west led to what was illogically called 'the race to the sea'. More realistically it established the opposite trench lines running south from the coast, through Flanders, crossing the Somme, then swinging east along the Aisne, through Champagne to Verdun and then turning south again through Alsace-Lorraine. Thus the areas in which so many men were to fall during the next four years were determined by the first battles of the Marne and the Aisne.

Early in 1917 pressure for a major Allied offensive in the west was mounting, in part from the French and General Nivelle, the Commander-in-Chief of the Armies of the North and North-East, but also from the British Cabinet. In the west the Battle of Arras began on Easter Monday, 9 April, 1917, only nine months after the Somme offensive of July, 1916, which had gained the Allies so little ground and lost them so many lives. The 'great' Nivelle Offensive from the south began on 16 April, hopes being high that with this onslaught, following hard upon the Arras offensive, the Germans would finally be defeated in two great battles. The French line lay partly along the Aisne, and, further east, below the brow of the Chemin des Dames, before running south-eastward north of Rheims. Despite a very heavy opening barrage, which dealt effectively with the German artillery, the machine guns above the Aisne on the Chemin des Dames were not silenced. Only in the west was there limited success, with the retreat of the Germans from the river at Vailly to a line below the crest of the Chemin des Dames. Within forty-eight hours it was clear that the hopes of a breakthrough had withered away; even the limited objective of gaining the Chemin des Dames had failed, and the secondary attack east of Rheims fared no better.

The losses on both sides were great, but for the French grievous; a figure of 187,000 may be near the truth. A sense of utter failure and disillusionment settled upon the French Army, mutinies broke out in Champagne, and increased during May and June, the news of the Russian revolution possibly having stimulated agitators. Meanwhile the Chemin des Dames, a symbol of the great days of France, was to remain in German hands until near the end of the War.

The final battles of the Marne and the Aisne of 1918 followed the German offensive of May and July. General Ludendorff, aged 53, who had been opposed to the attack upon Verdun, took command, with Hindenburg, of the German Army after Verdun. He had devised new methods of attack, including the use of gas shells. He was responsible for the great German offensive of 1918.

This page: *River Aisne*
Opposite: *A Russian Cemetery*

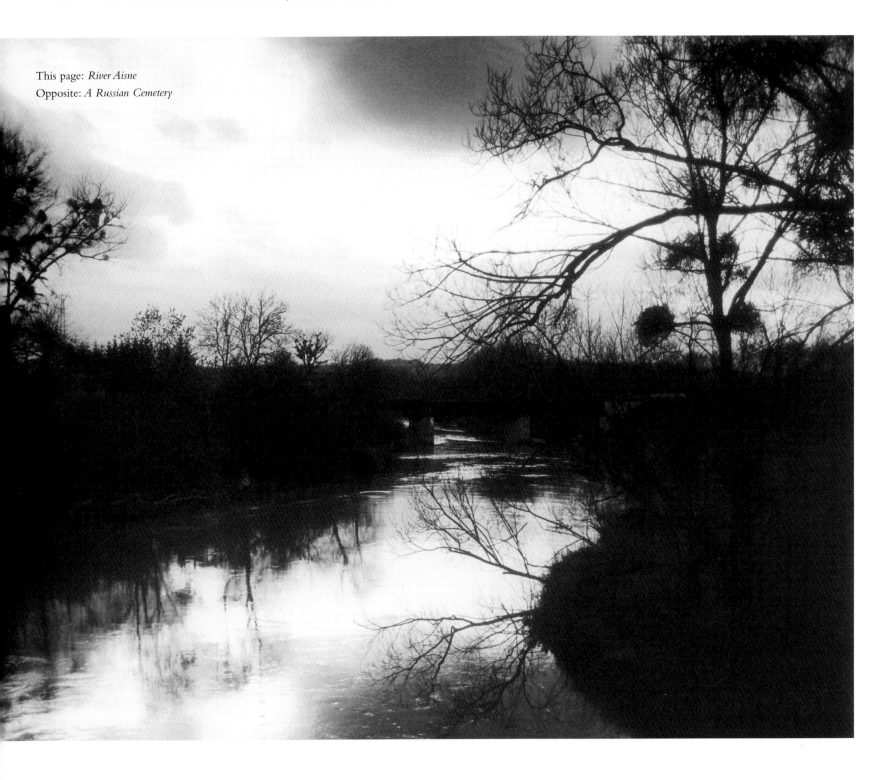

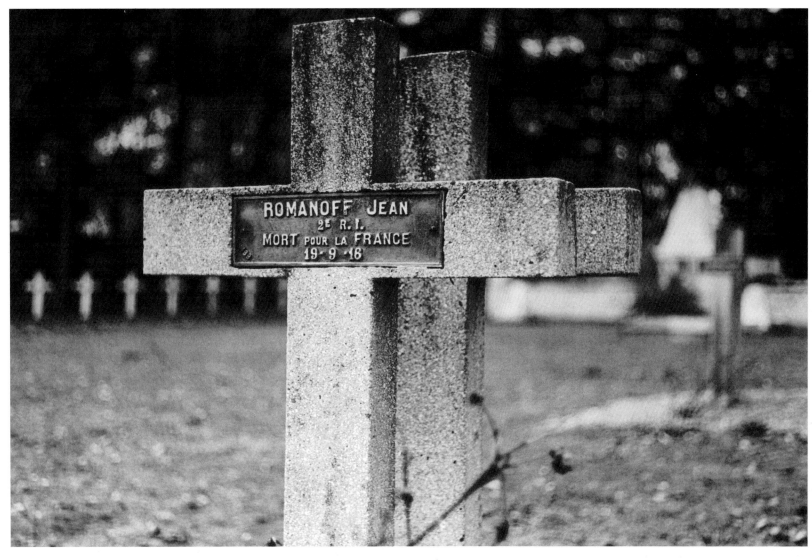

Having failed to achieve the final breakthrough in Flanders in March, Ludendorff attacked the French on the Chemin des Dames sector, hoping to draw French forces from the west and allow a final successful attack upon the British, who would be left unsupported. Partly because the French moved forward to exposed positions on the Chemin des Dames, the massive barrage in the early morning of 23 April allowed the Germans to storm through the French and British divisions, cross the Aisne, and by 3 June they had reached the Marne between Château Theirry and Dormans. Then it was that fresh American troops did much to halt the Germans, and above Château Thierry they cleared part of Belleau Wood.

One final thrust by the Germans came in July, west of Rheims, and was held by French, Italian and British troops. But Ludendorff had outstripped his lines of communication, he could not protect the western flank of his salient, and the final defeat of the Germans began with the French attack of 18 July. The Americans attacked above Château Theirry and by early August the Germans had retreated across the Marne and the Aisne. The Chemin des Dames was finally in French hands.

CHAMBRECY ITALIAN CEMETERY

Passing through the gallant weary Italians who had destroyed an entire German division and severely handled several others, the British struck along the Ardre river valley at Marfaux, won it, lost it, and then partly regained it, and captured Courton Wood.

J.A. HAMMERTON *A Popular History of the Great War*

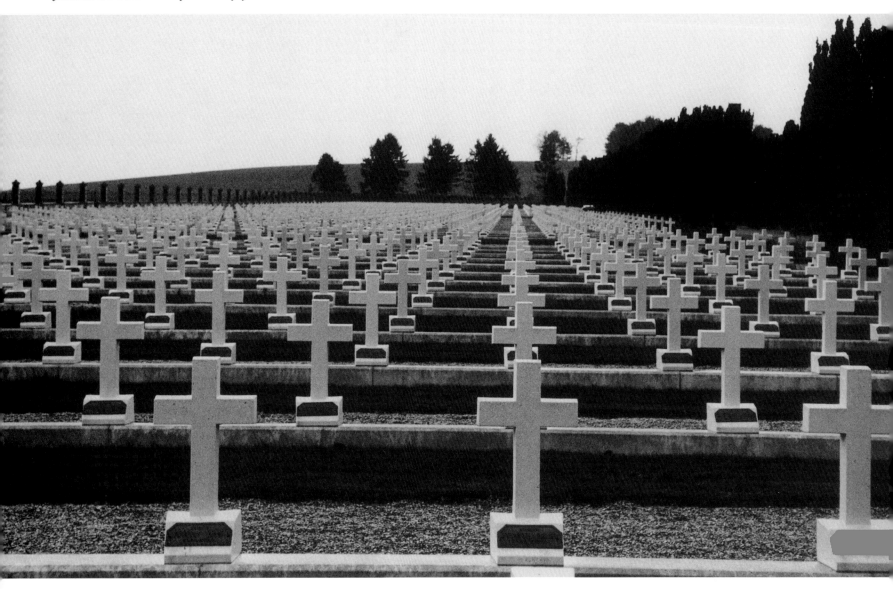

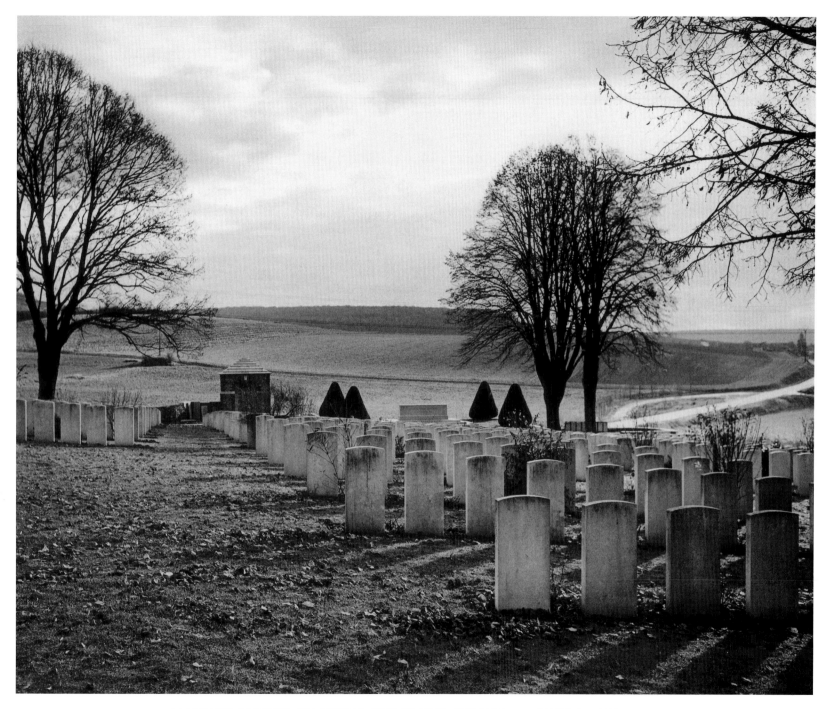

MARFAUX BRITISH CEMETERY. IDENTIFIED BURIALS 788. UNIDENTIFIED 341

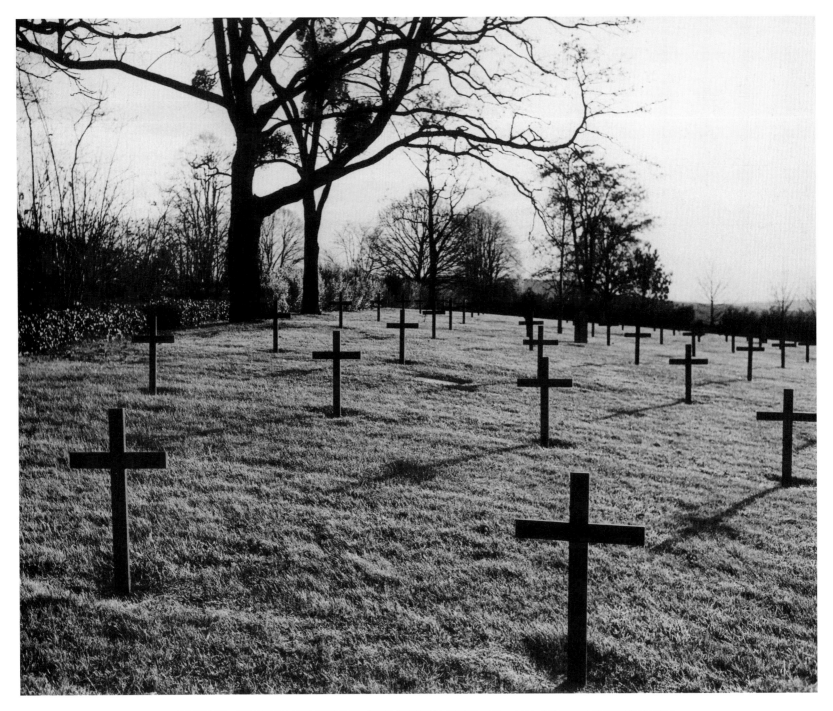

MARFAUX GERMAN CEMETERY. IDENTIFIED BURIALS 1,697. UNIDENTIFIED 2,720

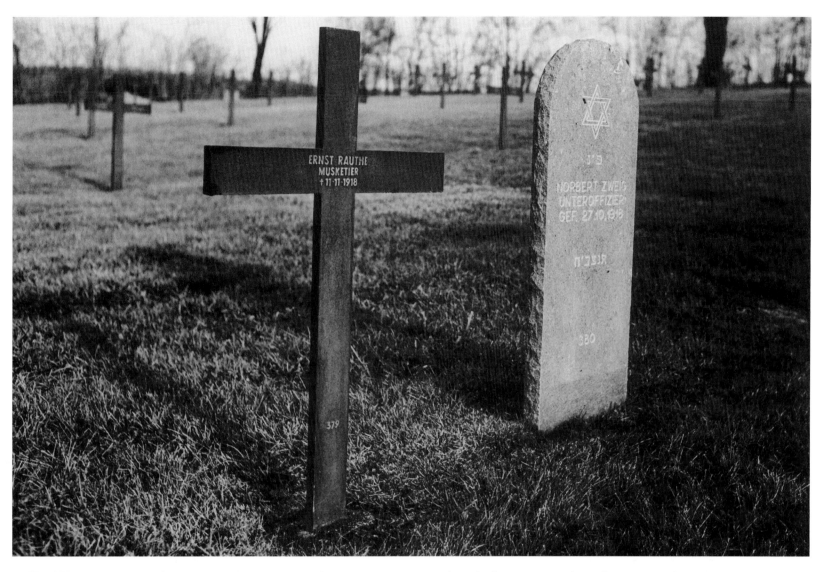

The three major phases of fighting on the Marne and the Aisne, 1914, 1917 and 1918, were costly. For the French the Nivelle Offensive of 1917 was disastrous in terms of men and morale, a plight from which they did not recover until July, 1918. With the French and the British stood two Italian divisions, many of whom lie buried in the Italian Military cemetery at Chambrecy. The Americans, who played a major part in halting the final German offensive on the Marne, lost heavily; 2,288 lie buried in the Aisne-Marne cemetery, and the names of 1,060 missing are recorded, within sight of the German cemetery at Belleau Wood. On 12 September, 1918, as the lines moved northwards, the Americans drove the Germans from the St Mihiel Salient, south of Verdun; the memorial at Montsec records the battles of the St Mihiel Salient. In the American cemeteries of St Mihiel and Meuse-Argonne 18,000 men lie buried and the names of 1,200 who have no known graves are recorded. It is difficult to estimate German losses; 163,000 may have fallen in the Nivelle Offensive of 1917. The British suffered especially heavily in 1914 and during the last German attack of 1918. In the Commonwealth cemeteries of the Marne and the Aisne, there are 5,600 identified and 2,600 unidentified burials, with the names of 7,700 on memorials to the missing.

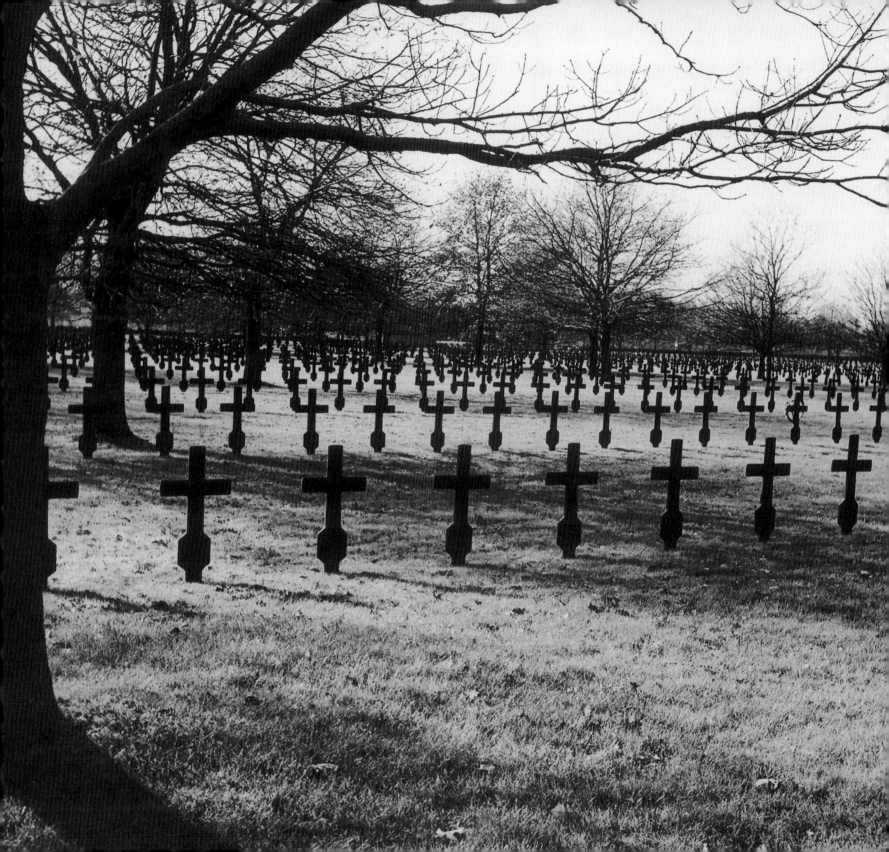

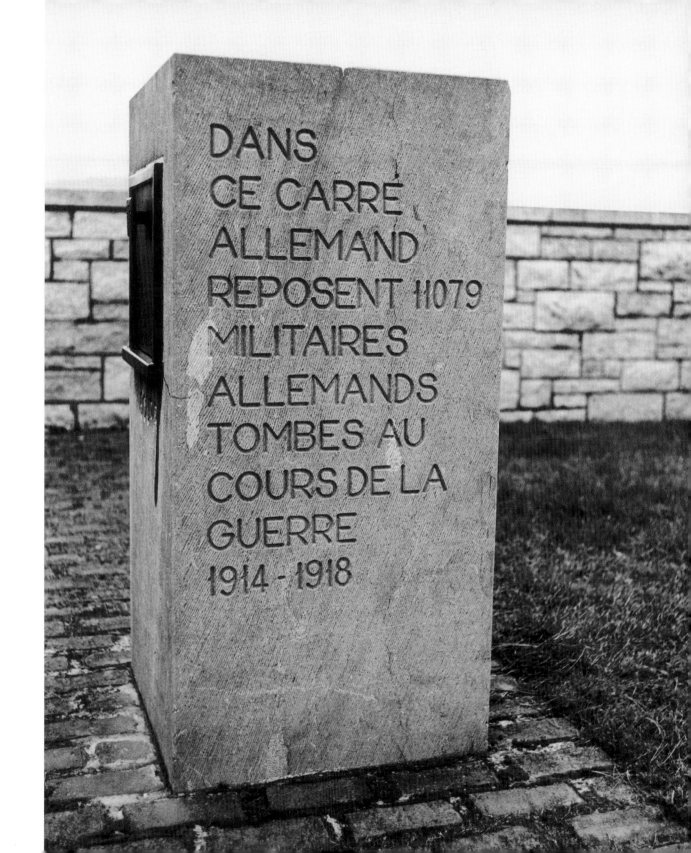

DANS
CE CARRE
ALLEMAND
REPOSENT 11079
MILITAIRES
ALLEMANDS
TOMBES AU
COURS DE LA
GUERRE
1914 - 1918

Opposite and this page: *Fort de Malmaison German Cemetery*

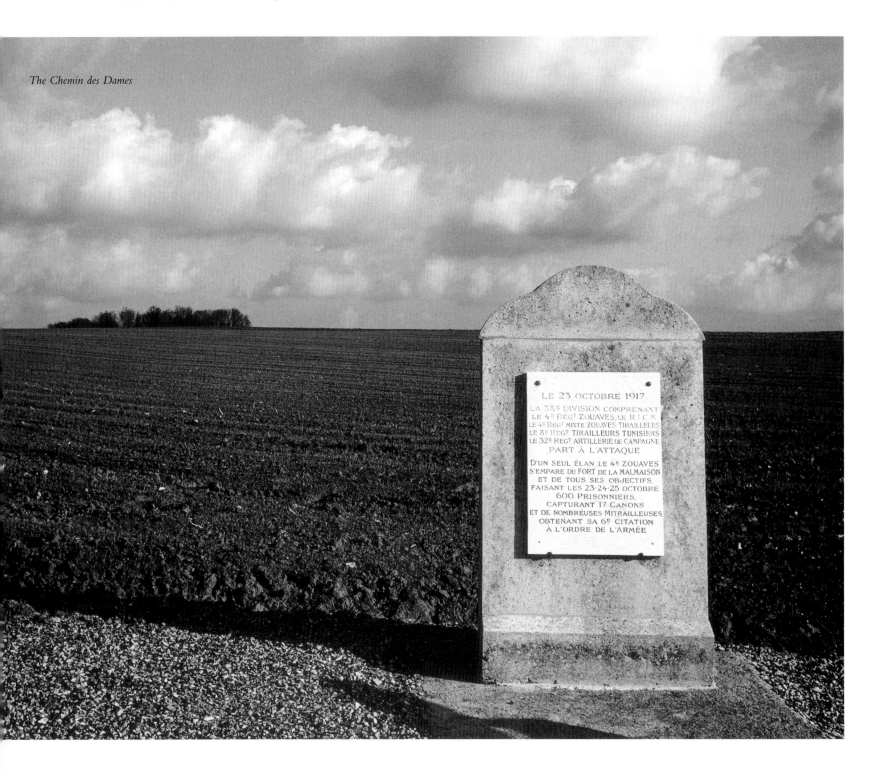

The Chemin des Dames

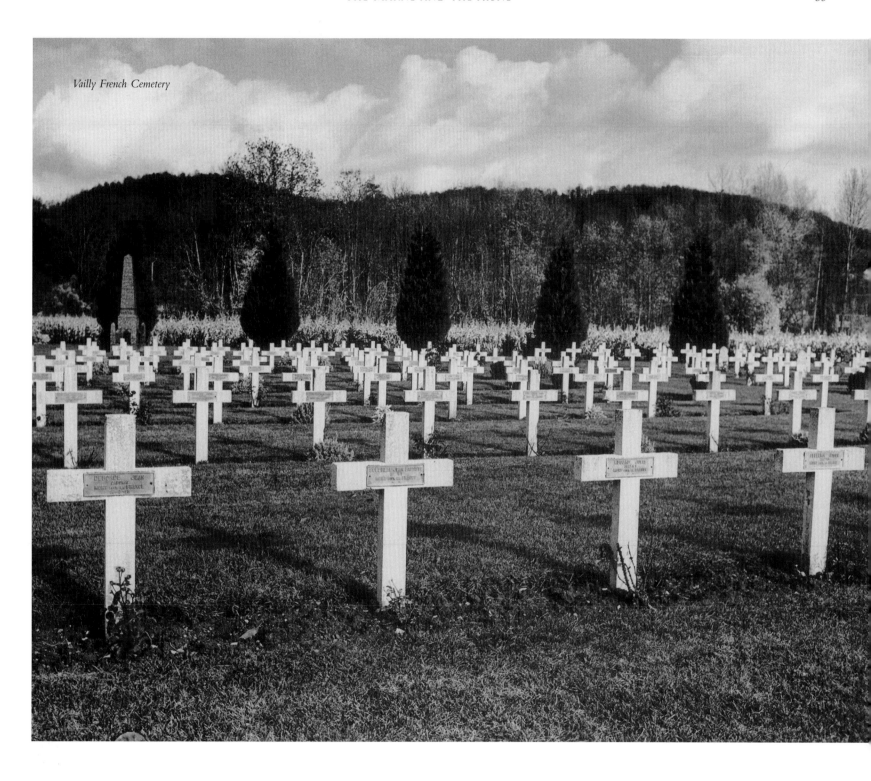

Vailly French Cemetery

Vailly French Cemetery

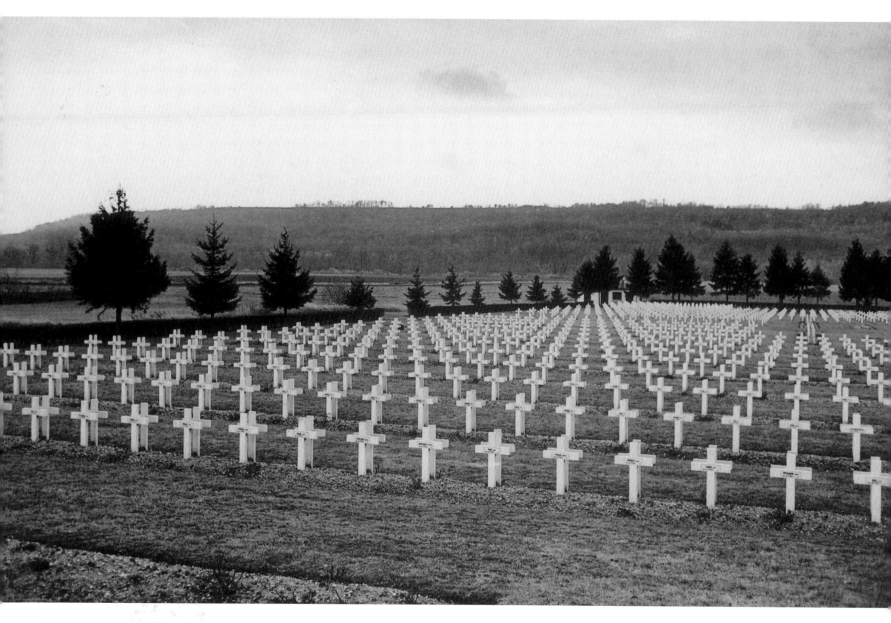

SOUPIR FRENCH CEMETERY

As we are about to begin the battle upon which depends the fate of our country, it is necessary to remind all that the time for retreat has ended. Every effort must be made to drive back the enemy. A soldier who can no longer advance must guard the territory already held, no matter what the cost. He must be killed in his tracks rather than draw back.

CESAIRE JOFFRE *The Two Battles of the Marne*

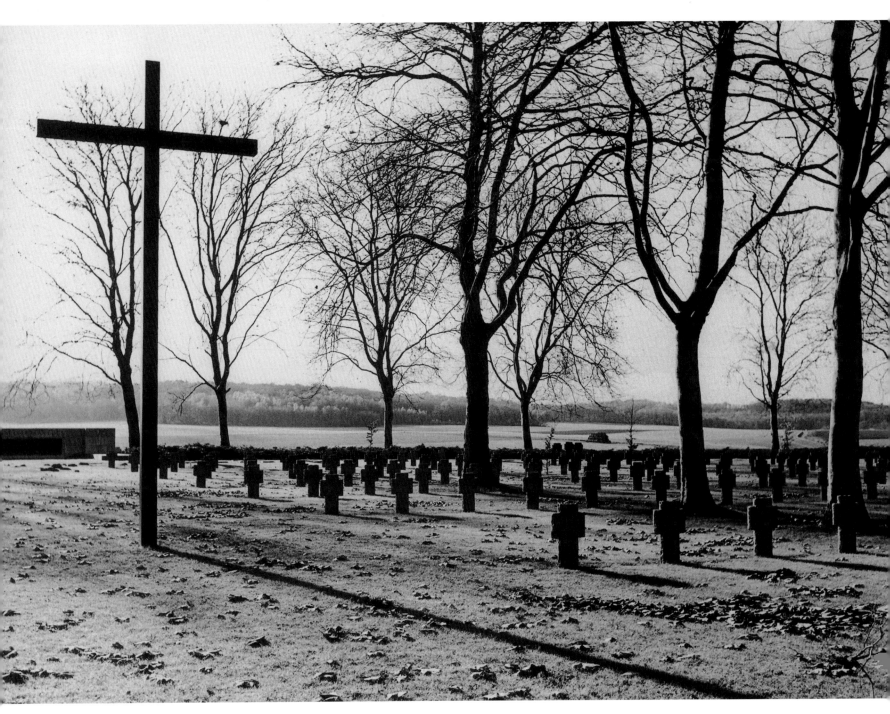

BELLEAU GERMAN CEMETERY. IDENTIFIED BURIALS 4,307. UNIDENTIFIED 4,322

AISNE-MARNE AMERICAN MILITARY CEMETERY
IDENTIFIED BURIALS 2,288.
MEMORIAL TO 1,060 OF THE MISSING

Between June 6th and 10th 1918 came the taking of Bouresche and next the Belleau Wood affair by the Marines, supported by the Twenty-Third. It was point-blank fighting, as hot as anything could be for a green man, and some places like Lucy were thick with dead. Still they got through, though the casualties were high; one battalion for example, lost seventy-five per cent of its men when going through an exposed wheatfield.

HARVEY CUSHING *A Surgeon's Journal*

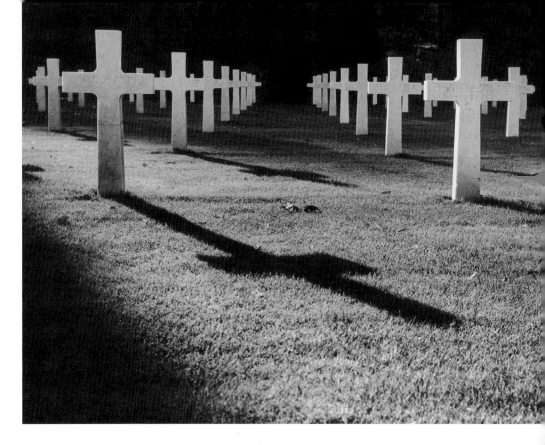

Regarding the actual fighting of the Americans, their attacks were undoubtedly brave and often reckless. They lacked sufficient dexterity or experience in availing themselves of topographical cover or protection. They came right on in open field and attacked in units much too close-formed. Their lack of actual field experience accounts for some extraordinarily heavy losses.

ERICH VON LUDENDORFF *The Two Battles of the Marne*

Mangin pointed out many errors in Ludendorff's account of the operations, and particularly noted his contemptuous reference to the American troops, who fought admirably and inflicted on the Germans very heavy losses.

J.A. HAMMERTON *A Popular History of the Great War*

Above right: *Aisne-Marne American Military Cemetery*
Below right: *Montsec American Monument*

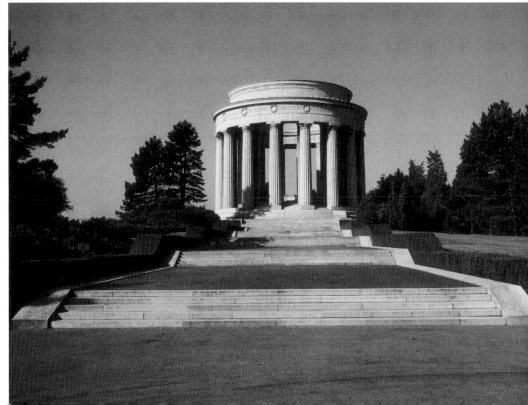

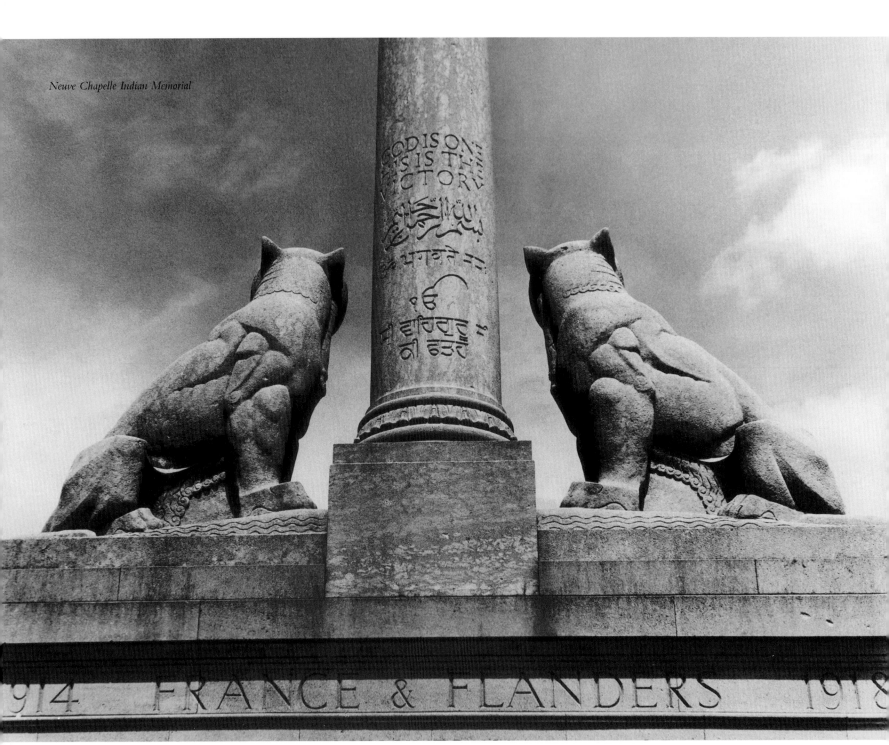

Neuve Chapelle Indian Memorial

ARTOIS

On April 30 (1917) when Edward wrote from Brocton Camp, he had heard only that morning of Geoffrey's death, and did not yet know that he had been killed by a sniper while endeavouring to get into touch with the battalion on his left some hours after the attack on the Scarpe began. Shot through the chest, he died speechless, gazing intently at his orderly. The place where he lay was carefully marked, but when the action was over his body had disappeared and was never afterwards found.

VERA BRITTAIN *Testament of Youth*

The Battles of Artois occupy geographically a central position on the Western Front with Flanders to the north and east, the Somme to the south and west, and the Aisne, the Marne and Champagne to the south-east. Once the lines were established in 1914, fighting continued in the area throughout the four years, with certain heavier battles, such as Neuve Chapelle, Loos, Arras and Vimy being given particular names. Already in October, 1914, Neuve Chapelle, north of La Bassée, was the scene of fighting by the Indian Corps which halted the German advance by retaking that village.

Early in 1915 there were plans for a major Allied offensive in the west, in part to relieve pressure upon the Russians whose military situation was parlous, but also to encourage Italy to enter the war on the side of the Allies. Joffre's plan was for a French offensive in Champagne, and a second Allied attack in Artois upon the more northerly section of the German salient. In March the French in Champagne fared badly, the advances were limited, and the losses heavy, with a total of 90,000 killed, wounded or taken prisoner. Sir John French was reluctant to await a successful outcome of the French attack in Champagne, if it depended upon the withdrawal of French troops from Ypres Salient which would seriously weaken that largely British-held sector. Therefore, on 10 March he attacked independently at Neuve Chapelle. The Indian division was heavily committed, and the attack, although starting brilliantly, slowed after three days with an advance of only 1,000 yards on a front of 1 mile. It could be argued that Sir John French's anxieties, and his premature action, contributed to the failure of the later combined British and French offensive in September. Despite these setbacks, Joffre still believed that a double offensive could be successful, with the French in the south attacking in Champagne, and the British attacking in Artois between La Bassée and Arras. The Champagne offensive was to be the main attack.

By September, 1915, the British supply of munitions had improved, and therefore the double offensive opened on 25 September. In Champagne, on a 15-mile front between Rheims and Verdun, the French advanced only 1¼ miles before being halted by the German second line. A second French attack had little more effect. The British attack, which later became known as the Battle of Loos, also began on Saturday 25 September, 1915, its main direction being from the line of the Bassée Canal, south-east towards Loos, Grenay and Lens. This was the Artois of mining towns and villages, with slag heaps and brickworks, which provided good bases for many well-fortified German positions. Haig had six divisions of which three were regular and three new. The initial release of gas had no effect upon the enemy because a south-easterly wind carried the gas back over the British left flank. Despite a heavy morning mist the advance was successful, with the London Irish, the Highlanders and the London Territorial Division, playing a major part. By the end of the first day Loos had been cleared, in the course of which there was fierce fighting in the town cemetery. The Highland regiments, the Camerons and the Gordons, whose original plan was to continue east beyond Loos to Hill 70, north of Lens, were the victims of confusion in planning. Having taken Hill 70, there was no plan to consolidate their position; but their diminishing number was beyond recall as they pursued the enemy, without support, and fell to machine-gun fire beyond Hill 70.

Because the initial success with an advance of up to 4 miles had not been foreseen, the reserves, which included the Guards, were still far back at Béthune and Noeux, and thus the chance to exploit the success of that first day was lost. It was not until Monday afternoon, 27 September, that the attack by the 3rd Guards Brigade, with the Welsh and Grenadiers, made military history. In perfect formation, under withering shrapnel and machine-gun fire, they regained the lost ground and took Hill 70. But the enfilading fire made it impossible to hold. In September and October bitter fighting continued north of Loos and Hill 70, especially around the Hohenzollern Redoubt. After the last major British attack, on 13 October, the Battle of Loos came to an end.

Neuve Chapelle Indian Memorial to 4,843 Missing

We had to pass the wooden garden of the Chateau. In the woods are about two score graves, half of our men and half of Indians –Khdirs and Alis – beautifully tended graves shining in bead wreaths and pine crosses. Over them in the moonlight a nightingale was singing loud and sweet. Its first notes were so close and so low I was startled.

HAROLD CHAPIN *War Letters of Fallen Englishmen*

The major battles of Artois in the spring of 1917 became known generally as the Battle of Arras and included that for Vimy Ridge. They were designed mainly by the French as a prelude to, and integral part of, the great Nivelle Offensive on the Aisne, which would dislodge the Germans from the symbolic and commanding Chemin des Dames. The two great offensives should bring the Allies final victory.

Since the battles of the Somme had reached their dismal conclusion in the November blizzards of 1916 and the mud of the Ancre, there had been only one further Allied attack astride that river – in February, 1917. However, the effects of the Somme battles had told upon the Germans, who shrewdly withdrew, during the first three months of the year, to the heavily-fortified Hindenburg Line, which pivoted east of Arras, and ran south-east to St Quentin, Laon and the Chemin des Dames.

The Arras offensive began on Easter Monday, 9 April, 1917, and the Nivelle offensive on the Aisne seven days later. The 14-mile Commonwealth front extended from Givenchy, north of Vimy, to Croisilles, south-east of Arras. The southern part of the front faced the Hindenburg Line, and the more northern section east of Arras was astride the River Scarpe. The bombardment began on 4 April and its climax, before the infantry attack of 9 April, was far heavier than that of the Somme on 1 July, 1916. On the left the Canadians stormed and held Vimy Ridge, to which long tunnels had been built, and by 9.30 am the majority of the German second lines had fallen. Over 3,000 Commonwealth troops were killed. But as so often, after the initial success, the advance faltered. The ground was wet, rapid movement of men and materials was impossible, and in the southern section the Hindenberg Line held; reinforcements and better planning might have allowed the line to be breached, or at least turned. Within forty-eight hours Falkenhayn, Commander-in-Chief of the German 9th Army, had brought fresh reserves forward to form a virtually new army. On the 11th the Australians at Bullecourt had made lodgements in the Hindenburg Line, but, without reserves, and with a barrage mistakenly cancelled, they could advance no further. In all these attacks the only notable success was the fall of Monchy-le-Preux, near the Cambrai road. There were further German counter-attacks on 23 and 24 April, and another attempted British offensive on 3 May, perhaps to encourage Nivelle in his ill-fated offensive on the Aisne. But the troops were exhausted, and although fighting round Bullecourt continued for two weeks, the main Arras offensive petered out. Like Nivelle's offensive it was a tactical and strategic failure.

The losses in Artois are difficult to estimate. On the Indian memorial to the missing at Neuve Chapelle there are 4,843 names; on the Arras Memorial 35,928, and at Loos 20,589. The Commonwealth losses at Loos were about 60,000, of which some 15,000 were killed or missing and never found, and in the battles of Arras the total Commonwealth losses were over 150,000. Neither side gained any territory of significance in any of these battles.

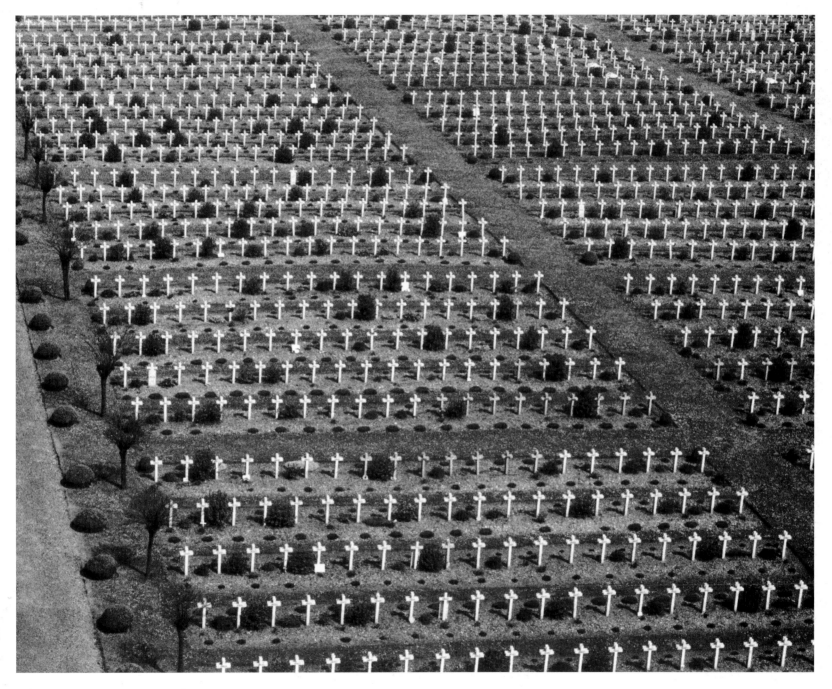

NOTRE DAME DE LORETTE FRENCH NATIONAL MEMORIAL AND CEMETERY. 20,000 INDIVIDUAL GRAVES.
20,000 UNKNOWN IN THE OSSUARY

Artois

MONCHY-LE-PREUX
37TH DIVISION MEMORIAL

In Monchy I saw a number of gas casualties. They were pressing their hands to their sides and groaning and choking, while water ran from their eyes; some of them died a few days later in frightful agony.

ERNST JUNGER *Storm of Steel*

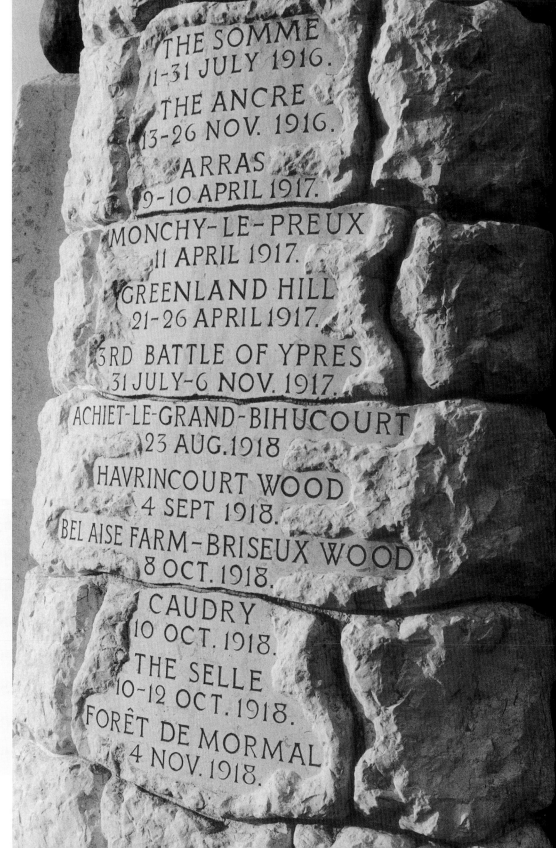

THE SOMME
1-31 JULY 1916.

THE ANCRE
13-26 NOV. 1916.

ARRAS
9-10 APRIL 1917.

MONCHY-LE-PREUX
11 APRIL 1917.

GREENLAND HILL
21-26 APRIL 1917.

3RD BATTLE OF YPRES
31 JULY-6 NOV. 1917.

ACHIET-LE-GRAND-BIHUCOURT
23 AUG. 1918

HAVRINCOURT WOOD
4 SEPT 1918.

BEL AISE FARM-BRISEUX WOOD
8 OCT. 1918.

CAUDRY
10 OCT. 1918.

THE SELLE
10-12 OCT. 1918.

FORÊT DE MORMAL
4 NOV. 1918.

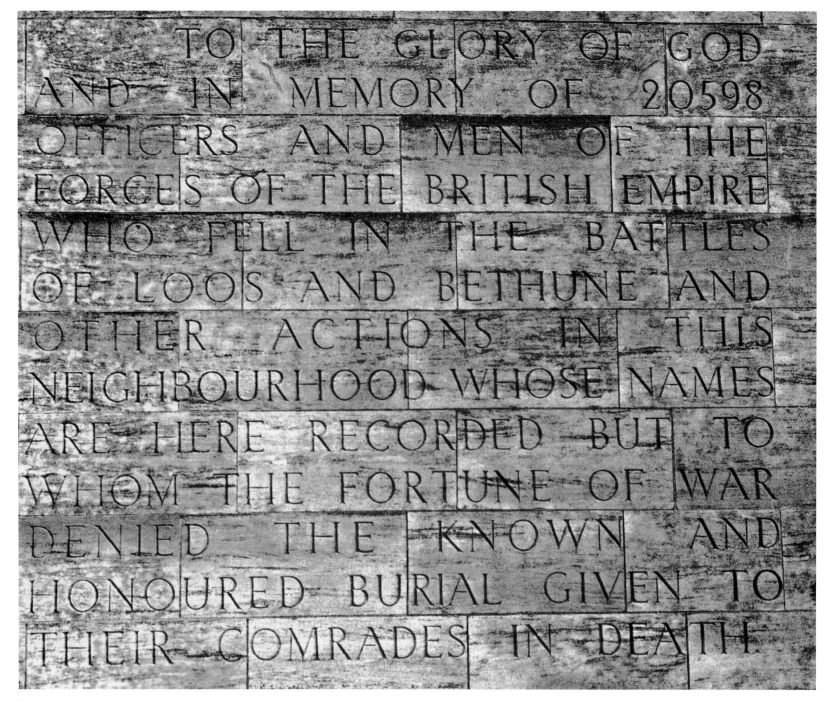

TO THE GLORY OF GOD AND IN MEMORY OF 20598 OFFICERS AND MEN OF THE FORCES OF THE BRITISH EMPIRE WHO FELL IN THE BATTLES OF LOOS AND BETHUNE AND OTHER ACTIONS IN THIS NEIGHBOURHOOD WHOSE NAMES ARE HERE RECORDED BUT TO WHOM THE FORTUNE OF WAR DENIED THE KNOWN AND HONOURED BURIAL GIVEN TO THEIR COMRADES IN DEATH

DUD CORNER CEMETERY, LOOS. IDENTIFIED BURIALS 684. UNIDENTIFIED 1,128

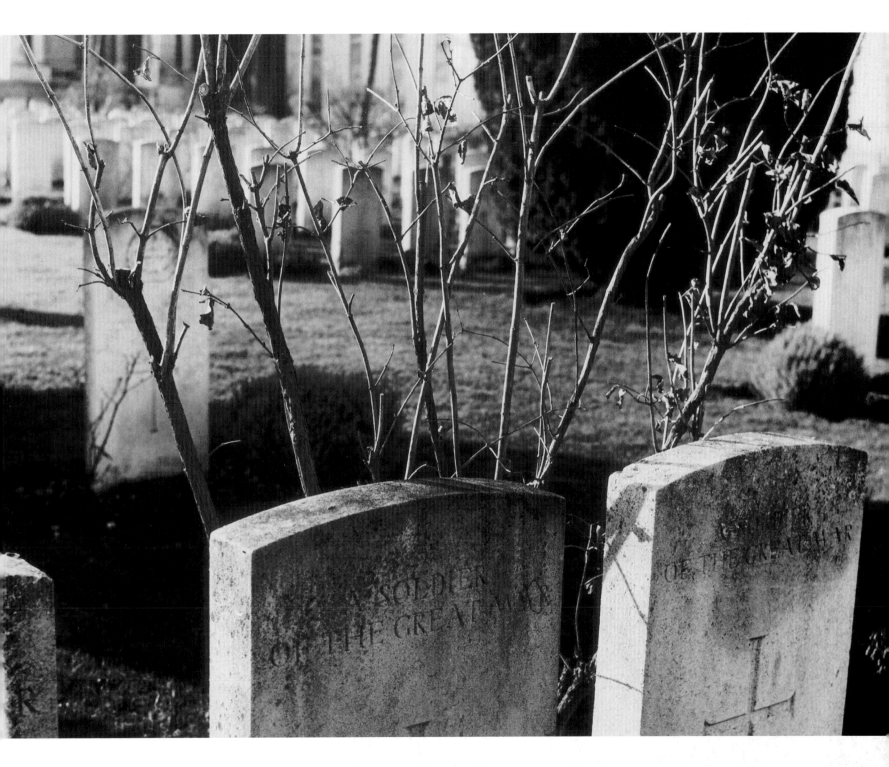

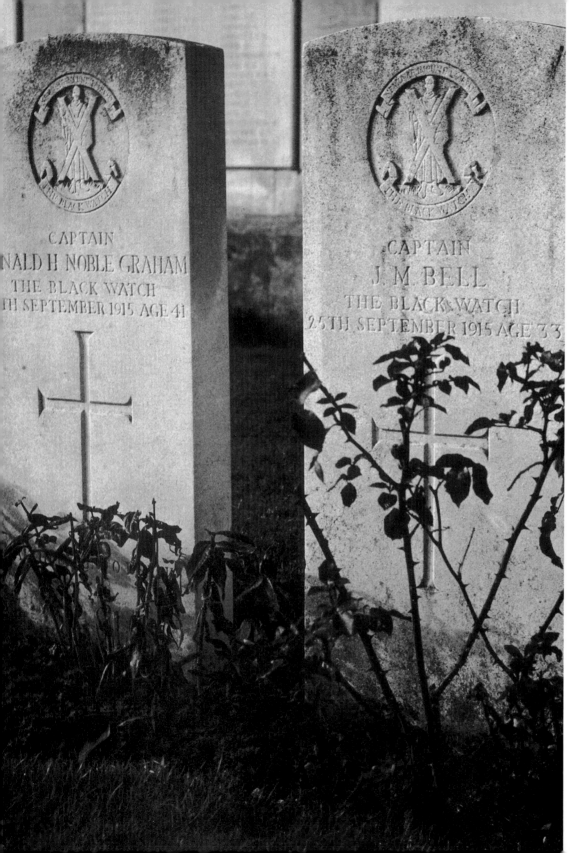

LOOS

The battle of Loos was remarkable in one respect. Here for the first time the men of Kitchener's army were engaged in a major operation. Composed of the flower of the Country's manhood, the new troops fought with desperate valour. But here, as later on the Somme, lives were squandered and men disabled for the sake of an advance that could have no real effect on the main issue.

WINSTON CHURCHILL *The World Crisis*

VIMY

The Canadians at Vimy had suffered appallingly, yet the official communiques told unblushing lies about the casualties.

SIEGFRIED SASSOON *quoted in Goodbye to All That*

And so across the lines to the ridge where words fail to give any conception of the desolation. No convulsion of Nature could have done what man and man's machines had done. We bumped ours way along a partly repaired road which led through Zouave Valley in which the Canadians had been desperately floundering for so long in the wet and the cold.

HARVEY CUSHING *A Surgeon's Journal*

Left and previous page: *Dud Corner Cemetery, Loos*
Opposite and overleaf: *Vimy Ridge Canadian Memorial*

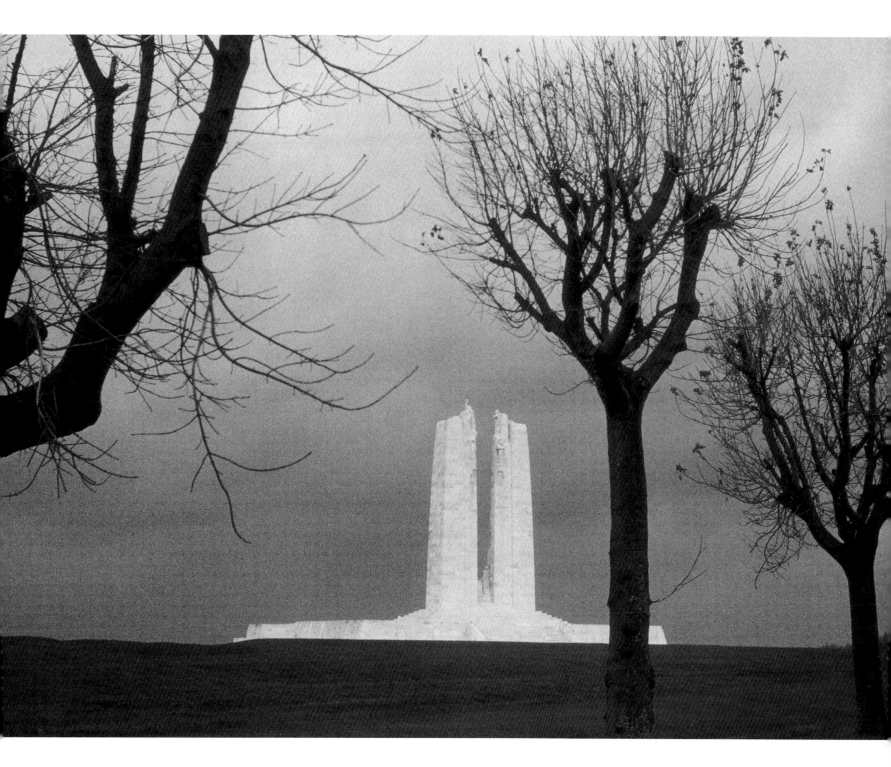

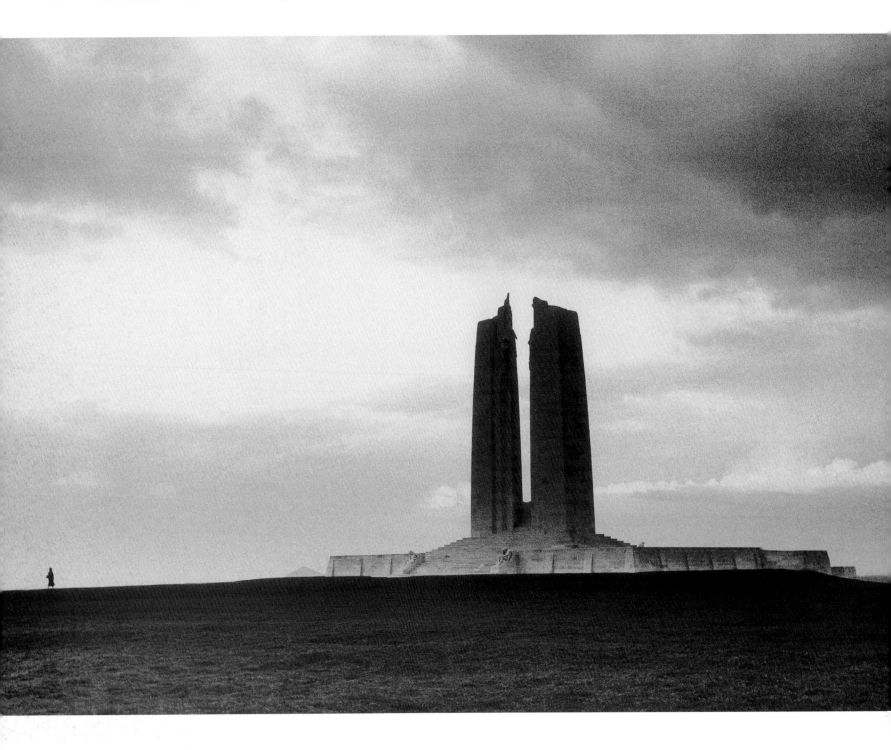

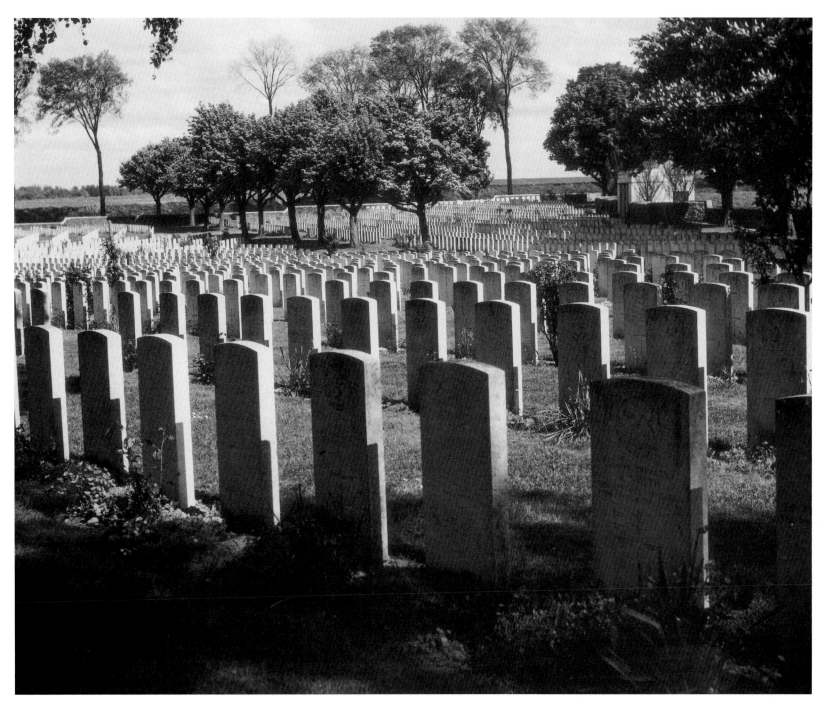

CABARET ROUGE BRITISH CEMETERY. IDENTIFIED BURIALS 3,179. UNIDENTIFIED 4,478

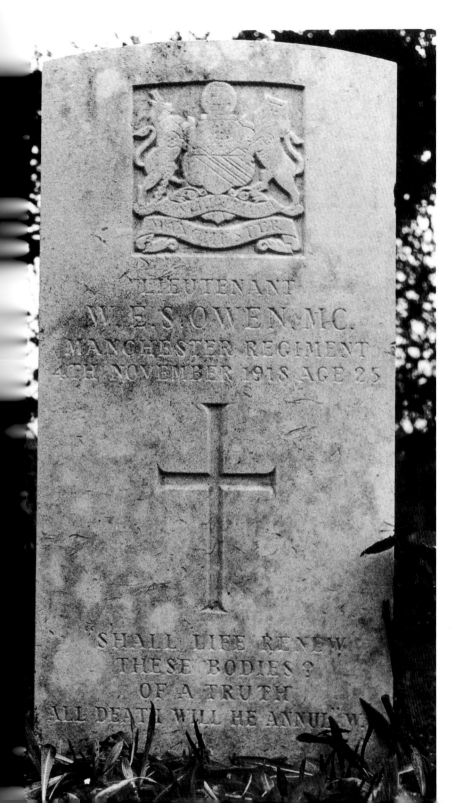

ORS COMMUNAL CEMETERY.
IDENTIFIED BURIALS 59. UNIDENTIFIED 4

It is a great life. I am more oblivious than alas yourself, dear Mother, of the ghastly glimmering of the guns outside and the hollow crashing of the shells. There is no danger down here, or if any, it will be well over before you read these lines.

WILFRED OWEN *Wilfred Owen; Selected Letters*

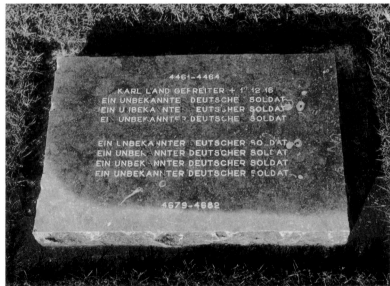

LANGEMARCK GERMAN CEMETERY.
19,378 INDIVIDUAL BURIALS. 24,916 IN MASS GRAVES

THE YPRES SALIENT

After a few testing visits to Talbot House, Archie Forest had summed up Christianity and found it greatly to his liking; after a week he had presented himself for Baptism; a month later he was Confirmed and made his first Communion; the week following he was killed a little past midnight at St Jean on his way back to safety.

P.B. CLAYTON *Plain Tales from Flanders*

Ypres – or more correctly Ieper because the City lies in the Flemish part of Belgium – has a significance for the Commonwealth similar to that which Verdun has for the French. Both Ypres and Verdun were scenes of 'sacrificial misery' where the Germans were halted, and where repeated attack and counter-attack resulted in great loss of life with little gain in land. Within the small area that formed the Ypres Salient lie 193,000 Commonwealth dead, of whom 100,000 have no known resting place, and whose names are recorded on the great memorials of the Menin Gate and Tyne Cot.

The Ypres Salient, projecting some 7 miles east of the City into what was, for the major part of the War, land held by Germans, was the result of the battles fought by the British, Belgians, and French in September and October, 1914. This was the stubborn resistance to the most northerly sweep of the Schlieffen Plan (see Flanders 1914). In some respects it was also the result of the final attempt of each side to outflank the other towards the sea, although the term 'the race to the sea' is an over-simplification and an exaggeration of the true objective.

North of Ypres on 20 October, 1914, the Germans attacked the Belgians, who had hoped to hold the line of the Yser river and canal, but after four days of fighting the Belgians were exhausted and fell back to the line between Nieuport on the coast and Dixmude. The flooding of the land helped to halt the Germans advance and thereafter the line held.

The battles which were later named First (1914), Second (1915) and Third (1917) Ypres represent particularly ferocious phases, when each side in turn attempted, at enormous cost, to make advances in what had become a static war of attrition. 'First Ypres' began on 30 October, 1914 when the Germans attacked the line of the Salient. The British were forced back from the Messines Ridge, Gheluvelt fell, only to be retaken, and Passchendaele was already behind the German line. At Kemmel the French suffered heavily, while Wytschaete, Ploegsteert ('Plugstreet') and Messines were held. It was at this early stage of the War that the German Student Battalions first appeared, young volunteers often below military age, who fought with ferocity and unthinking patriotism. They died in their thousands, especially round Langemarck, but they also slaughtered their enemies. The final German attack of First Ypres came in early November, 1914, mainly from the direction of Menin. That was the crisis of the battle. The line just held and the Salient remained carved out of the German line. The establishment of the Salient cost the British at least 50,000 men; German losses were even greater.

'Second Ypres' began on 22 April, 1915, with the release of chlorine gas by the Germans. This, and the subsequent fighting, made 'Second Ypres' one of the worst battles of the War, and reduced the Salient to a bulge projecting, at the most, 2 miles east of the city. Although there had been warnings of forthcoming use of gas by the Germans, the Allies had not taken any precautions. The yellow-green cloud of gas was blown by a south-east wind towards a section of the line north of Ypres, held by a French Colonial Division; they were the first of many to suffer the deadly respiratory effects of chlorine, and those who survived were forced to withdraw behind the Yser Canal.

For the next few weeks 'Second Ypres' raged throughout the Salient. To the north-east of Ypres there was particularly heavy fighting, which involved the Canadians between 24 and 30 April. The withdrawal from Langemarck and Poelcappelle became known as the battle of St Julien. Unfortunately all was not well with High Command. Sir Horace Smith-Dorrien was relieved of the command of the 2nd Corps, and was replaced by General Plumer, previously Commander of the 5th Corps. The British believed that an orderly withdrawal to a more tenable line was needed, but Marshal Foch maintained that lost ground could, and should, be retaken, and was violently opposed to withdrawal. Foch, born in 1851, whose Jesuit background was unusual for a career soldier, was, by 1914, of great eminence through his teachings of the principles and conduct of war. He laid great stress on the power of moral force, a view which had contributed to the French tradition of attack. But the realities of 'Second Ypres', including further gas attacks on 2 and 3 May, resulted in British pragmatism, rather than French military tradition, holding sway, but not without counter-attacks and indecision, which increased the losses.

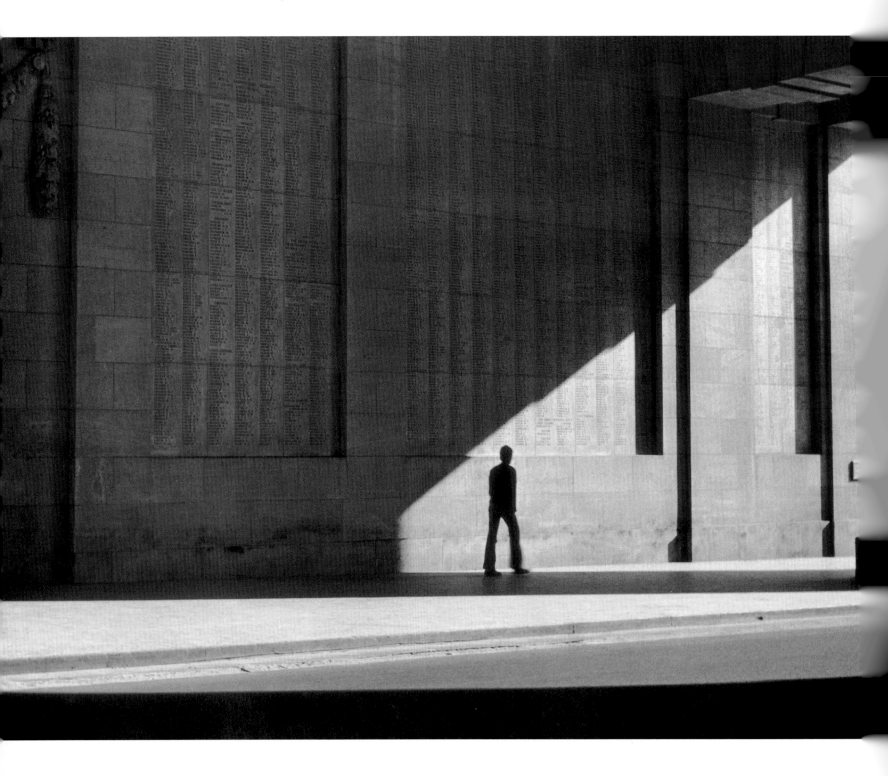

CRABTREE J.
CRANE J.
CRANFIELD H.
CROSS E.
CROWTHER R.
CROWTHER S.
CUMMINGS E.
CUNNINGHAM J.
DAGNALL T.
DALZIL D.
DANCER T.
DARNBOROUGH J.
DAVEY G.
DAVIES C.
DAVIES T.
DEAN T.
DERBYSHIRE J.
DEWHURST H.
DOBSON T.
DOWNING J.
DUERDEN D.
DUERDEN W.
DUFFY J.
DUNCAN W.
DUNN H.

HEARN M.
HEATON H.
HELLIWELL A.E.W.
HEMSWORTH G.
HENRY S.
HERRIN H.E.
HETTRICK A.
HEYWOOD W.
HIBBERT J.W.
HIGGIN M.
HIGHTON J.T.
HILTON A.
HOLCROFT C.
HOLDEN T.
HOLGATE J.
HOLT J. 204007
HOLT J. 204082
HOOK J.
HORAN T.
HORSFALL J.
HOUGHTON J.
HOWARTH R.
HULME A.
HULME R.
HULME W.
HUMPH
IBB

NEEDHAM M.
NIELD A.
NOONE T.
NORMAN G.E.
NUTTALL C.N.
OAKDEN A.
OAKES D.
O'CONNELL M.
O'GRADY T.
OLIVER J.
O'NEILL J.
PAGE T.
PALFREYMAN J.H.
PARKER J.C.
PHILBIN H.
PLOWRIGHT J.
POOLE A.E.
POTTER D.
POTTER J.H.
QUIGLEY
RAINS W.H.

PAUL W.E.
POLLOCK M.K.

LIEUTENANT
COZENS-BROOKE
J.G.S.
HENDERSON N.W.A.
KENNEDY N.
LYON C.J.
MACKENZIE C.G.G.
NESS G.S.
ROSS-THOMSON A.

SECOND LIEUT.
ALSTON C.McC.
ANDERSON E.L.

CO. SJT. MAJOR
BROWN E.G.
GARDINER L.G.
PAYNTER C.E.

SERJEANT
CAIRD J.H.
CAUSON F.
CORNHILL W.
HEDGER A.
McCOMBIE W.I.
MASON J.
MILLS A.
MURRAY T.
PETTITT A.
PUGH P.
REDDING J.
RICHARDSON E.H.
SMITH H.H.
STRINGER E.W.

LANCE SERJEANT
BARRY M.
DONOVAN J.
DURIE W.
INCHES J.D.C.M.
MILLS F.H.
PORTEOUS R.
RITCHIE J.
TAYLOR R.J.

CORPORAL
ALBANY J.W.

THE MENIN GATE, YPRES. 54,365 NAMES OF THE MISSING

The sad Salient lay under a heavy silence, broken here and there by the ponderous muffled thump of trench mortar shells round the line. We passed big houses, one or two, glimmering whitely, life in death. There was in the town itself the same strange silence, and the staring pallor of the streets in that daybreak was unlike anything that I had known. The Middle Ages had here contrived to lurk and this was their torture at last. We all felt this and when we got out of the lorry by the Menin Gate (that unlovely hiatus) we scarcely seemed awake and aware.

EDMUND BLUNDEN *Undertones of War*

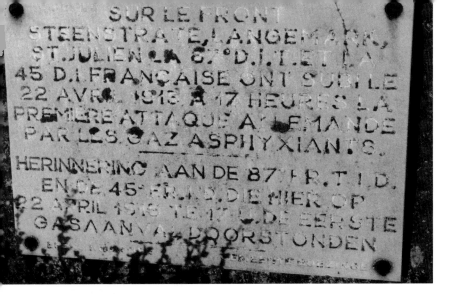

Artillery Wood Cemetery

The final stages of 'Second Ypres' were fought between 8 and 25 May to the east and south-east of Ypres. Hill 60, at the southern end of the Salient, had been mined by the British on 17 April, and was held thereafter. On 8 May German attacks from the east opened the Battle of Frezenburg Ridge, and Hooge, Sanctuary Wood and Zillebeke saw great loss of life. The final German attack on 24 and 25 May fell upon Bellewarde, Hill 60 and Pilckem with the largest cloud of gas yet released. In the five weeks of 'Second Ypres' Commonwealth losses were some 60,000; the depth of the Salient was shortened by, at the most, 5 miles, and Ypres remained a battered symbol of Belgian resistance.

'Third Ypres' of 1917 was the most costly of the battles to regain, largely successfully, the ground lost in the Salient in 1915. It included, in its final stages, the struggle through mud and morass to capture the ridge and the destroyed village of Passchendaele. It was a battle which evoked much criticism of Douglas Haig, who had succeeded Sir John French as Commander-in-Chief in December, 1915; but it was a criticism based, as it is so often, upon hindsight, and which disregarded the strategic pressures upon the leaders at the time.

The first phase of the battle, in May and June, brought the Allies remarkable success. South of Ypres the bombardment of the Messines and Wytschaete Ridges began on 21 May. On 7 June at 3.10 am the painstaking mining of the Messines Ridge, through 19 long deep galleries, created a manmade earthquake which resounded through Flanders and even across the Channel. The Commonwealth Forces carried Messines and Wytschaete, the latter by Ulstermen and Irish, and by 14 June the line forming the southern sector of the Ypres Salient had advanced by some 3 miles. Despite these successes, the front line was placed in a state of defence. Six weeks of fine weather were allowed to pass in preparation before the next phase of the attack began, which was to be a major offensive to the north and east of Ypres.

The Germans on the ridges to the east were able to observe the preparations, and they were not slow to construct a system of concrete pillboxes, and to move men and guns from the Russian Front. There was an Allied air offensive on 11 July, and an artillery bombardment began on 18 July, but the infantry did not attack until 21 July. That day, north of Ypres, French troops attacked towards the forest of Houthulst, and the British towards Pilckem.

But the rain came; between 30 July and 6 August, there was only one dry day. With all the drainage systems already destroyed in the earlier battles, the terrain was transformed into what later became a series of morasses and muddy pools, which added death by drowning to slaughter by weapons. The major offensive east of Ypres was delayed until 16 August, allowing yet more time for German defensive preparations. When the offensive east of Ypres began later in August, there was a break in the weather, the land dried to some extent, and advances were made along the Menin road, at Broodseinde and at Polygon Wood.

But the lull in the weather did not last, and the later battles were fought in the worst conditions of the War. Poelcappelle was taken in October, but the Germans stood firm on the few tongues of dry land which led up to the ridge at Passchendaele, and which looked down upon the swamps of the numerous 'bekes'. Names such as Zonnebeke and Zillebeke to this day have an ominous ring. Eventually Crest Farm and Passchendaele were taken by the Canadians on 6 November, the ridge was in Allied hands, and the battle closed on 26 November. By then the preparations for the Cambrai offensive were complete. Commonwealth losses between 31 July and 10 November were nearly a quarter of a million, and the Germans probably similar. Haig's persistence in attacks across the swamps and morass to gain the ridges to the east, with Passchendaele at the centre, caused great loss of life, and was the counterpart of the German's vain attempt to take Verdun by 1916. Both armies suffered grievously from decisions often based upon theory and emotion, and which were the result of a wider but mistaken strategy.

I was getting ready to go out, with the window wide open, when a sort of yellow smoke began to creep into the room. I shut the window angrily, thinking: 'These rascals of Englishmen, they burn bad coal that they bring from their country'. But in the village I met someone who was suddenly taken sick and who retired hurriedly into her house not waiting to explain her malady. This evening the Officers told me that the powerful cloud of asphyxiating gas had killed many soldiers at Langemarck and Steenstratt, and that the poisonous sheet has followed the line of the canal right up to us.

BARONESS ERNEST DE LA GRANGE *Open House in Flanders*

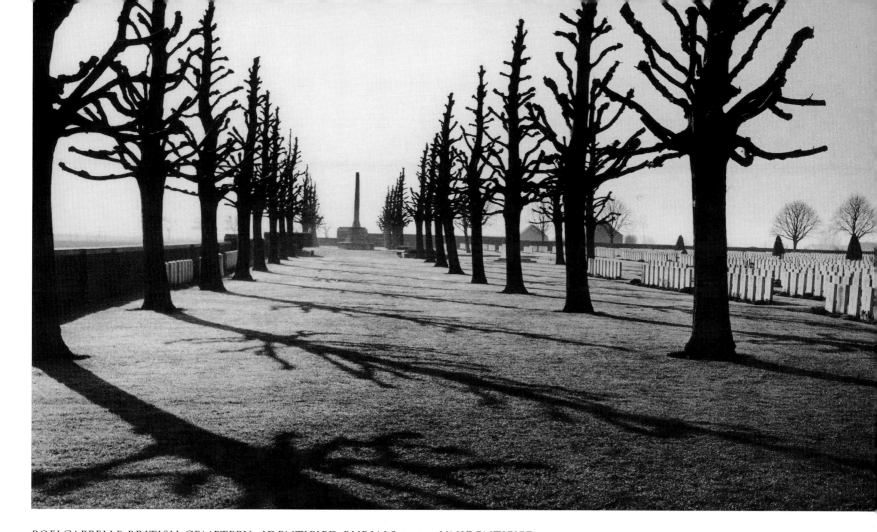

POELCAPPELLE BRITISH CEMETERY. IDENTIFIED BURIALS 1,246. UNIDENTIFIED 6,232

11 October 1917. This second day after a battle is always to be dreaded – bad cases, many of them lying out a day or two. The news does not sound quite so good today – a German counter and the guards driven back from Poelcappelle.

HARVEY CUSHING *A Surgeon's Journal*

It has surely been a great Push! Even for us who gather in the lees of War. The men are in great heart – full of fight . . . our losses have hardly been light, but compared to the Germans! – and Helfferich was telling them in May the War would be ended by the submarine without any more killing! We are full up. My ward is full and this morning with the pathologist, Mike Gonnell, we examined and dressed I don't know how many men in the Church Tent – the English Padre came to me strafing because we have 'desecrated the Altar' by using it to hold our bandages and gauze and solutions! I countered that I could not imagine God being really annoyed about it – the Church of England needed to be disestablished! I now think it should be kicked downstairs! The Scotch Presbyterian, speaking of the use of his tent, said he could not see any better use for it – a difference of point of view which accounts for the Covenanters!

ROBERT FOSTER KENNEDY *The Making of a Neurologist*

SANCTUARY WOOD CEMETERY
IDENTIFIED BURIALS 635. UNIDENTIFIED 1,353

At times one's thoughts fly back to all the precious things in England a thousand times more precious now. I think of Farnham, Winchester, Oxford in Summer. What Winchester Meads are like on a half-holiday in June – or Magdalen Cloisters on a May evening. And one thinks of all the family and the happy times we have had – the love that binds us all, and Mother and all she is to me, and I don't feel ashamed of wondering fairly often if I shall see them again, and if so when.

GILBERT TALBOT *printed privately, 1916*

VANCOUVER CORNER

The usual rumble and rattle from the trenches seemed to have increased noticeably. By 5 o'clock a hurricane of noise and heavy shelling. A rumour or two reached me; and I walked uneasily through our wards and offices. The good Dr Thompson was operating upon a girl's skull; the wounded soldier, in the half-coma we knew later as shell shock, was being tended and was muttering continuously 'White faces . . . the moonlight . . . white faces . . .' As I walked out in the corridor, I passed where the tall spire of our Chapel had come down through the roof and was leaning half-shattered and enormous on the floor I could hear the Northumbrian Field Ambulance in another wing singing loudly;

> *'. . . in the heights*
> *and in the depths be praised;*
> *in all his works most wonderful . . .'*

and it sounded ironic.

GEOFFREY WINTHROP YOUNG *The Grace of Forgetting*

Left: *Sanctuary Wood Cemetery*
Opposite: *Vancouver Corner Canadian Memorial*

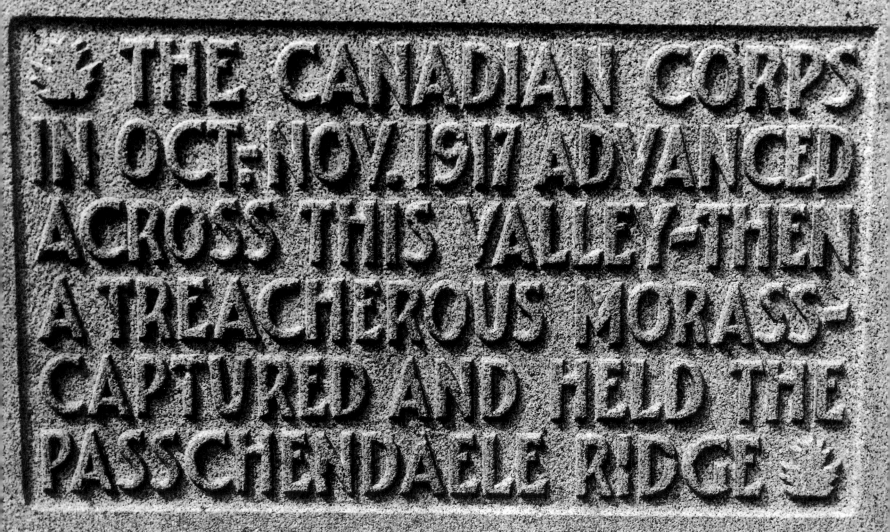

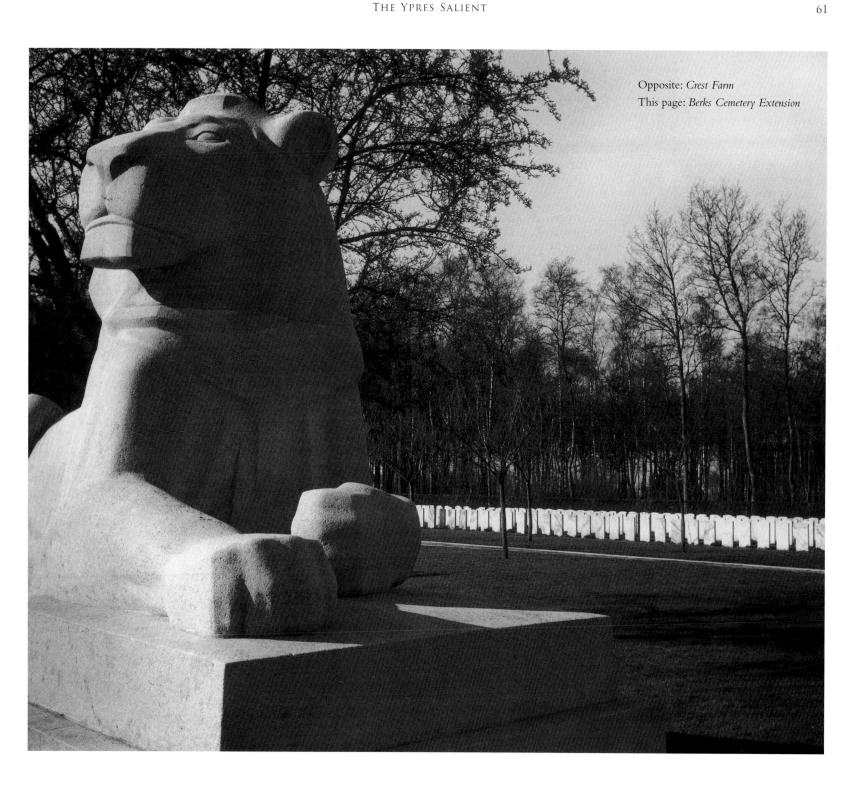

Opposite: *Crest Farm*

This page: *Berks Cemetery Extension*

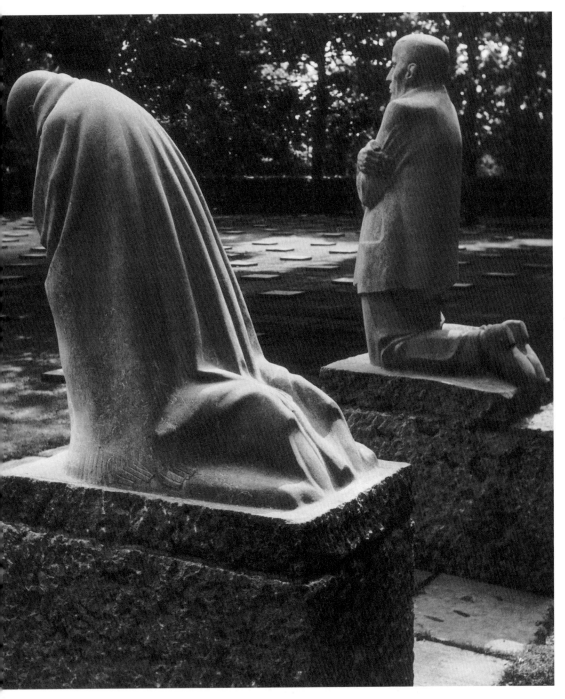

VLADSLO GERMAN CEMETERY. 25,664 DEAD

PASSCHENDAELE

For at this period attacks were still being launched (an appropriate equivocation) against Passchendaele. Three months of sacrificial misery had not been enough to pay for that village height, and so in the distance we heard through the ruining Autumn many mornings of gun fire, stubborn and constant, and knew that wounded men were drowning and the unwounded were being driven mad before the concrete forts. It was said that the Canadians took Passchendaele, and finding it utterly untenable, of their own accord came back to their old posts.

EDMUND BLUNDEN *Undertones of War*

The very name with its suggestions of splashiness and a passion, at once was subtly appropriate. This nonsense could not have come to its full flower at any other place but at Passchendaele. It was pre-ordained. The moment I saw the name on the trench map, intuitively I knew what was going to happen.

WYNDHAM LEWIS

VLADSLO

I look upon the people and the Nation handed on to me a responsibility conferred upon me by God, and I believe as it is written in the Bible that it is my duty to increase the heritage, which one day I shall be called upon to give an account. Whoever tries to interfere with my task shall I crush.

KAISER WILHELM *Voices from the Great War*

This war with all its ugliness is great and wonderful.

MAX WEBER *Voices from the Great War*

PLOEGSTEERT WOOD MILITARY CEMETERY. IDENTIFIED BURIALS 163. UNIDENTIFIED 2.

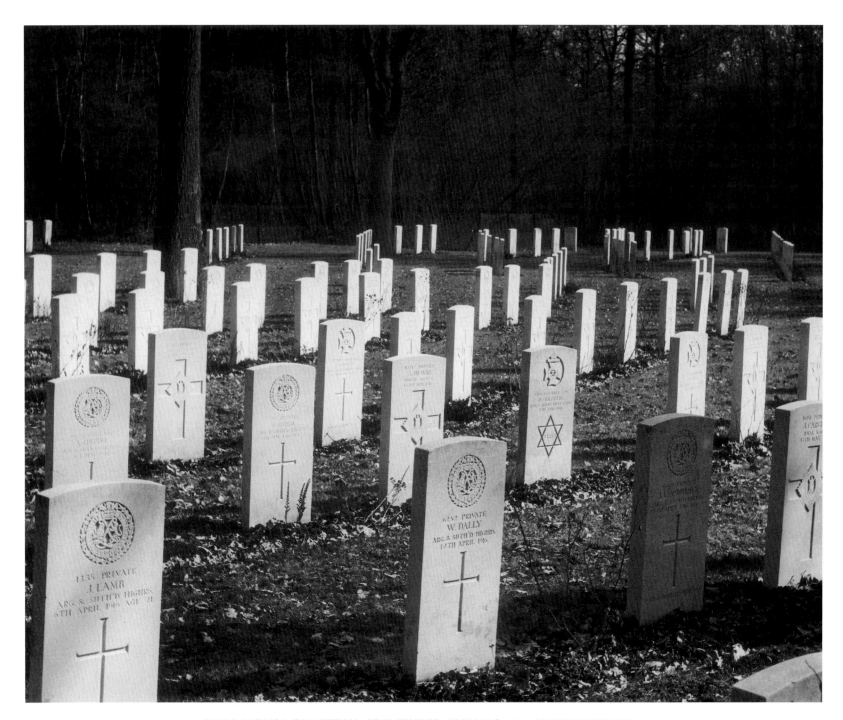

RIFLE HOUSE CEMETERY. IDENTIFIED BURIALS 228. UNIDENTIFIED 2

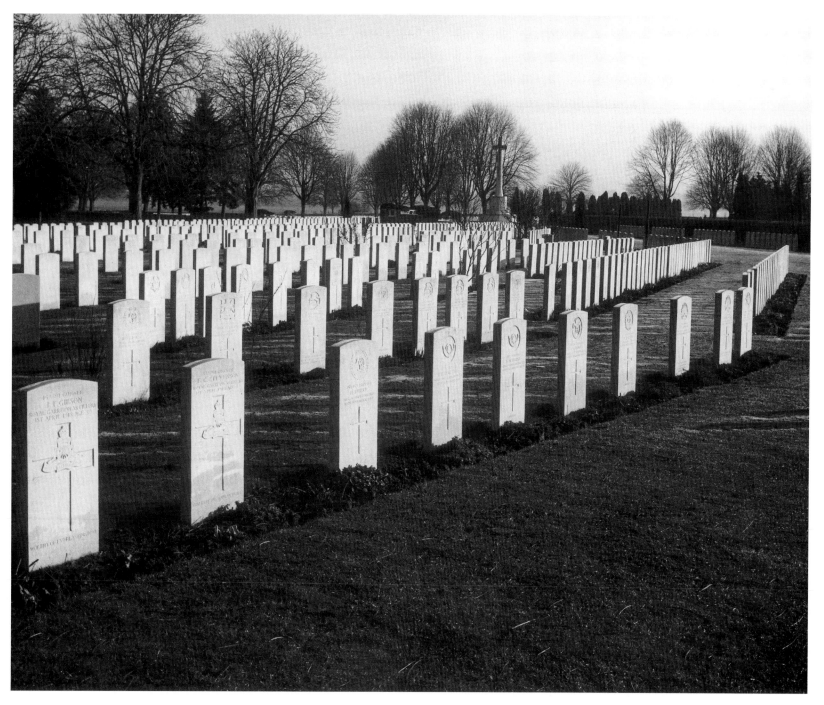

BEDFORD HOUSE CEMETERY. IDENTIFIED BURIALS 2,127. UNIDENTIFIED 3,010

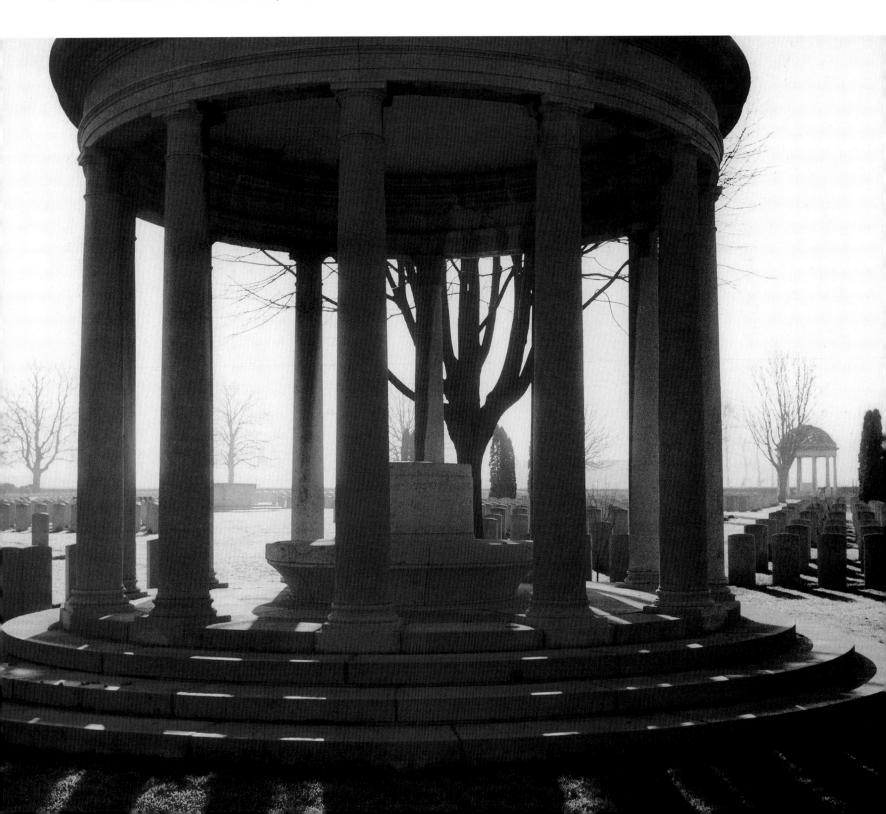

MESSINES AND WYTSCHAETE

*The long-legged Padre has been attending
burials and tells me of the officer just in who
was saved from a chest wound by a Bible
in the upper part of his tunic. Moral. The
wounded on the crowded stetchers all over
the big court invariably say 'Not so bad Sir',
however bad it may be. And they all have
very good news from the Ridge, Messines and
Wytschaete taken, and still going on.*

HARVEY CUSHING *A Surgeon's Journal*

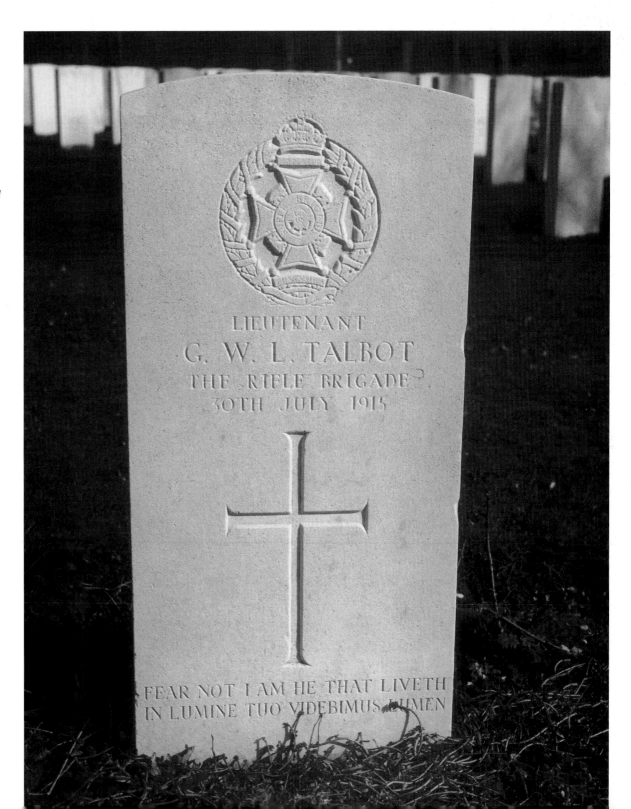

Opposite: *Bedford House Cemetery*
Right: *Buttes New British Cemetery*

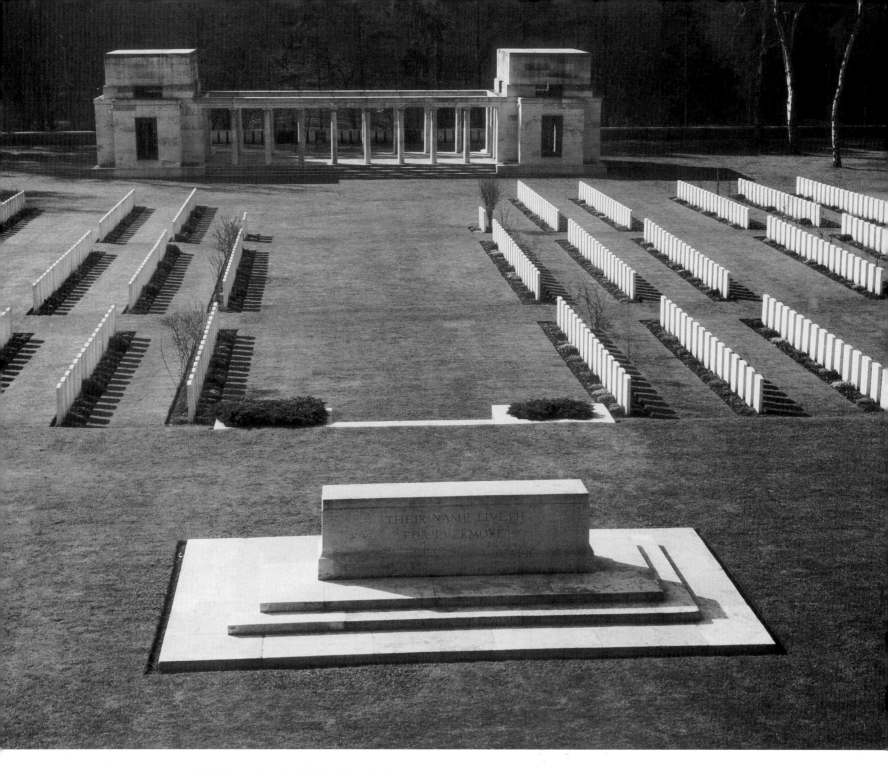

BUTTES NEW BRITISH CEMETERY. IDENTIFIED BURIALS 428. UNIDENTIFIED 1,673

Houthulst Belgian Military Cemetery

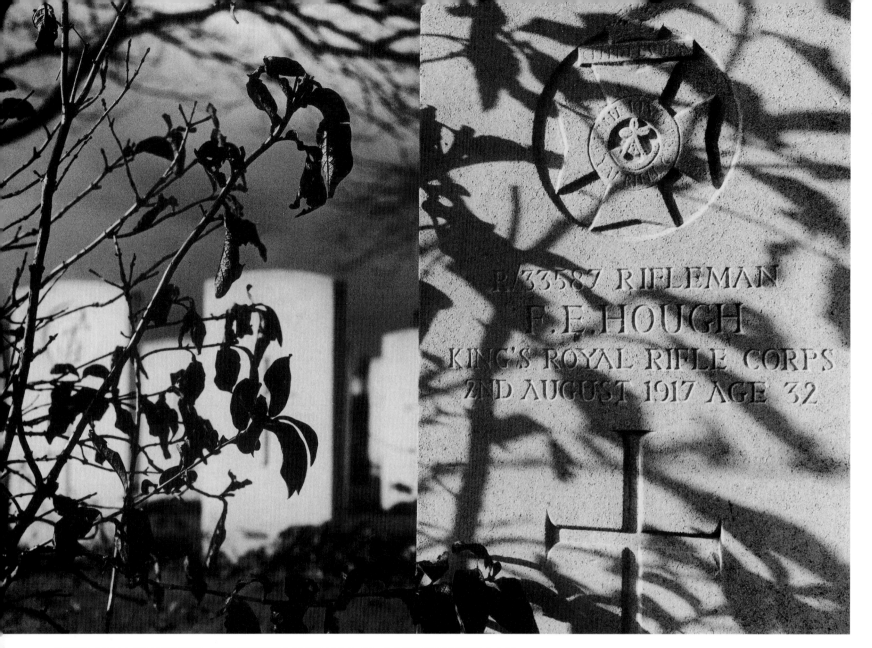

IRISH FARM CEMETERY. IDENTIFIED BURIALS 1,148. UNIDENTIFIED 3,267

Let the reader imagine any narrow strip of twenty-five miles known to him – the course of the Thames say from London to Maidenhead or from Pangbourne to Oxford – suddenly rushed by many thousands of men, many of them falling dead or maimed upon the way. For the look of the charge let him remember some gust of wind on a road in Autumn when the leaves are lying. The gust sweeps some array of leaves into the road and flings them forward in a rush, strangely like the rush of men as seen from a distance. As in the rush of men many leaves drop out, crawl again forward, cease, quiver and lie still.

JOHN MASEFIELD *The Old Front Line*

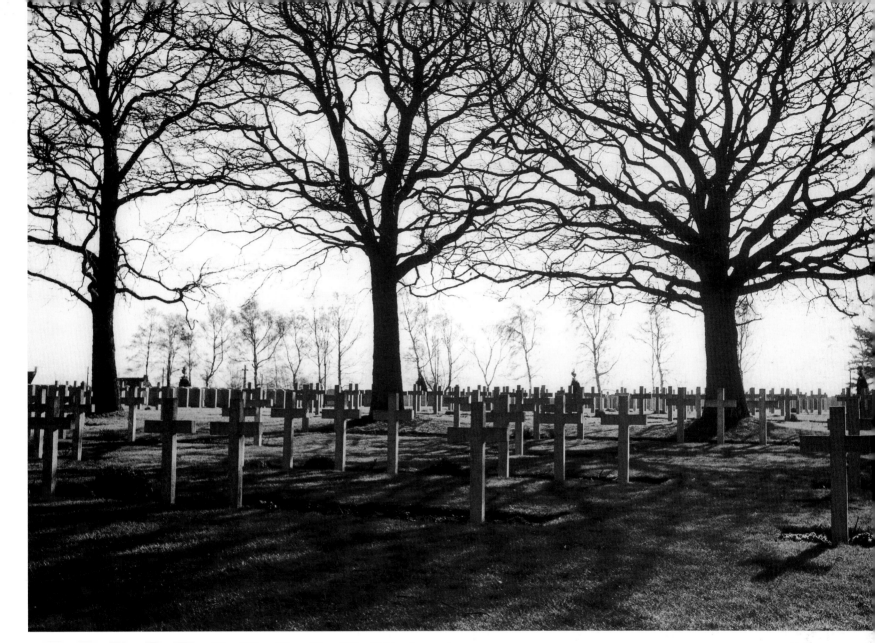

LIJSSENTHOEK MILITARY CEMETERY. IDENTIFIED BURIALS 9,878. UNIDENTIFIED 24

Down again at Poperinghe, I found that the civilian hospital had just been shelled, in which we had sent some of our sick, and they began to take in wounded British soldiers at the Sacre Coeur. Four nuns and twelve old women were killed, many wounded. I fetched cars and cleared them out, a dreadful business, in a panic of the staff. The old people half dead already with terror.

GEOFFREY WINTHROP YOUNG *The Grace of Forgetting*

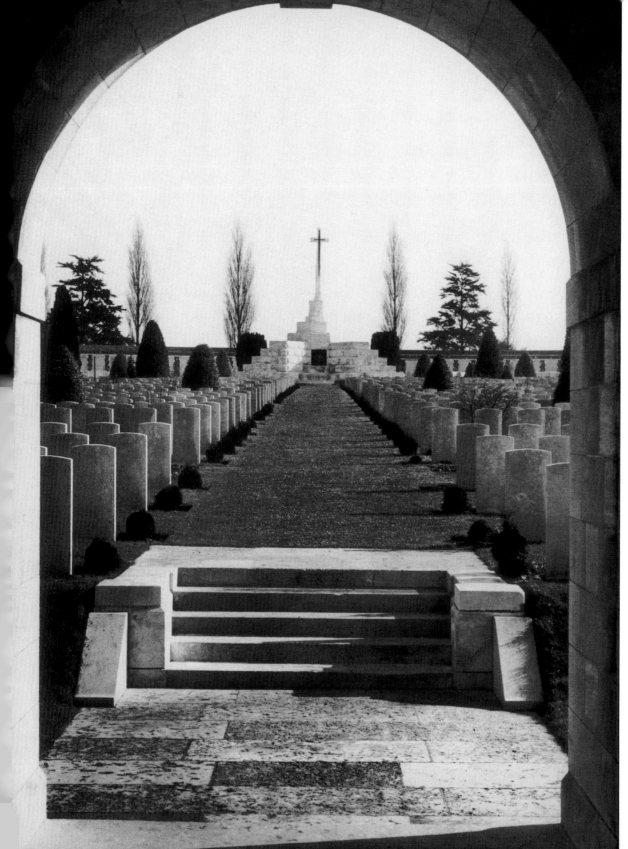

PROWSE POINT

Meanwhile the British offensive against Passchendaele unrolled its sombre fate. The terrific artillery pulverised the ground, smashing simultaneously the German trenches and the ordinary drainage. By sublime devotion and frightful losses small indentations were made upon the German front. In six weeks at the farthest point we had advanced four miles. Soon the rain descended and the vast crater field became a sea of choking fetid mud in which men, animals and tanks floundered and perished hoplessly.

WINSTON CHURCHILL *The World Crisis*

TYNE COT CEMETERY
IDENTIFIED BURIALS 3,586
UNIDENTIFIED 8,366

Dear Mrs Judge
It is proposed to remove the remains of all those buried in isolated graves to cemeteries where the graves can be properly cared for. All reburials will be carefully and reverently carried out. Imperial War Graves Commission 28 June 1920

Dear Mrs Judge
I very much regret to have to inform you that when this work was undertaken it was found to be impossible to identify the grave of Lance Corporal Judge with absolute certainty. Imperial War Graves Commission 12 December 1921

Tyne Cot Memorial and Cemetery

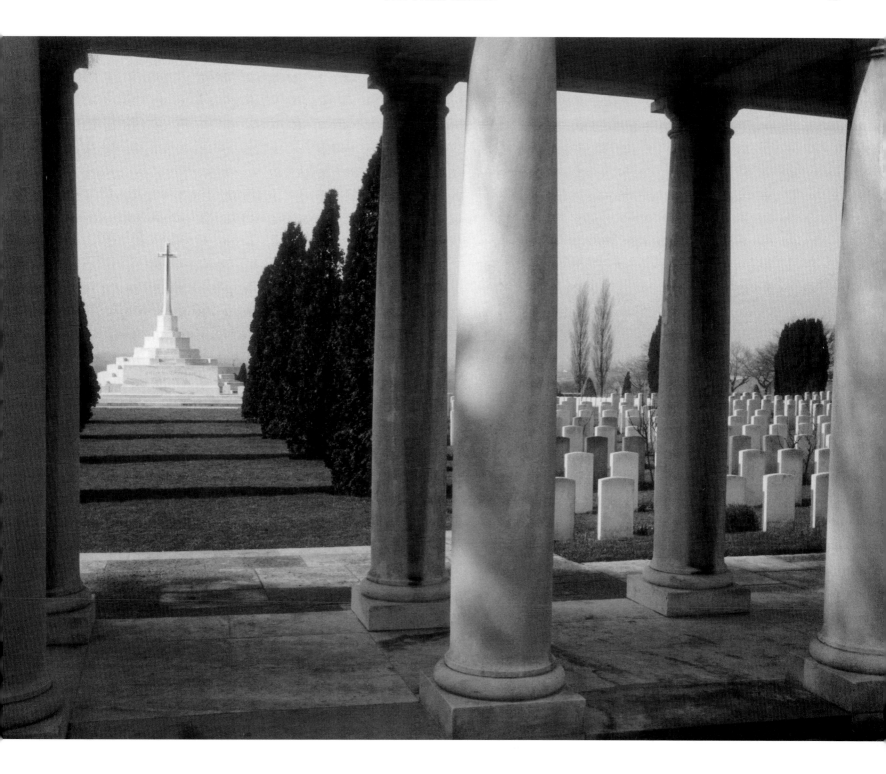

GALLIPOLI

THE NARROWS

If there was one place in the whole world that was impregnable, it was this peninsula, and they say no army in the world except ours could have seen half its numbers mown down, and still come on and made a good landing.

GUY NIGHTINGALE *A Place Called Armageddon*

Gallipoli is a name that, even to those born long after the events, captures the imagination with a curious mixture of nostalgia, of sadness and of hopes dashed. As in other famous defeats, it is difficult to separate glory, waste, errors of command and failures of supply. The debate will long continue over the possible effects upon the course of the Great War which might have followed victory and the opening of the Dardanelles. ANZAC, that evocative acronym for the Australian New Zealand Army Corps, came to mean a breed of Antipodeans forged in the steep gullies below Lone Pine and on a short stretch of beach on the Aegean shore.

The strategic background to the campaign is complex, and the objectives were not accepted without argument at the time. The Ottoman Empire, the Sick Man of Europe, stood astride the boundaries between Europe, Asia, and Africa, with tentacles reaching into the Balkans, that sensitive and still largely uncommitted area under the belly of the Austro-Hungarian Empire. To the south there was the threat to Egypt and the Suez Canal, through which there passed the Britannic rulers, administrators and exploiters of the great Indian subcontinent, as well as the fruits of that jewelled tree of empire.

It was to the east, however, that the protagonists of the Gallipoli campaign turned for their strongest arguments. The Triple Entente of 1904 between Britain, France and Russia had transformed the German and Austro-Hungarian fear of encirclement into reality. A few days before the outbreak of war in August, 1914, Germany and Turkey had signed a secret alliance. The influence of the German Military Mission in Turkey steadily increased, and the Turkish crews of the German battleships *Breslau* and *Goeben* at Constantinople were replaced by the real German crew. By September, 1914, the Dardanelles was closed to the Allies. The British

Naval Mission to Turkey, which had hardly been credible since the abrupt cancellation of the delivery to Turkey of two British-built warships in August, was withdrawn. Thus the only 'warm-water' route for Russian trade was closed, and for much of the year military help could not reach that later beleaguered ally through the frozen Baltic. In October, 1914, the *Goeben* and *Breslau*, with a Turkish squadron, made a foray into the Black Sea and bombarded Odessa, Sevastopol, and Novorossisk; any remaining Allied illusions about the Turkish position were finally destroyed.

By early 1915 the Russians were beginning to show the signs of defeat that later precipitated the cataclysmic events of 1917. In France and Flanders there was strategic stagnation, with only the prospect of the 'Blood Test', as Churchill called it. In the Balkans there were still uncommitted states. There was also the belief, albeit mistaken, that if the Dardanelles were opened and a British fleet appeared off Constantinople, perhaps without firing a single salvo, Turkey would sue for peace. The Central Powers would then be forced to deplete their armies in the west, and the war, at least in France and Flanders, would be shortened.

These were the arguments and hopes that lay behind the Dardanelles campaign. Once the decision had been taken, there followed the scenario of the mighty Kitchener, Secretary of State for War, the aged Fisher, First Sea Lord, and the youthful Churchill, First Lord of the Admiralty, juggling with the conflicting demands of a naval or military operation. The military reluctance to release troops from the Western Front, and the traditional belief in the power of naval guns against shore batteries, carried the day, culminating in the failure to force the Narrows on 18 March, 1915. How near to defeat were the Turkish forts is still uncertain, but the effect of the drifting minefields upon the fleet was catastrophic.

Thus the War Council stumbled towards the plan for a military landing on the Gallipoli Peninsula, the purpose being to take the heights, and then gain the European shore of the Narrows. A French force was to land on the Asian side of the Dardanelles. That achieved, the Navy would be able to force the Narrows and steam through the Sea of Marmora to Constantinople.

From February, 1915, onwards the Turks knew that the Allies would attack the Peninsula. The defeat of the British Navy on 18 March not only made

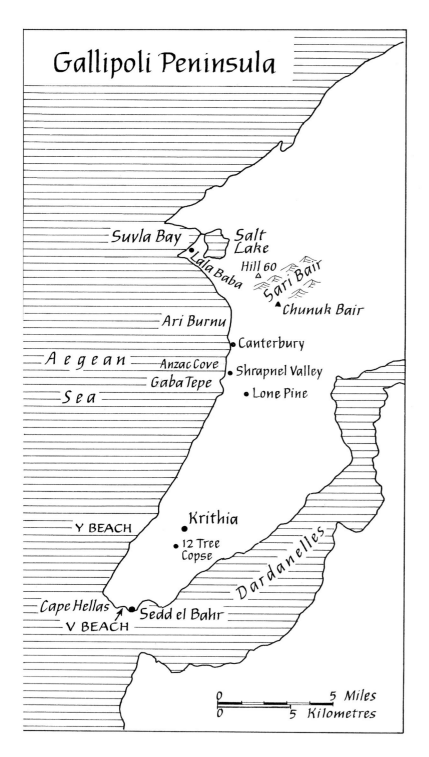

the attack more certain, but also gave the Turkish soldiers a confidence which, with the organization of Liman von Sanders, and the inspiration of Mustafa Kemal, finally brought victory. Otto Liman von Sanders, part of the increasing German presence in Turkey, was sent to Constantinople in 1914. He became a Field-Marshal in the Turkish Army and was Commander-in-Chief of the Turkish forces in Gallipoli. Mustafa Kemal, born in Salonika in 1880, had had a chequered career in the Turkish Army and was identified with the revolutionary movement of 1909. It was almost by chance that he was posted to the Gallipoli Peninsula in 1914, having been Military Attaché at Sofia. Meanwhile, the expeditionary force was dogged by hasty and inadequate preparation, by indecision in high places, and by failing support for the strategy in the face of growing demands in the west and in the Balkans.

It was as late as 12 March, 1915 that General Ian Hamilton, then aged 62, was appointed Commander-in-Chief of the expeditionary force. He had served with distinction under Kitchener in the South African (Boer) War, and since 1910 had been Commander-in-Chief of the Mediterranean Forces. There was much mutual respect and admiration between Hamilton and Kitchener, a reflection of their days together in South Africa. But in the Gallipoli saga Hamilton cuts a sad figure – literary, human, perhaps too human, and only too aware of the military and logistic shortcomings of his most valiant army, but lacking the ruthlessness which a Commander-in-Chief requires. Of the men ashore it is Birdwood, Commander of the ANZACs, who captures the imagination as the inspiring leader in the field.

The landings, or attempted landings, on 25 April, 1915, (known thereafter as ANZAC Day) concentrated on two areas. At the southern tip of the Peninsula there were five landing beaches around Cape Helles, while 13 miles up the coast was Gaba Tepe, the planned site of the ANZAC landing. The southern landing beaches were chosen for the British and were considered to be the spearhead. At V Beach below the village of Sedd-el-Bahr there was a strange silence as the *River Clyde*, a steamer specially prepared for landing troops, moved towards the shore after the naval bombardment had seemingly pulverised any Turkish defences. But the Turks had not been silenced, their sudden fire was withering, and many of the British died on the lighters or in the water. The beach was nevertheless taken and held at great cost. There are 696 graves in the V Beach cemetery. Three other beaches were taken and held without great loss, but at Y Beach, the most northern of the Helles landings, there was much confusion. The beach was held, but communications and command failed, the early opportunity to advance was never taken, casualties mounted to 700 by the following day, and the British force was taken off.

The ANZAC assault, planned to land on Gaba Tepe beach, went sadly astray. The small assault boats were swept a mile north in the hours before

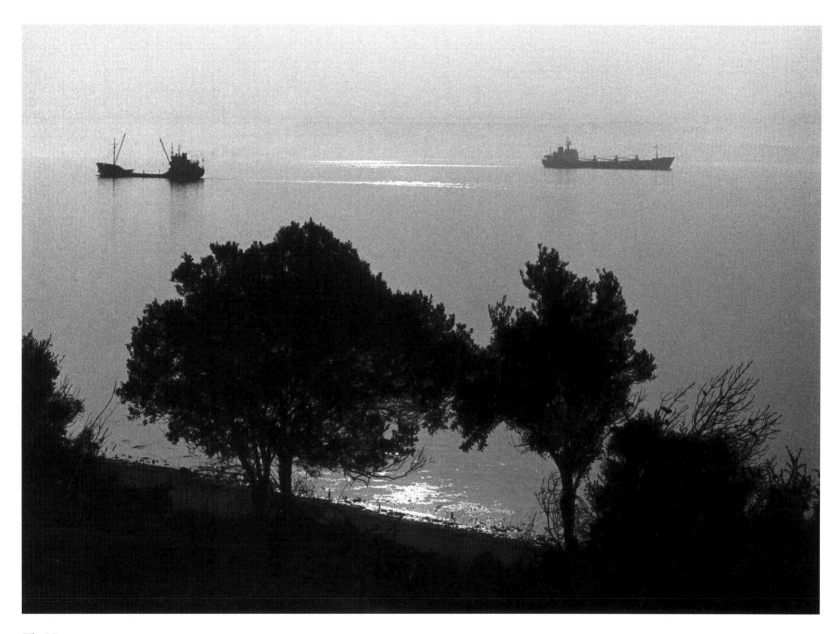

The Narrows

The sun is just setting and all the beach is purple, while the turrets and battlements of the castle just capture the last rays, and the Dardanelles are deep blue under Mount Ida. The sunsets here are glorious. The only thing which spoils it is the incessant bombardments of heavy guns.

GUY NIGHTINGALE *A Place Called Armageddon*

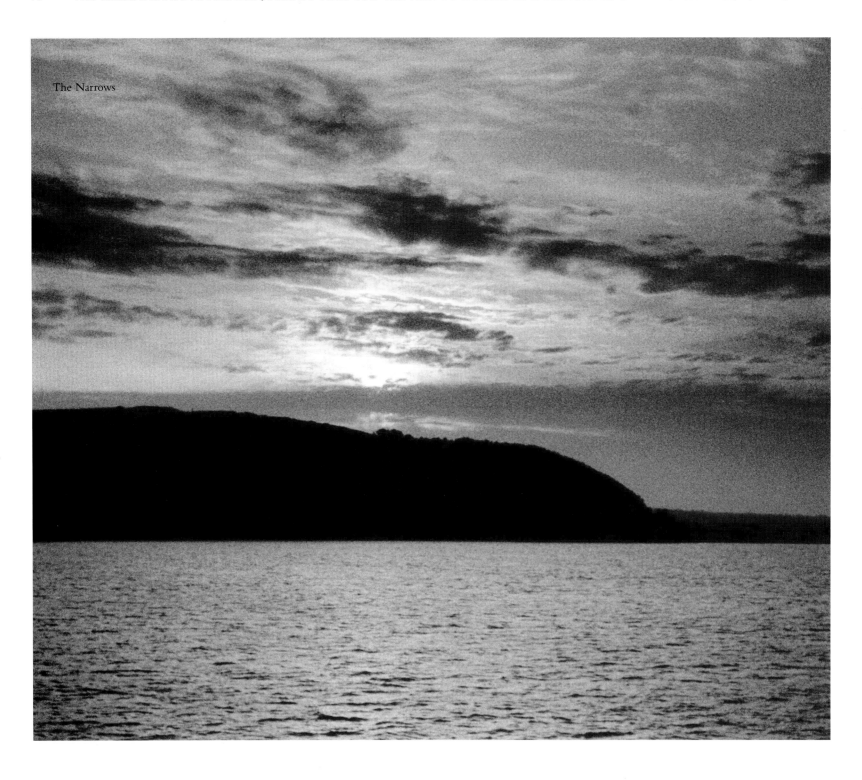

The Narrows

ANZAC COVE

Nunc Dimittis, oh Lord of Hosts. Not a man that knows he's making for the jaws of death. They know, these men do, they are being asked to prove their enemies to have lied when they swore a landing on Gallipoli's shore could never make good.

IAN HAMILTON *Gallipoli Diary*

dawn, and the men found themselves landing on the narrow, short beach of Ari Burnu, with its cliffs and steep gulleys. Despite this, 8,000 men landed within a few hours, but the losses were heavy and became heavier. Many of these men lie in the cemeteries of Canterbury, Beach, Ari Burnu, Shrapnel Valley, and Shell Green. Despite all the difficulties of fire and terrain, groups of ANZACs climbed the steep gulleys and reached the top of the Sari Bair ridge and the peak of Chunuk Bair, and looked, Cortez-like, upon the prize of the Narrows.

However, the cup of victory was dashed from their lips, as the young Mustafa Kemal reached the ridge at that moment, rallied some fleeing Turks, held the ANZACs with his battalion, and committed all three of the regiments to the fight for Chunuk Bair. That afternoon and evening the Turks counter-attacked, ANZAC casualties streamed down the gulleys, ANZAC outposts fell back, and the position was so desperate on the beach and in the gulleys that Birdwood proposed to Hamilton at 11 pm that the ANZACs should re-embark. Hamilton's reply contained the famous words, 'Now you have only to dig, dig, dig until you are safe'. And so the ANZACs stayed on the cliffs and in the gulleys below Chunuk Bair for eight months, suffering, laughing, fighting and dying, culminating in the capture of Lone Pine plateau in August. But they never gained the tactical victory which would have given them the Sari Bair ridge and the command of the Narrows. On the Lone Pine memorial are the names of 4,932 ANZACs who have no known burial place. On or below the ridge many others, ANZAC and British, lie in the cemeteries whose names recall the land and the men: Johnston's Jolly, Courtney's and Steel's Post, Quinn's Post, The Nek, Walker's Ridge, Plugge's Plateau, The Farm, 4th Battalion Parade Ground.

Inland from Cape Helles there were repeated attempts to advance and take the village of Krithia, the last on 28 June, but the line was never established more than 3 miles from Cape Helles. The Turks received large reinforcements and, despite the arrival of an Indian Infantry Brigade and the East Lancashire Brigade, the Commonwealth forces did not make any material headway. The Helles Memorial bears 20,783 names, and in the cemeteries of Lancashire Landing, Pink Farm Redoubt, Skew Bridge and Twelve Tree Copse the majority of graves (4,049) are British. Hope of an Allied victory was still alive in July. Twenty-five thousand troops were on their way from Britain, and the final attempt to carry the Peninsula and open the Dardanelles was made on 6 August. Twenty thousand men were successfully landed at Suvla Bay, north of Anzac, and there was remarkably little opposition, as they crossed the Salt Lake towards the hills. At the same time the reinforced ANZACs attacked Lone Pine and Chunuk Bair,

the object being to link up with the Suvla Bay force. But that force failed to advance and the conclusion is inescapable that, whether due to poor provision, lack of water or desultory leadership, the force came to a halt unnecessarily beyond the Salt Lake at a moment when the Turks were ill-prepared to meet them. In the Suvla cemeteries of Hill 60, Azmak and Lala Baba lie some 4,960 men. Thereafter the reinforced Turks prevented any Commonwealth advances at Suvla, Chunuk Bair or Helles.

The closing chapters are full of sadness, recrimination, bravery and even nostalgia. On the Western Front the Germans were threatening Verdun, a bastion which, for France, was a sacred symbol that the disaster of Sedan would never happen again. That, the failure at Loos and the stagnation of trench warfare made any release of men or shells from the Western Front unthinkable. In the Balkans, Belgrade was attacked by the Germans and Austrians, and Serbia by the Bulgarians. Thus only Rumania and Greece were uncommitted, and in order to bolster Greek resolve to side with the Allies and to halt the Bulgarians, a Salonika force had to be assembled quickly by drawing on troops from Gallipoli. Hamilton went home in October, a sad and somewhat maligned figure, who had always lacked the support from home which he needed for a successful campaign, but whose organization was fallible. General Sir Charles Monro, who took his place, rapidly assessed the situation and concluded that there was no prospect of strategic success. The weather turned cold, there were heavy storms, and even snow, as the force was slowly evacuated. Plans were devised to mislead the Turks into believing that the force was intact until the final evacuation of the last 17,000 men, without loss, on the night of 7 January, 1916.

In the Gallipoli campaign of eight months, 34,000 Commonwealth troops died, of whom 27,000 were buried in unidentified graves, or whose bodies were never found. About 9,000 French and 66,000 Turks died. The Turkish memorials do not mark the dead, but record the events and sacrifices which defeated the Commonwealth forces. The land round Anzac is sacred to the memory of those who fell, as are the cemeteries throughout the Peninsula. The concept of opening the Dardanelles was brilliant, but the campaign was less than so in its preparation, its tactics and its excavation. The thought of what might have been achieved is still tantalizing.

Opposite: *V Beach Cemetery*

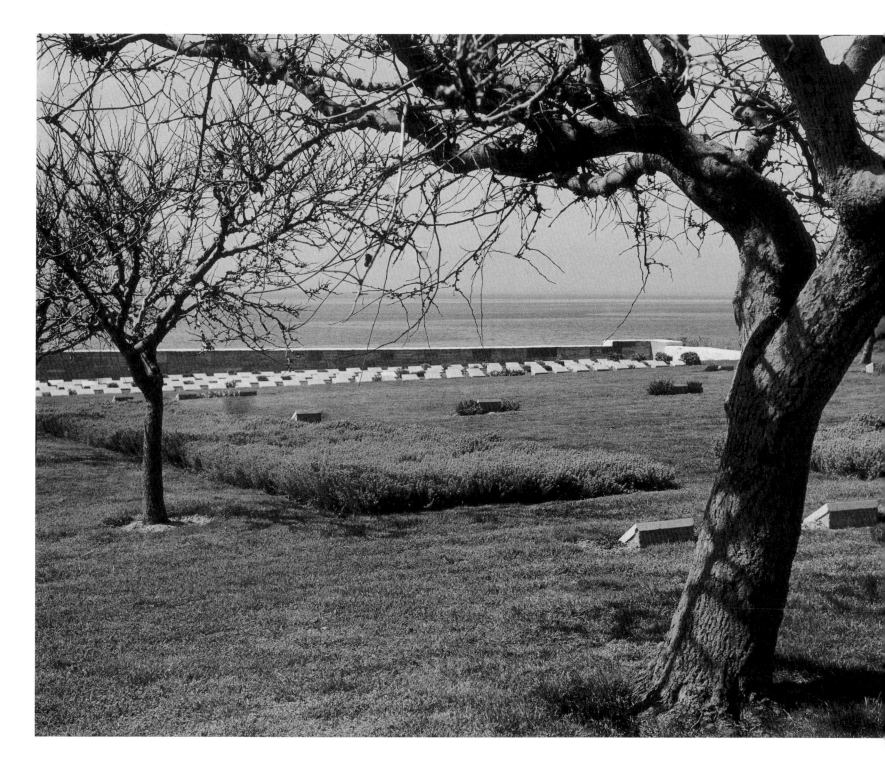

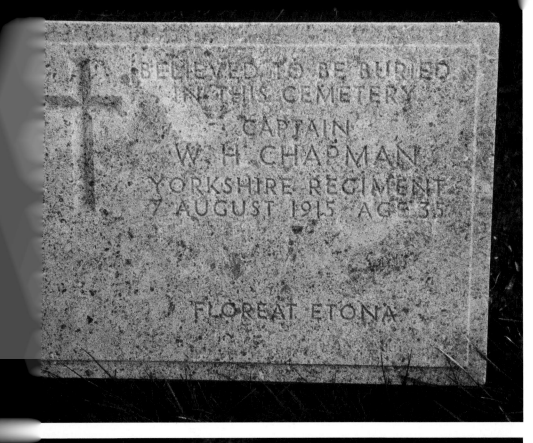

V BEACH CEMETERY. IDENTIFIED BURIALS 696

When day dawned the survivors of the landing party were crouched under the shelter of the sandbank; they had no rest; most of them had been fighting all night; all had landed across the corpses of their friends. No retreat was possible, nor was it dreamed of, but to stay there was hopeless.

JOHN MASEFIELD *Gallipoli*

ARI BURNU CEMETERY.
IDENTIFIED BURIALS 216. UNIDENTIFIED 37

We are now on our last legs. The beautiful battalions of 25 April are wasted skeletons now, shadows of what they had been. The thought of the river of blood, against which I painfully made my way when I met these multitudes of wounded coming down to the shore, was unnerving.

IAN HAMILTON *Gallipoli Diary*

STRAND MILITARY CEMETERY.
IDENTIFIED BURALS 788 UNIDENTIFIED 354

Above left: *V Beach Cemetery*
Left and Opposite: *Ari Burnu Cemetery*
Overleaf: *Turkish Graves*

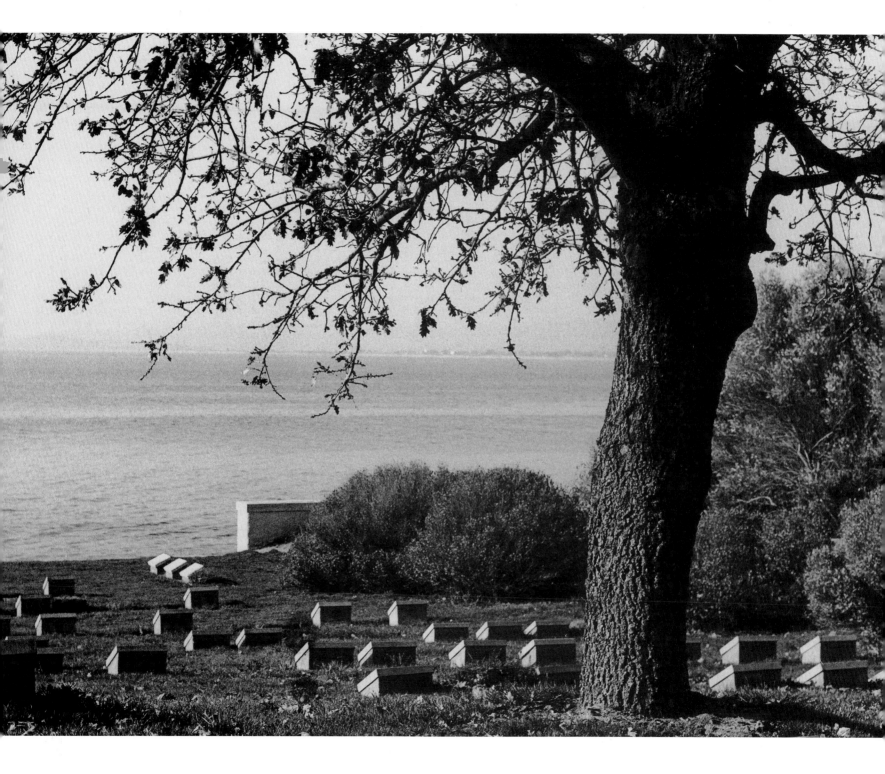

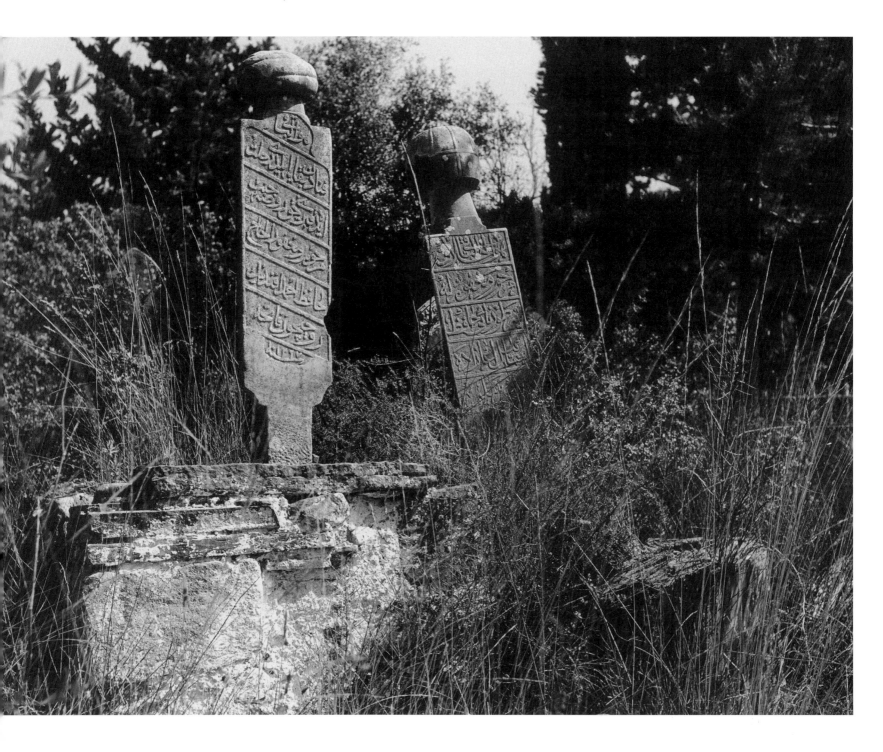

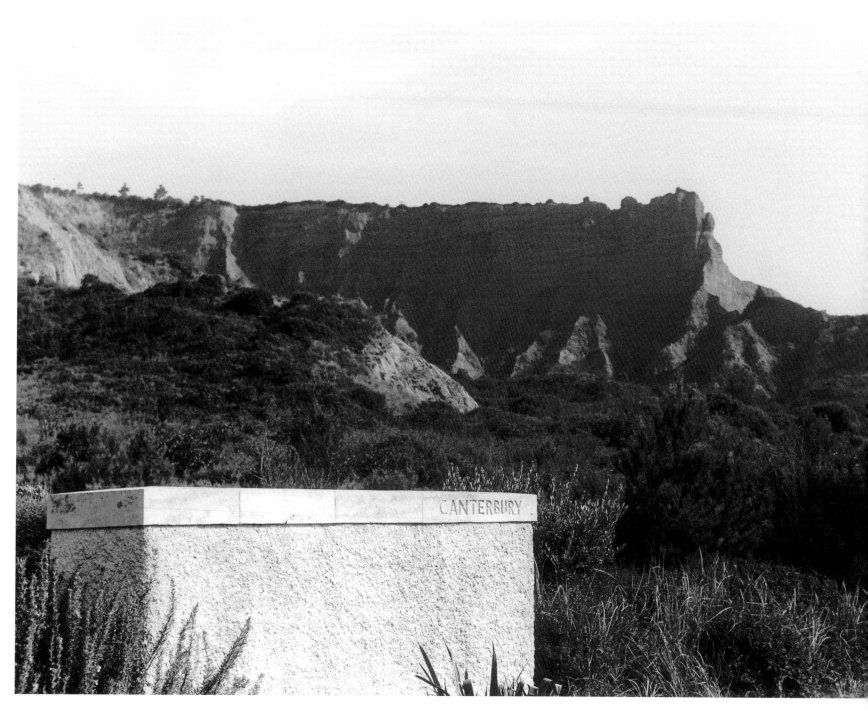

CANTERBURY CEMETERY. IDENTIFIED BURIALS 26. UNIDENTIFIED 1

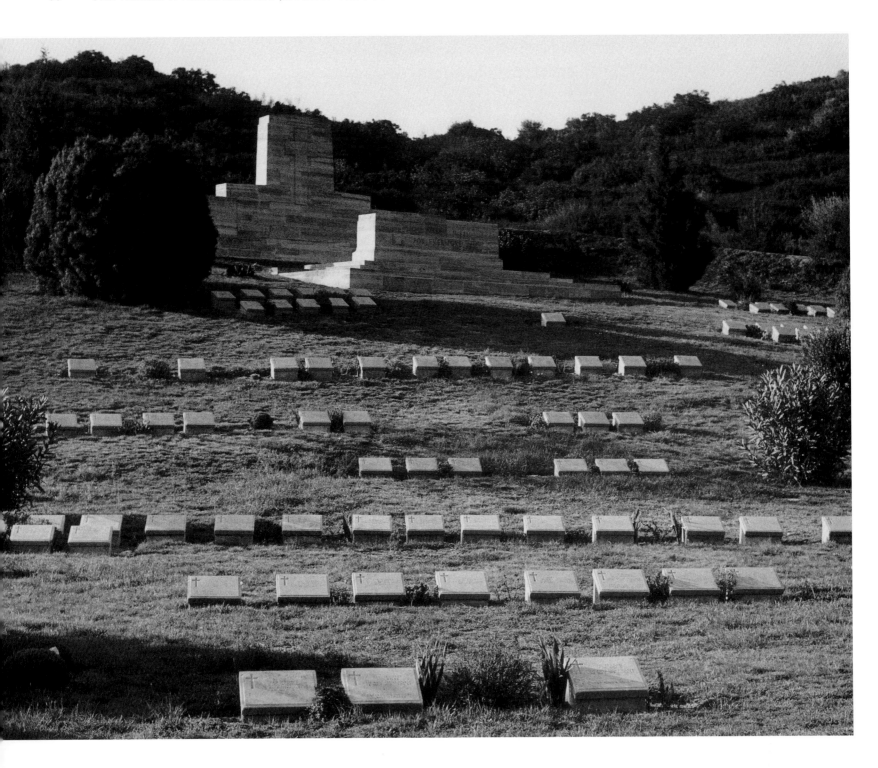

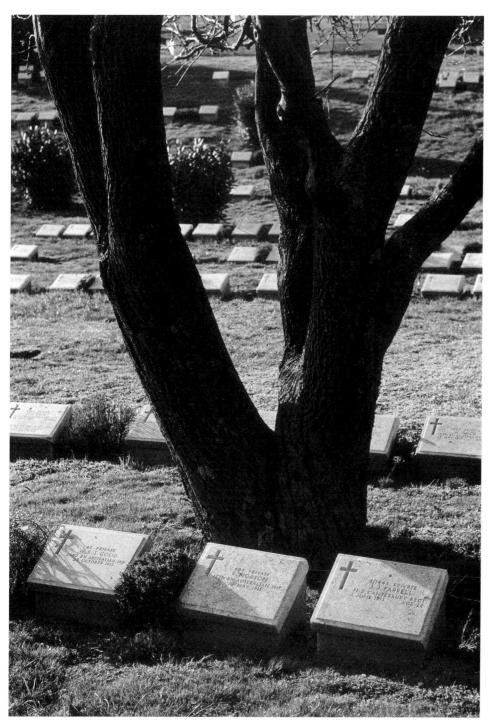

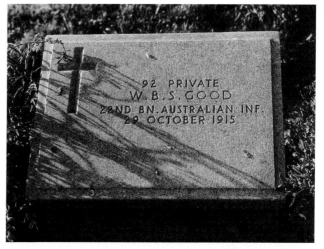

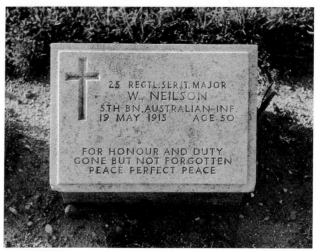

SHRAPNEL VALLEY CEMETERY.
IDENTIFIED BURIALS 611. UNIDENTIFIED 72

Our platoon was the last to make their way down to the beach. How I got down that ravine God only knows, for I was absolutely done up and the others were the same. We had no time for food and our bottles had been empty for hours and it was dry work too. When we reached the beach we waded waist-deep to the boats and were hauled in by the attendant Blue Jackets and were taken on board HMS Goliath after being ashore about 36 hours.

HORACE BRUCKSHAW *The Diaries of Private Horace Bruckshaw*

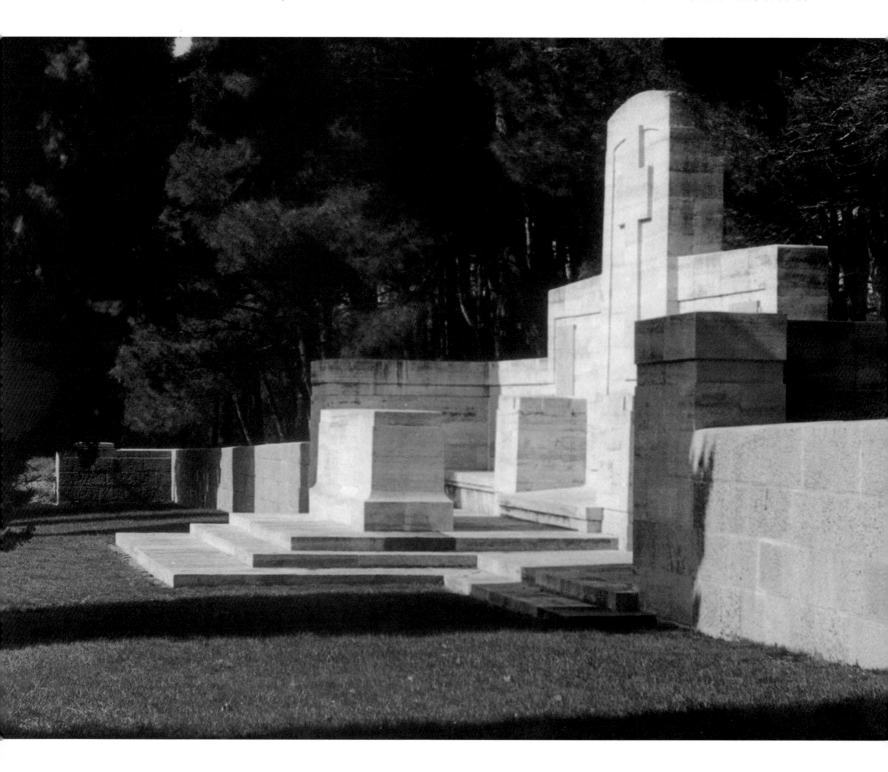

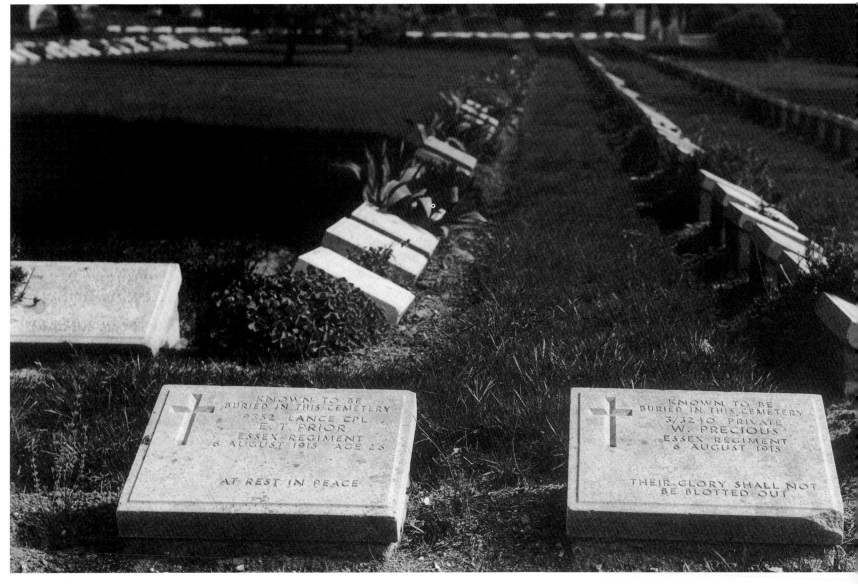

TWELVE TREE COPSE CEMETERY. IDENTIFIED BURIALS 1,407. UNIDENTIFIED 1,953

Some felt, as they passed those graves, that the stones were living men, who cast a long look after them when they had passed, and sighed, and turned landward as they had turned of old. Then in a rising sea, whipped with spray, among the noise of ships weltering to the rails, the battalion left Cape Helles; the River Clyde dimmed into the gale and became a memory, and the Gallipoli campaign was over.

JOHN MASEFIELD *Gallipoli*

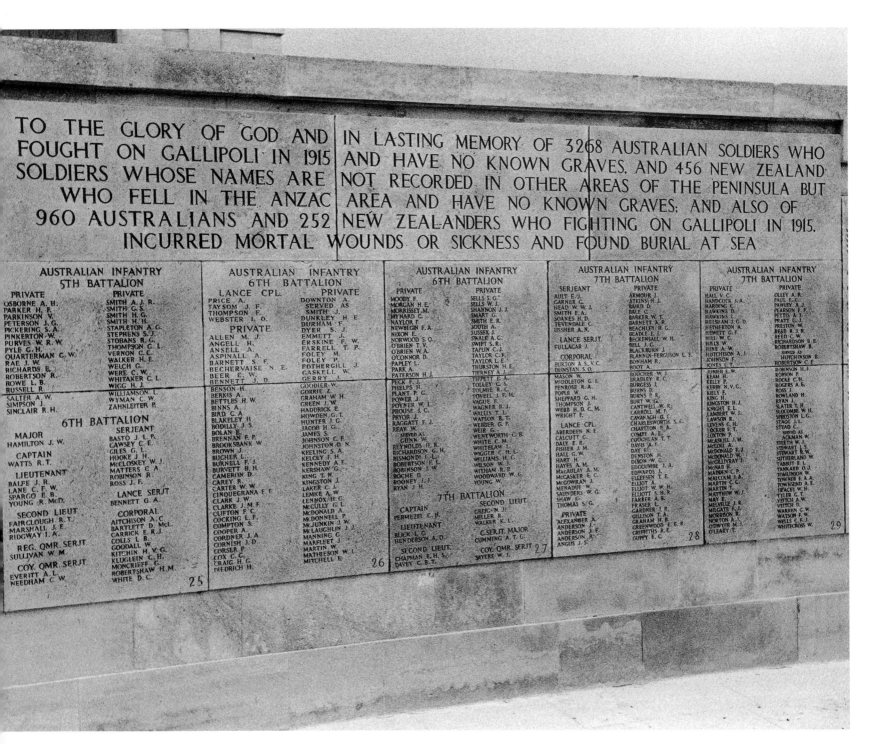

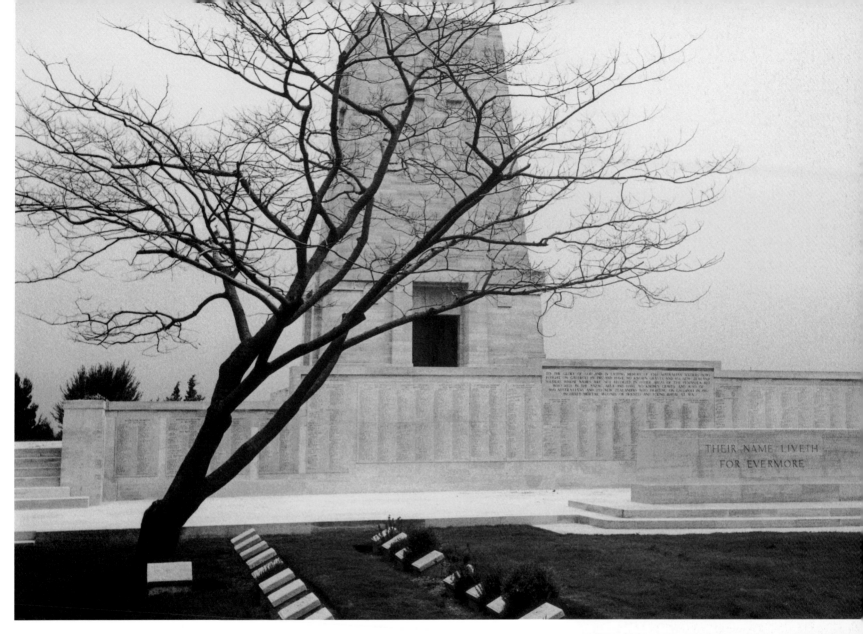

LONE PINE CEMETERY AND MEMORIAL. IDENTIFIED BURIALS 668.
UNIDENTIFIED 499. NAMES OF THE MISSING 4,932

To die violently and be laid in this shell-swept area is to die lonely indeed. The day is far off, but will come, when splendid mausolea will be raised over these heroic dead. And one foresees the time when steamers will bear up the Aegean pilgrims come to do honour at the resting place of friends and kindred, and to move over the charred battlegrounds of Turkey.

HECTOR DINNING *The Anzac Book*

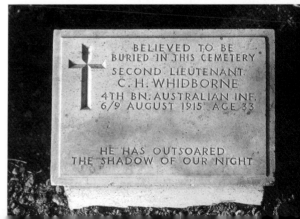

BELIEVED TO BE
BURIED IN THIS CEMETERY
SECOND LIEUTENANT
C. H. WHIDBORNE
4TH BN. AUSTRALIAN INF.
6/9 AUGUST 1915 AGE 33

HE HAS OUTSOARED
THE SHADOW OF OUR NIGHT

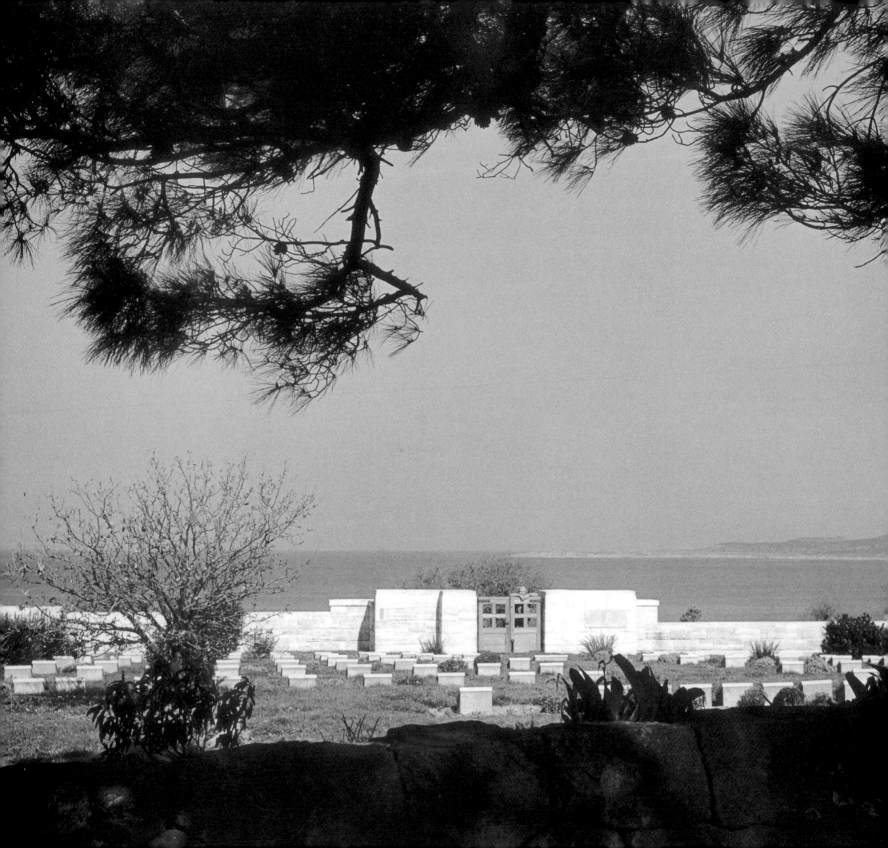

LALA BABA CEMETERY. IDENTIFIED BURIALS 216

A week lost was about the same as a division. Three divisions in February could have occupied the Gallipoli peninsula with little fighting. Five could have captured it after March 18. Seven were insufficient at the end of April, but nine might just have done it. Eleven might have sufficed at the beginning of July. Fourteen were to prove insufficient on August 7. Moreover one delay breeds another.

WINSTON CHURCHILL *The World Crisis*

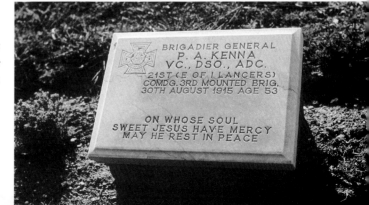

BRIGADIER GENERAL
P. A. KENNA
VC., DSO., ADC.
21ST (E OF I LANCERS)
COMDG. 3RD MOUNTED BRIG.
30TH AUGUST 1915 AGE 53

ON WHOSE SOUL
SWEET JESUS HAVE MERCY
MAY HE REST IN PEACE

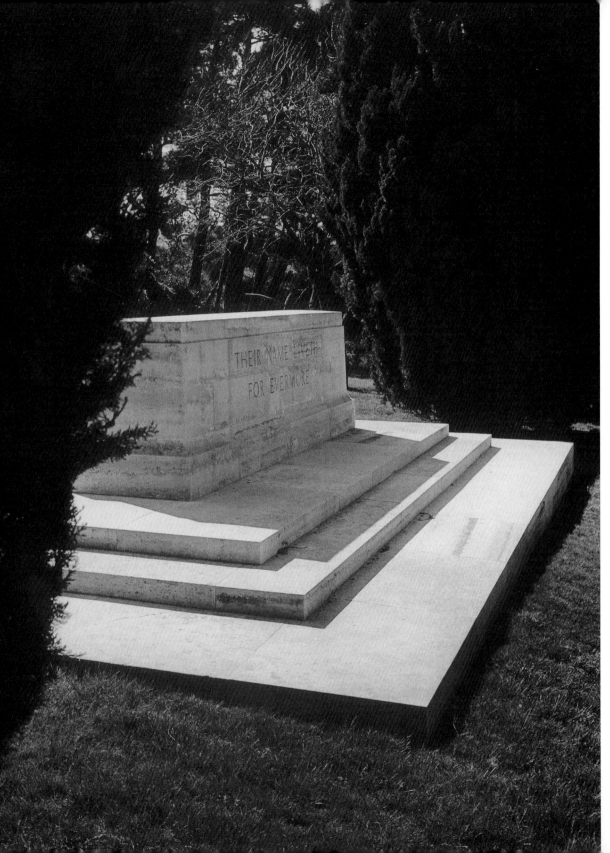

HILL 60 CEMETERY
IDENTIFIED BURIALS 89
UNIDENTIFIED 699

*At Gallipoli, Mum, there is no such thing as
behind the firing line. Down the beach – in your
dugout, it is all the same, and the man that has set
foot on Gallipoli, in my opinion, has done his bit.*

THOMAS DRY *War Letters of Fallen Englishmen*

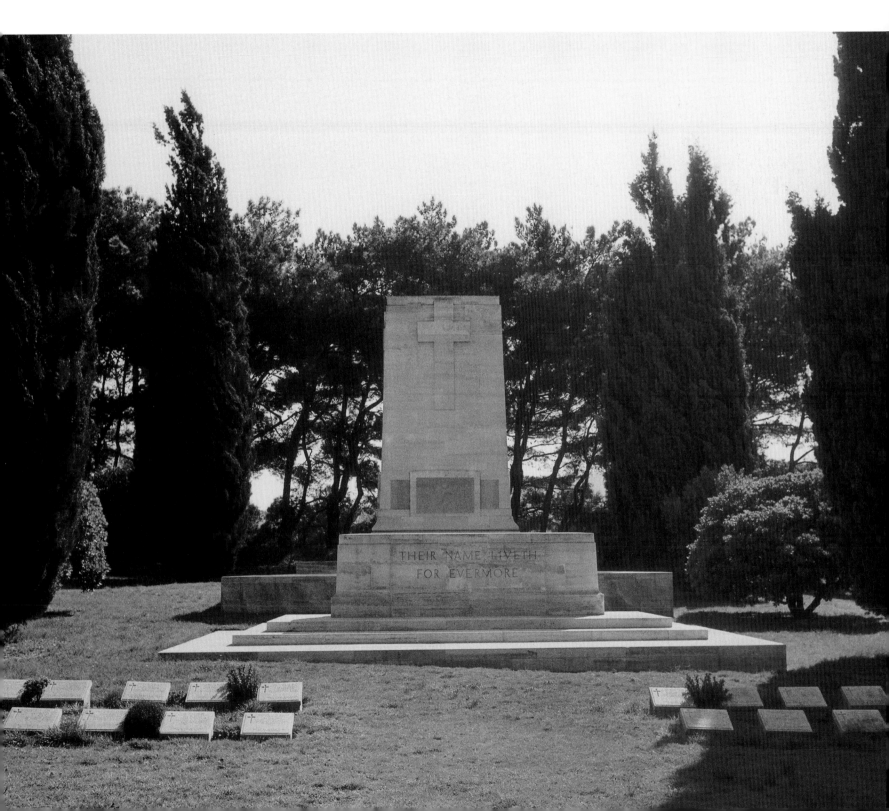

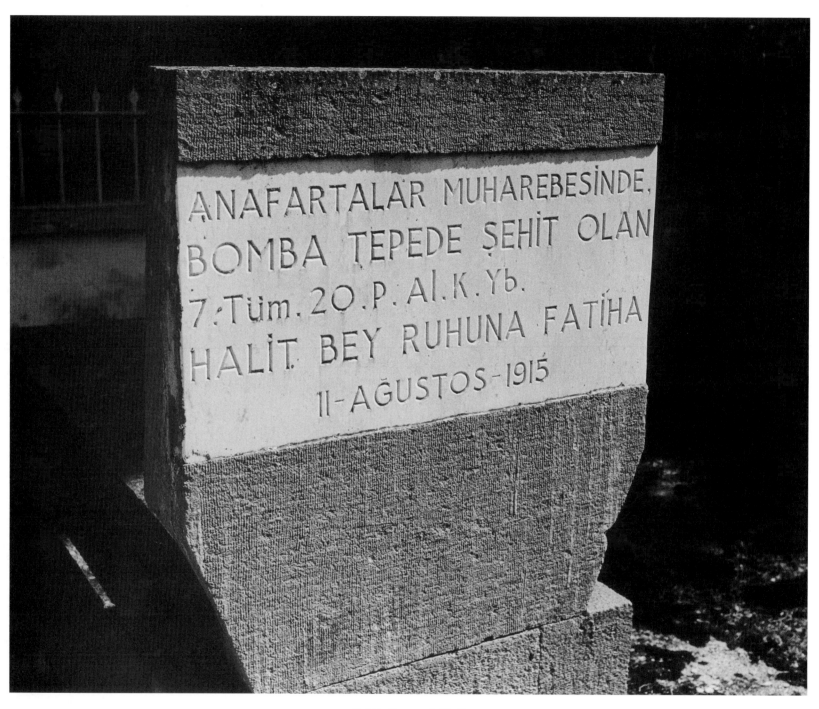

Turkish Grave at Gallipoli

VERDUN

I expressly commanded that there should be no retreat. The order was loyally carried out and in setting the example of obedience, one brigade commander and three regimental commanders were killed. Not a single man was seen retiring.

GENERAL DEBENEY *quoted in 'Verdun'*

Verdun is a name which remains sacred in the history of France. It symbolizes the struggle, through the ages, against the Germanic hordes, which, in the modern era, began with the Franco-Prussian War and the defeat of France in 1870. Only forty-five years later came the sacrificial misery of Verdun, when the Germans were halted at enormous cost. Finally in 1940 France fell, to be liberated in 1945, when, ironically, Pétain was branded as a traitor, he who had been the saviour of Verdun in 1916.

By the end of 1915 the pattern of the War in France was established. The scale of the opposing forces had risen steadily and the number of troops, with all the supporting services, could be counted in hundreds of thousands. New cities had been created, like cities of ants in which those at the front struggled and were destroyed, while the land behind teemed with the workers to maintain that struggle. The concept of the artillery bombardment dominated the scene, supported by the massive heavy industry of the major powers. Both sides felt that 1916 would be the year of the great offensives, which could settle the issue. Hopes on the Allied side that this could be achieved elsewhere than on the Western Front had been dashed, no more so than in the failure of the Gallipoli expedition. In the east, Russia, although still a military power, was moving towards her own disaster, and was no longer a major threat to Germany. Thus both sides believed that the Western Front held the key to the 'final' offensives which would bring victory that year.

Verdun lies about 100 miles east of Paris. In the first weeks of the War, as the massive German right-wing advance into Belgium and Flanders had developed, the French advanced eastwards into Alsace-Lorraine, a land which meant so much to France, but which had been in German hands

since 1870. After bitter fighting and fierce attacks by both sides, and later poor staff work by the Germans which lost them the opportunity for major advances, the forts of Alsace-Lorraine held. The French line also held, and ran from north to south through Verdun, Toul, Nancy and Epinal.

Thus matters stood until the great offensive of 1916. For reasons which were in part strategic and in part symbolic, the Germans chose Verdun as the 'anvil on which to break the French Army'. The city itself lay astride the River Meuse which runs south to north. To the east and north-east of the city, on a plateau, were a series of forts, first established after the Franco-Prussian War. By February, 1916, the forts formed a salient, the front line being about 3 miles beyond the forts and, at the most, 12 miles from the city.

The first of many massive bombardments by the greatly superior German artillery began on 21 February, 1916, limited to a frontage of only 6 miles. One French division was annihilated, and within four days the Germans had advanced by up to 4 miles, the ungarrisoned Fort Douaumont had fallen, and the French were facing their most significant defeat since 1870. At this desperate moment General Pétain took command. Henri Philippe Pétain was aged 60, and in 1914 was Commander of the 4th Brigade of Infantry. In June, 1915, he had assumed command of the French 2nd Army and had played an important part in the offensive in Champagne and at Vimy. His forte was the use of heavy artillery with precision and to good effect. The French artillery held the Germans on the right (east) bank of the Meuse, and the War of Attrition in a hideous landscape of shell holes, slime, snow and often darkness began in earnest.

On 6 March the Germans extended their attack to the left (west) bank of the Meuse, and the carnage was appalling in the battle for the dominating hill, Le Mort Homme. Although the opposing lines thereafter became relatively static, it was not trench warfare, but incessant and very costly raids and bombardments by each side; many men died and their bodies were never found. The battle raged into June; Fort de Vaux fell to the Germans when the survivors of that garrison could no longer hold out, after hand-to-hand fighting, often in darkness, and with flame throwers. In that month the Germans used phosgene gas shells. But despite their losses of men and of the outer forts, the French line held throughout the

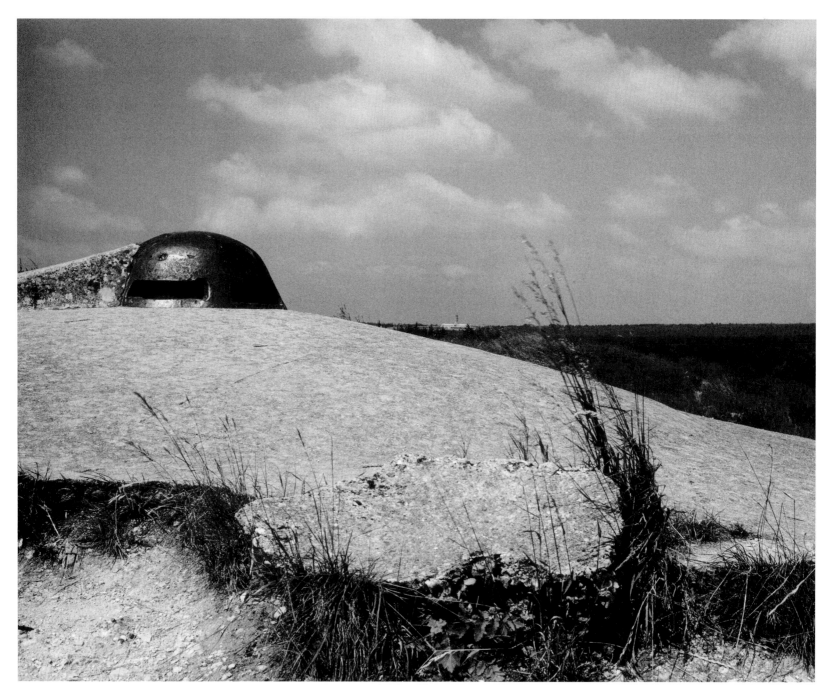

FORT DE VAUX AND DOUAUMONT OSSUARY. THE OSSUARY, IN THE DISTANCE, CONTAINS THE REMAINS OF OVER 130,000 FRENCH AND GERMANS

summer, although Pétain had considered plans for a withdrawal. To what extent the opening of the Somme offensive on 1 July, 1916, saved Verdun, is a matter of some debate. The Allied preparations for the Somme made it imperative that Verdun was held, despite Pétain's doubts, and the opening of the offensive certainly forced General von Falkenhayn to reduce his efforts to take Verdun. By the autumn, the French were able to recapture the forts of Douaumont and Vaux, and by December Verdun was safe.

The losses at Verdun in the space of only five months were prodigious. Of the French, a total of about 300,000 were killed or wounded, of the Germans slightly less; on both sides many have no known graves. The historic words '*Ils ne passeront pas*' and '*La Voie Sacrée*', as the road from Bar-le-Duc became known, with its ceaseless traffic of men and materials, epitomise an episode in French military history that still has an almost religious significance.

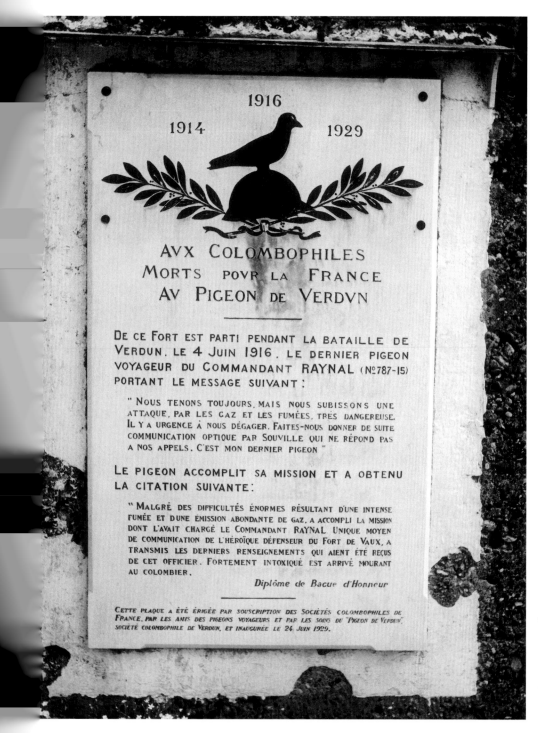

VERDUN

Verdun was to become an anvil upon which French military manhood was to be hammered to death by the German cannon. The French were to be fastened to fixed positions by sentiment, and battered to pieces by the artillery. By the end of April [1916] nearly a quarter of a million French and Germans had been killed or wounded in the fatal area, though influencing in no decisive way the balance of the World War.

WINSTON CHURCHILL *The World Crisis*

FORT DE VAUX

The German objective was to force a battle in a sector that France would defend at all costs, on psychological grounds. Belfort and Verdun answered these requirements, for the pride of the French nation would be touched and Frenchmen would shed their last drop of blood rather than lose these forts, felt by them to be flesh of their flesh.

HENRI PÉTAIN *quoted in 'Verdun'*

FORT DE VAUX AND DOUAUMONT OSSUARY

It is around 5 am and the sun is coming up over Fort Douaumont. The landscape is barren, swept clean by thousands and thousands of shells. It is all so difficult to understand. Life seemed so terribly cheap. Verdun absorbed everything fed into its hungry jaws and there is no limit to its appetite. As the Summer gave way to Fall 1916 our losses had become so alarming that further attacks were cancelled. Decimated divisions were shipped out and replaced by ones previously stationed in quiet sectors. These newcomers could not imagine what ordeals they soon would have to go through. My old friend Alfons Bucher already was gone, along with his whole regiment and division.

KARL HEIMGARTNER *In the Furnace of Verdun*

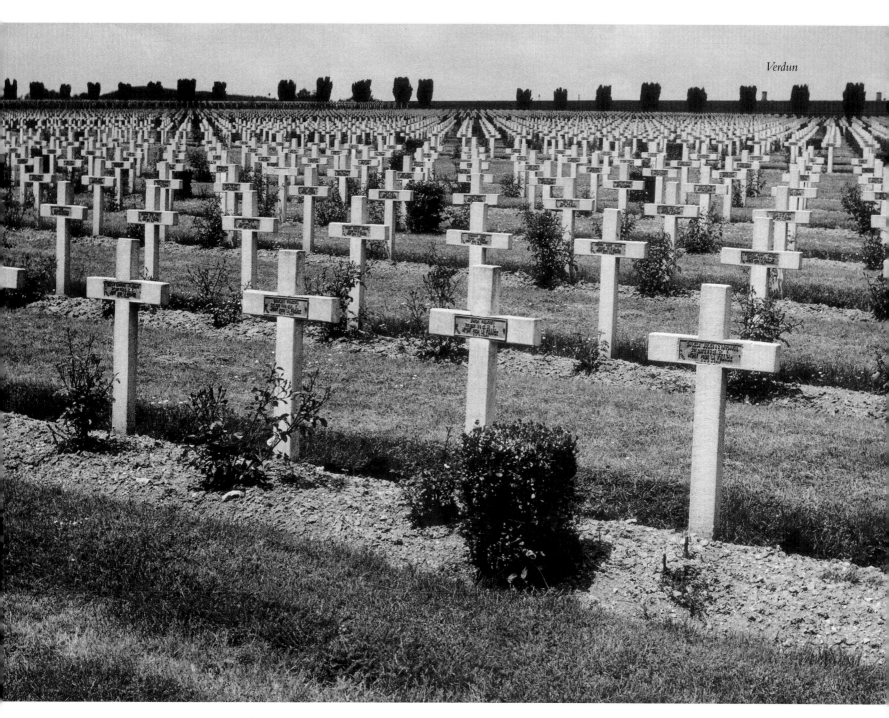

Verdun

DOUAUMONT FRENCH CEMETERY. IDENTIFIED BURIALS 15,000

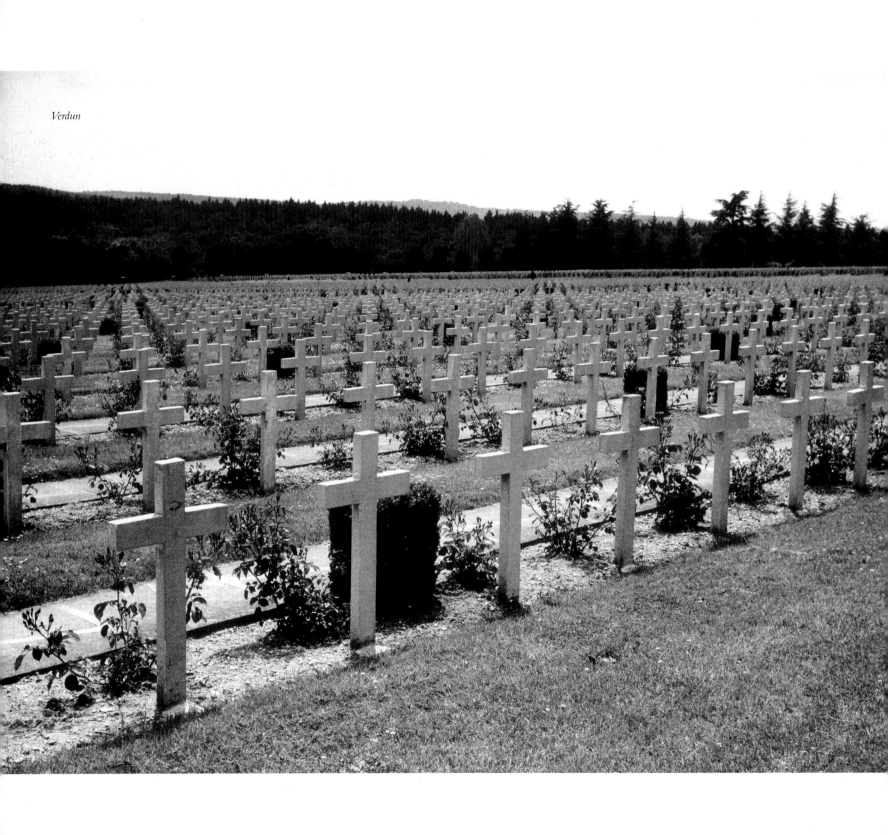

Verdun

THE SOMME

I have often wondered since then if all the leading statesmen and generals of the warring countries had been threatened to be put under that barrage during the day of the 20th July 1916, and were told that if they survived it they would be forced to be under a similar one in a week's time, whether they would have all met together and signed a Peace Treaty before the week was up.

FRANK RICHARDS *Old Soldiers Never Die*

The Somme, like Ypres, has a special and emotional meaning in the British memory of the Great War. The mixture of hope, heroism, failure, ill-timed efforts, perverse elements and death, during a limited campaign of less than four months, provides a vignette of the whole War.

By the spring of 1916 the French had held the Germans at Verdun at great cost, and were desperate for relief. The Dardanelles campaign had reached its sombre end with the final withdrawal in January. In the east, Russia was no longer a force which occupied major German forces. On the Western Front the costly battles of 1915, including Champagne and Loos, had brought only loss of life, and the front lines remained static. The most pressing need was the relief of the mangled French Army at Verdun by a major Allied offensive in the west, which would draw the Germans from Verdun, and at the same time contain and destroy a large part of their army. Haig had hopes of a deep penetration of the German line or even of a breakthrough, but General Rawlinson, Commander of the 4th Army, saw the planned offensive as a battle of attrition and destruction. In the event Rawlinson was right, but if the weather had not broken, the Somme might have been Haig's triumph.

Since the end of the battles of 1915, the Germans had had time, on a relatively quiet front, to build formidable fortifications on the chalk downs and plateaux north of the Somme and astride the Ancre. There they had established a chain of fortified villages with virtually impregnable catacombs, and a series of redoubts which acquired ominous names such as Leipzig, Hohenzollern, Schwaben and 'Stuff'. The British line extended more than 18 miles from Maricourt in the south, just north of the Somme, to Gommecourt, north of the Thiepval plateau. It was composed of the right corps of Allenby's 3rd Army and five corps of Rawlinson's 4th Army.

The total was eighteen divisions, and of the fourteen first-line divisions, eleven were men of Kitchener's New Army, or territorials. Thus the majority of men were volunteers, with strong country, town and village ties, in what some historians have uncharitably called an 'amateur army'.

The bombardment, the traditional opening for any offensive, began on 24 June and had to be continued for seven days because the weather caused the assault to be postponed from 29 June to the fateful 1 July. Much has been written in poetry and prose of that beautiful July morning on which began one of the most disastrous single days in British military history. In the north, at Beaumont Hamel, the Newfoundland Regiment was virtually destroyed; 790 men attacked in the third wave, 710 became casualties of whom 272 died. At Thiepval Wood, the Ulstermen, among others, perished in their thousands. In the centre there was slight progress up 'Sausage' and 'Mash' valleys towards Ovillers. Some of the attacks were likened to men advancing in line as if on parade, only to fall in thousands before the converging machine-gun fire. By nightfall all the Commonwealth advances had been checked. It was only the French, south of the Somme, who achieved a significant advance towards Peronne. The Commonwealth losses on that single day were 57,470, of whom 19,240 were killed or died of wounds.

Only on his right did Haig see any prospect of success, and so during the following days the main attack was restricted to that sector. Slowly, in a series of fierce encounters, the line advanced; Fricourt fell on 2 July, Mametz Wood by 12 July; there was a cavalry charge at High Wood on the 14th and on 14 and 15 July the South Africans achieved fame at Longueval and Delville Wood. There was an advance of 6,000 yards to the Bazentin Ridge, and Ovillers was taken on the 16th.

During the remainder of July, and during August, the battle was largely one of attrition, with small, but significant, Allied advances. Commonwealth losses were especially heavy at Pozières where the ANZACs fought. German losses were heavy, and their morale fell. There was discontent within the leadership, and Falkenhayn was replaced as Chief of General Staff of the Field Army by Hindenburg, who became Generalissimo, and Ludendorff acting as Assistant Chief of General Staff.

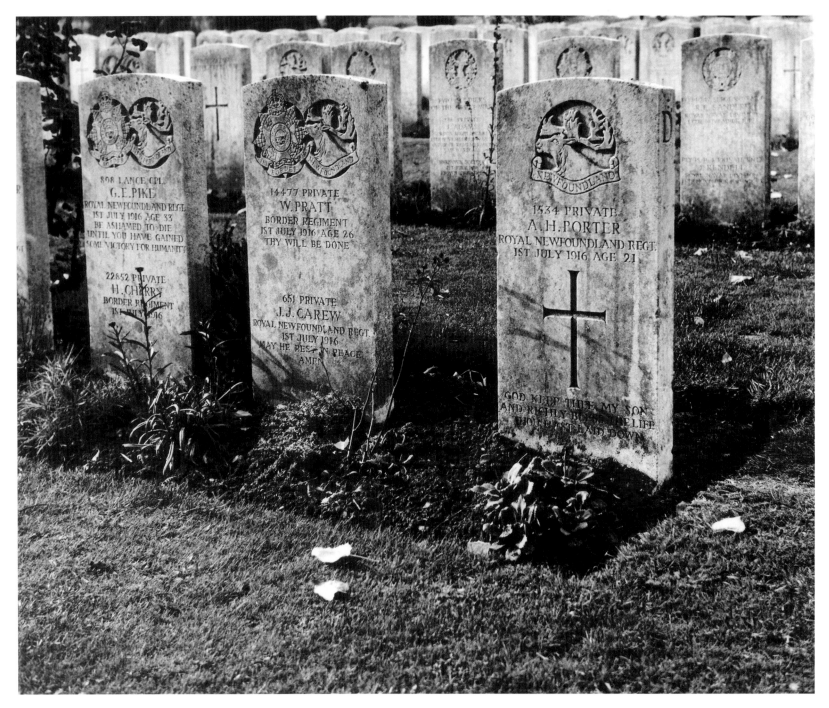

Y RAVINE CEMETERY, NEWFOUNDLAND MEMORIAL PARK, BEAUMONT HAMEL

In September the French extended the line 12 miles south of the Somme. They were at the gates of Peronne by 10 September. The end of this long first phase of the battles of the Somme began with another great bombardment on 12 September, and on the 15th Haig's great assault extended along the whole length of the line from Combles in the south to beyond Thiepval in the north. That day saw the secret 'tank' weapon in action, which cowed the German troops until the Infantry were upon them. Their advance was only 1½ miles, and Haig was later criticized for not using tanks in greater numbers, but his pleas for 1,000 had produced only 36. Nevertheless Courcelette, Flers and High Wood were cleared.

By 25 September, when Combles and Morval had fallen, the Allies held all the high ground north of Pozières, they were astride the Ancre, and the Germans had fallen back to their fourth line. Haig might well have felt that the deep penetration had been achieved and that a breakthrough to Bapaume and, even more significantly, north of the Ancre, was within his grasp, given another month of good weather.

But it was not to be. Already the ground was wet, and on 26 September the weather broke. The mud of the Somme was second only to the mud of Ypres. A constantly moving vast military machine soon transformed dry-weather tracks into impassable canals of mud, Napoleon's fifth element. At the same time, the Commonwealth troops came under direct artillery fire as they attempted to descend from the plateau towards Bapaume. Haig may have wanted to halt the offensive, but Joffre encouraged him to continue. Cesaire Joffre was 64 and had become Chief of the General Staff in 1912, and Commander-in-Chief in 1914. He was associated with the new French military school of *offensive à outrance* and *élan*. By some he was considered to be too much of an optimist; he tended to underestimate the enemy's strength, and his strategy was rarely original.

Throughout October the rain continued. Actions usually consisted of the taking and retaking of limited objectives and redoubts, often with great loss of life. The final symbolic success was the taking of Beaumont Hamel, the Thiepval Ridge and Beaucourt, but without any strategic gains. The battles of the Somme petered out in the blizzards of November, 1916.

As with so many battles of the Great War, historians' verdicts on the Somme vary. Undoubtedly it helped to save Verdun and caused the Germans great loss of men, material and morale; but, despite this, Germany fought for another two years and nearly defeated the Allies in the spring of 1918. Haig had been criticized for embarking upon an offensive with insufficient material and without clear and feasible strategic objectives.

Whatever the verdict, the official casualties in only four months were: 418,654 Commonwealth, 194,451 French and 650,000 Germans. On the memorials at Thiepval, Pozières, and Beaumont Hamel, there are 87,542 names of those who have no known graves. In the Commonwealth cemeteries there are 87,000 named headstones and 56,000 burials of those whose only identity is A SOLDIER OF THE GREAT WAR.

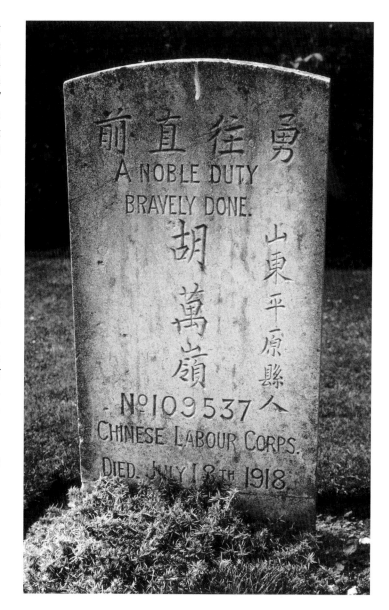

Gezaincourt

On July the 1st the weather after an early morning mist of the kind commonly called heavenly. I am staring at a sunlit picture of hell and still the breeze shakes the yellow weeds and the poppies glow under Crawley Ridge where some shells fell a few minutes ago.

SIEGFRIED SASSOON *Memoirs of an Infantry Officer*

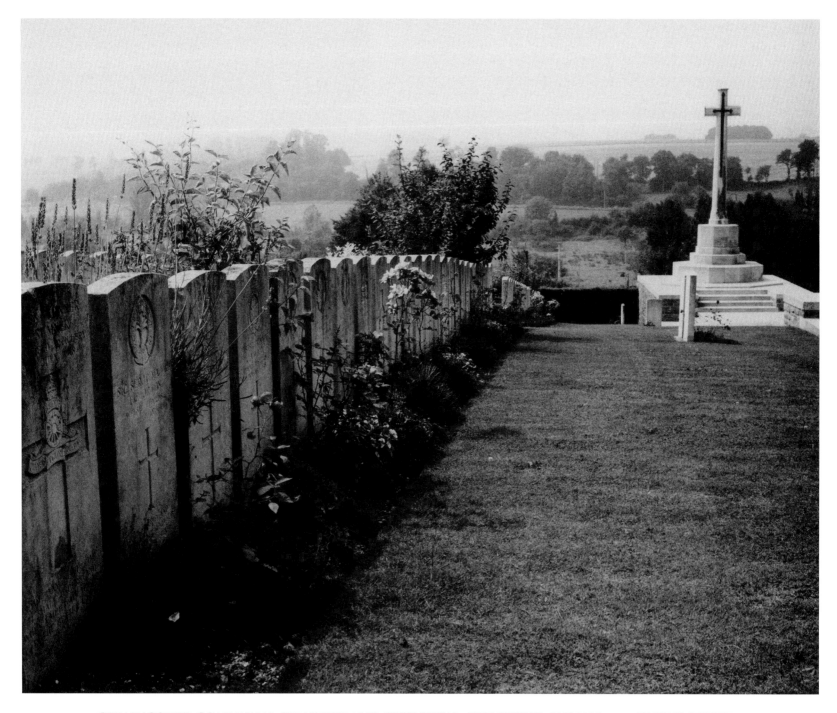

GEZAINCOURT COMMUNAL CEMETERY AND EXTENSION. IDENTIFIED BURIALS 593. UNIDENTIFIED 3

LOUVENCOURT MILITARY CEMETERY. IDENTIFIED BURIALS 151

When by 10 o'clock no news had come, unable to fight sleep any longer after a night and day of wakefulness, I went to bed a little disappointed but still unperturbed. Roland's family at Keymer Cottage kept an even longer vigil; they sat up until nearly midnight over their Christmas dinner in the hope that he would join them, and in their dramatic impulsive fashion they drank a toast to the dead. Next morning I had just finished dressing and was putting the final touches to the pastel crepe de chine blouse, when the expected message came to say that I was wanted on the telephone. Believing that I was at last to hear the voice for which I had waited for 24 hours, I dashed joyously into the corridor. But the message was not from Roland but from Clare. It was not to say that he had arrived home that morning, but to tell me that he had died of wounds at Louvencourt Casualty Clearing Station on December 23rd.

VERA BRITTAIN *Testament of Youth*

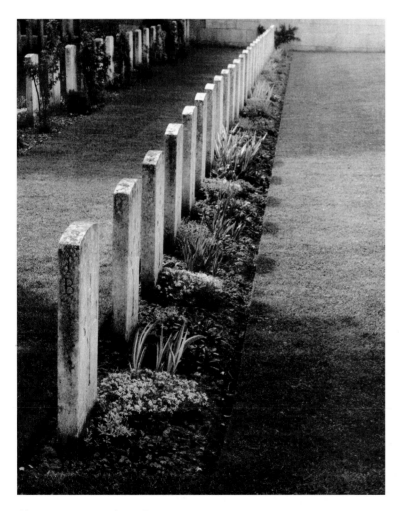

Above: *Lovencourt Military Cemetery*
Right: *Fricourt German Cemetery*

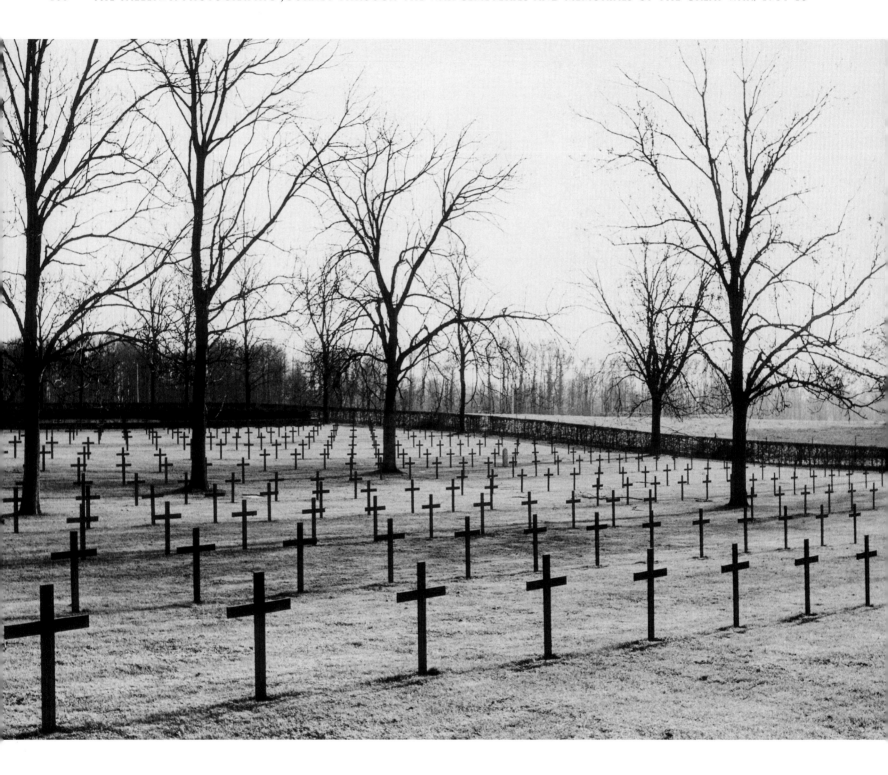

FRICOURT GERMAN CEMETERY
IDENTIFIED BURIALS 5,056. IN MASS GRAVES 11,970

*I started down the Fricourt road. People coming up grinned at me
with friendly and probably jealous compassion, and I grinned back.
I was suddenly filled with a surge of happiness. It was a physical
feeling almost, consciousness of a reprive from the shadow of death,
no less. That I had just taken part in a failure, that I had really done
nothing to win the War, these things were forgotten – if ever indeed
they had entered my consciousness. I had been through the Somme
battle and I was alive; that was enough.*

H.E.L. MELLERSH *Schoolboy into War*

*At 4 am on July 15th we struck the Meaulte-Fricourt-Bazentin road,
which ran through 'Happy Valley' and reached the more recent battle
area. Wounded and prisoners came streaming past in the half light. I was
struck by the dead horses and mules; human corpses were all very well
but it seemed wrong for animals to be dragged into the War like this.*

ROBERT GRAVES *Goodbye to All That*

POINT 110 NEW MILITARY CEMETERY
IDENTIFIED BURIALS 64

*I felt David's death worse than any other since I had been in France, but
it did not anger me as it did Siegfried. He was acting Transport Officer,
and every evening now, when he came up with the rations, went out on
patrol looking for Germans to kill. I just felt empty and lost.*

ROBERT GRAVES *Goodbye to All That*

Opposite: *Fricourt German Cemetery*
Right: *Point 110 New Military Cemetery*

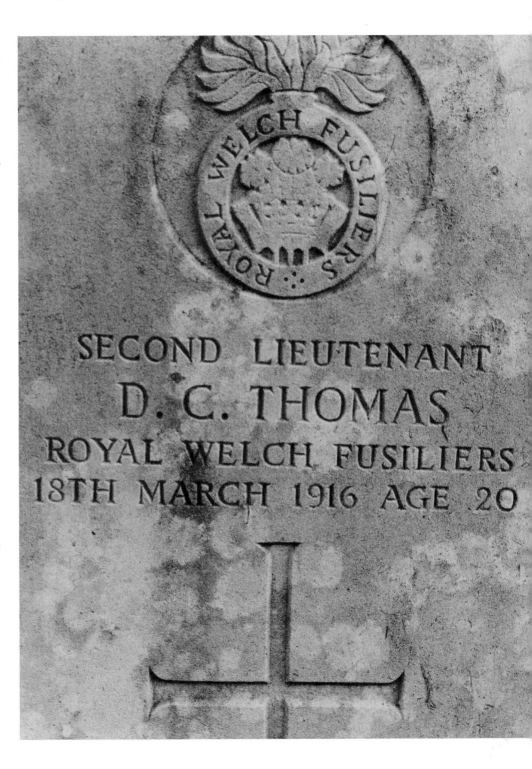

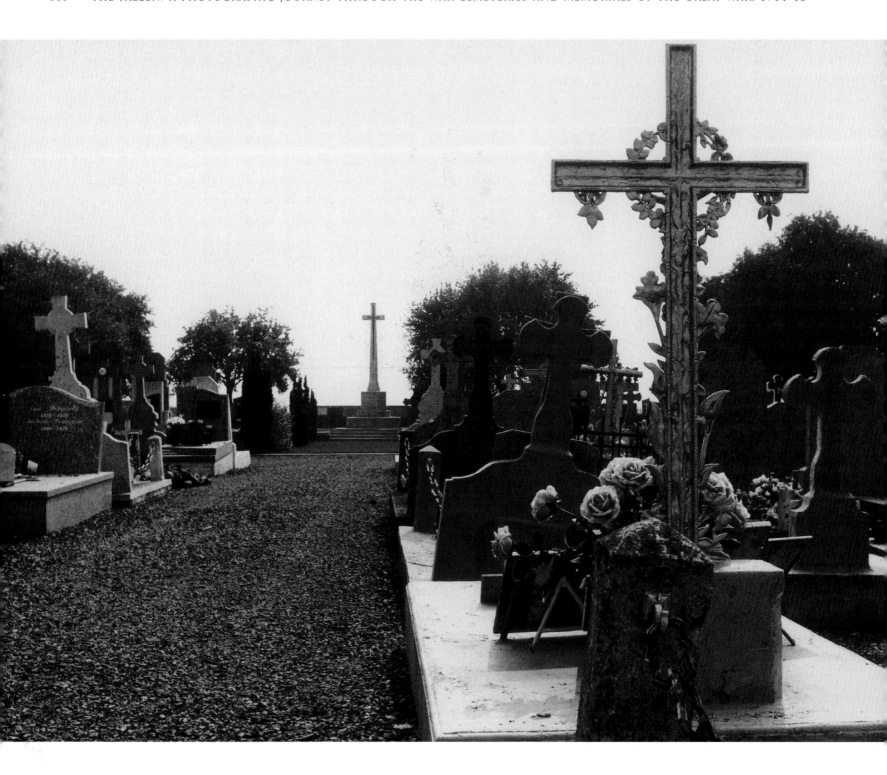

Hersin French Communal Cemetery

OVILLERS MILITARY CEMETERY. IDENTIFIED BURIALS 959. UNIDENTIFIED 2,477

It was then, turning back, that I knew what the novelists mean by a 'stricken field'. The village was guarded by tangle after tangle of rusted barbed wire in irregular lines. Among the wire lay rows of khaki figures, as they had fallen to the machine guns on the crest, thick as the sleepers in the Green Park on a Summer Sunday evening. The simile leapt to my mind of flies on a fly paper. I did not know then that, twice in the fortnight before our flank attack, had a division been hurled at that wire-encircled hill, and twice had it withered away before the hidden machine guns. The flies were buzzing obscenely over the damp earth; morbid scarlet poppies grew scantily along the white chalk mounds; the air was tainted with rank explosives and the sickly stench of corruption.

CHARLES EDMONDS *A Subaltern's War*

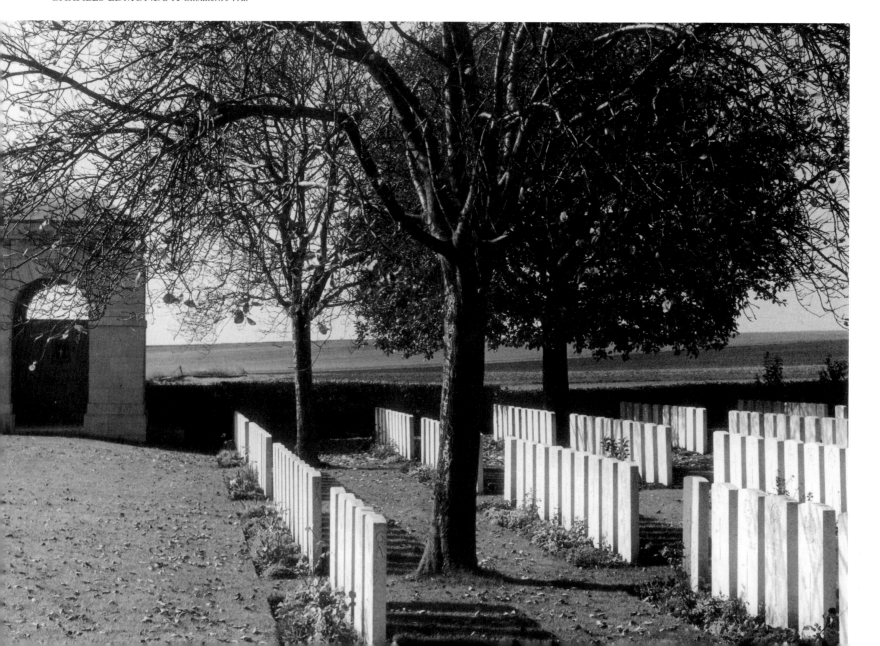

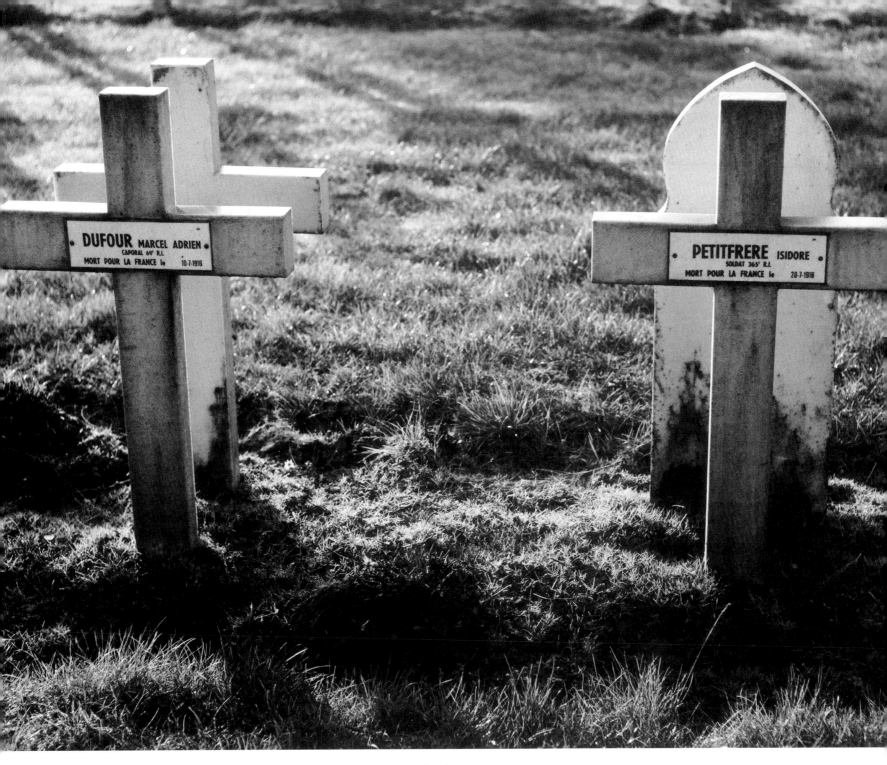

Biaches French Military Cemetery

BRAY GERMAN CEMETERY. IDENTIFIED BURIALS 1,079. IN MASS GRAVES 43

On 1st July we had the sad duty of burying some of the dead in our burial ground. Thirty-nine plain wooden coffins were lowered into the graves. The address by the Pastor Philippi was so affecting that men cried like children.

ERNST JUNGER *Storm of Steel*

BEAUMONT HAMEL

It is especially cruel for me to hear of all we gained by St Quentin having been lost. They are dying again at Beaumont-Hamel which already in 1916 was cobbled with skulls.

WILFRID OWEN
Wilfrid Owen; Selected Letters

NORFOLK CEMETERY.
IDENTIFIED BURIALS 325
UNIDENTIFIED 224

The action at Stuff Trench on October 21st and 22nd had been the first in which our battalion had seized and held any of the German area, and the cost had been enormous; not intemperate pride glowed among the survivors, but that natural vanity was held in check by the fact that we were not yet off the battlefield. The evenings were shutting in early, the roads were greasy and clogging, and along the wooded river valley the leaves had turned red and now had a frost-bitten chillier tinge; the ridges looked lonelier under the sallow clouds; but in mud and gloom the guns went on.

EDMUND BLUNDEN *Undertones of War*

NEW CITADEL MILITARY CEMETERY
IDENTIFIED BURIALS 363
UNIDENTIFIED 15

We are moving up tonight into the Battle of the Somme. The bombardment, destruction, and bloodshed are beyond all imagination. I am calm and happy but desperately anxious to live. Somewhere the choosers of the slain are touching, as in our Norse story they used to touch with invisible wands those who are to die.

THOMAS KETTLE *War Letters of Fallen Englishmen*

Left: *Norfolk Cemetery*
Opposite: *New Citadel Military Cemetery*

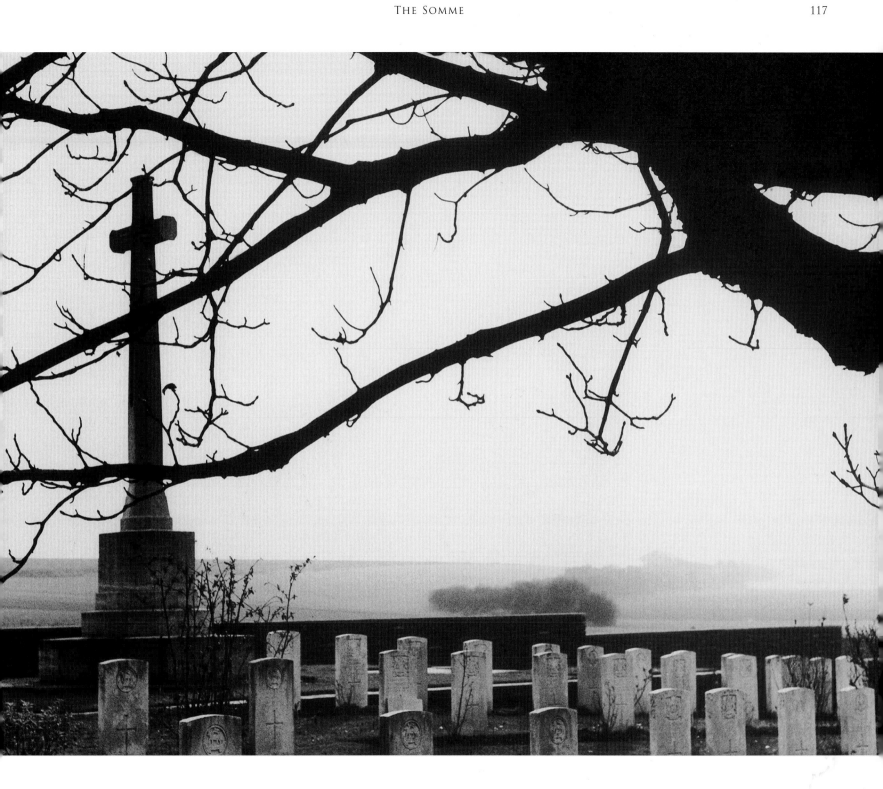

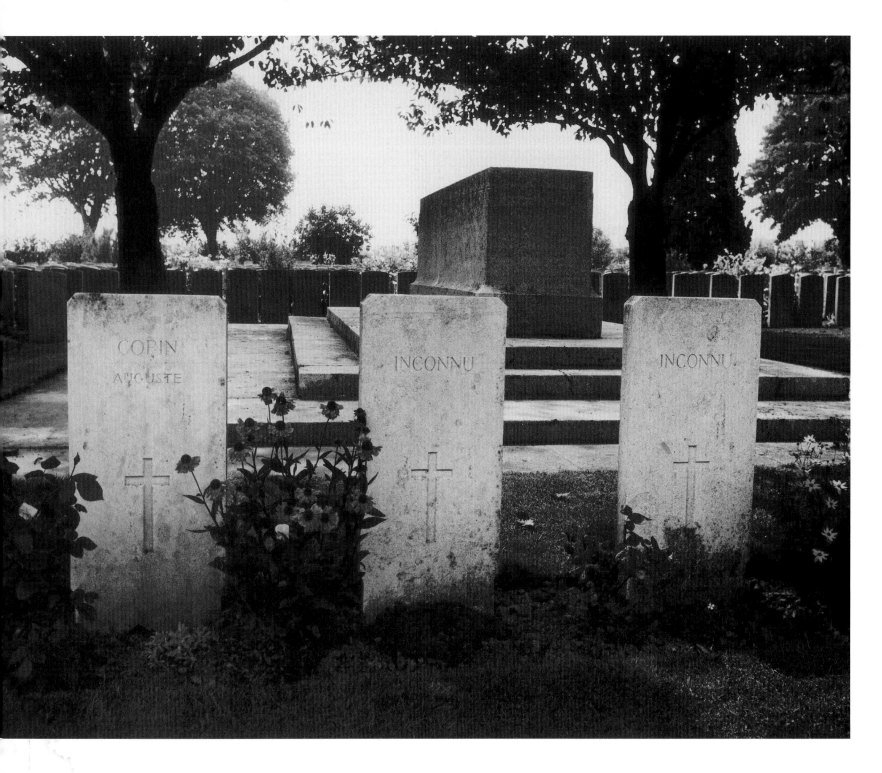

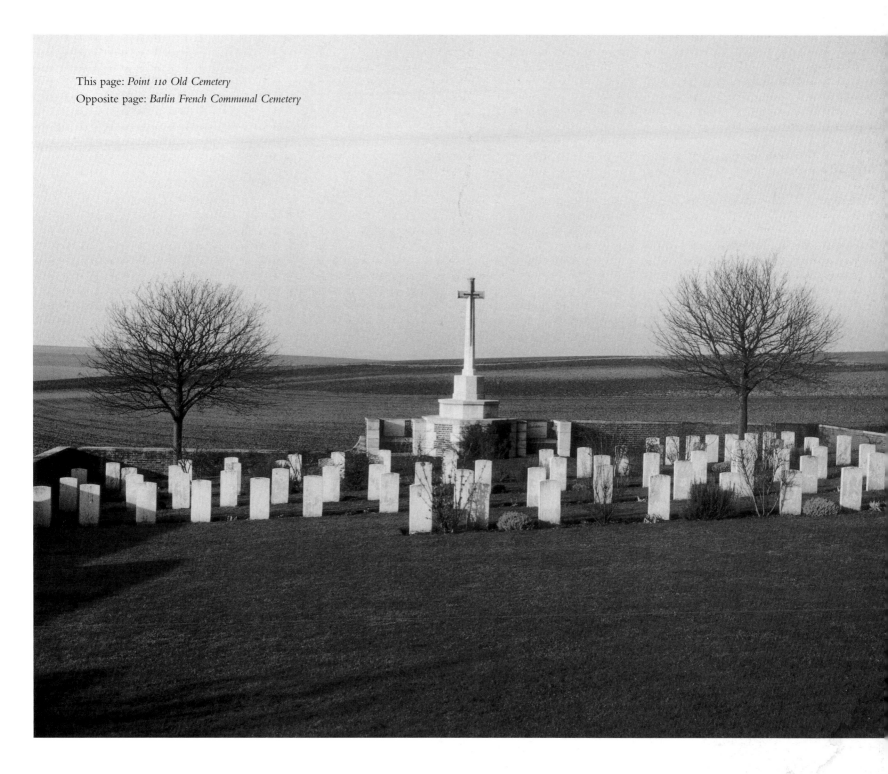

This page: *Point 110 Old Cemetery*
Opposite page: *Barlin French Communal Cemetery*

MUD

After those two days we were let down gently into the real thing, mud. It has penetrated now into the sanctuary, my sleeping bag, and that holy of holies my pyjamas. For I sleep on a stone floor and the servant squashed mud on all my belongings; I suppose by way of baptism.

WILFRED OWEN
Wilfred Owen; Selected Letters

ITALY

Italy's late entry into the Great War in May, 1915, was the last step in her efforts to acquire territories of Austria-Hungary in which the population was largely Italian. This objective was ultimately more persuasive than any altruistic motivation towards either the Central Powers or the Allies. The territories most at issue were the southern Tyrol (where the nationalities are still not fully at peace) and Istria (now in Croatia), including the important city and port of Trieste. The Triple Alliance of 1882 between Germany, Austria and Italy seemed to identify Italy with the Central Powers, whatever her true motives. But the agreement with France, in 1902, whereby each would remain neutral should the other be attacked, was evidence of Italy's opportunist aims, of which her two proclaimed allies became increasingly suspicious; by 1914 Vienna had unequivocally opposed Italy's claim to the south Tyrol and Istria. Italy's aims towards 'Italia Irredenta' were given the almost liturgical title of 'Sacro Egoismo' by Solandra, the Italian Prime Minister. The 'Egoismo' was an honest statement, and was the justification, or at least the explanation, for Italy's change from the Central Powers to the Entente Cordiale. In August, 1914, Italy proclaimed her neutrality on the pretext of the Austrian action against Serbia. The Pact of London in April, 1915, with Great Britain, France and Russia, whereby Italy was finally bought with promises, which included the South Tyrol, Istria, Dalmatia, and £50,000,000, concluded the Italian transformation from a Central to an Allied belligerent. For this she was to pay dearly in men, and the map of Italy today is only a little different from what it was in 1914.

Italy declared war on Austria on 23 May, 1915, but not until 27 August, 1916, on Germany. The rectangular Italian salient projected about 50 miles northward into Austria and faced the enemy to the east, north and west. The Austrians held most of the advantages in the mountainous country in the Trentino to the north, where fierce fighting by small groups brought few advances. The major battles were fought in the east, the Italian objective always being to cross the River Isonzo, to take Gorizia and then the mountains and plateaux of Carso in the south, which would open the way to Trieste, and inland to Leibach (now Ljublijana) and the plains of the Danube. The fruitless and very costly Italian attacks of 1915 became known as the first five battles of the Isonzo. General Luigi Cadorna, the Italian Commander-in-Chief, in planning the attacks, had hoped to defeat the Austrians before German forces could arrive in support. Although at times the Italians established bridgeheads over the river, the terrain favoured the Austrians on the slopes and heights east of the river, Gorizia was held, the Carso was never in real danger, and only Plava and Monfalcone were taken. The heavy artillery bombardments, with shells exploding on rocks and stony ground, were the prime cause of casualties. The losses in those first five battles were prodigious; for the Italians about 200,000 and for the Austrians about 100,000. Thus Cadorna's plan for defeating the Austrians before German forces joined them was a costly failure. The Austrians, unaided, had held the Italians on the Isonzo front, and also in the Trentino, with the support of only a Bavarian Alpine Corps.

In 1916 the Austrians attacked from the north; in the east the pattern of 1915 was repeated. In the Trentino and the Alto Adige, snow caused General Franz Conrad von Hotzendorf, the Austrian Chief of Staff, to postpone the Austrian attack until mid-May, but his deployment of forces, using the single railway running through Trentino, was skilful, and the mountains favoured the Austrians. The attack prospered, 5 miles were gained in five days, and by early June the Austrians held much of the Asiago Plateau. But the front became extended to about 40 miles, and Italian counter-attacks in June forced the Austrians to withdraw north of the Plateau.

On the Isonzo there was a brief Italian attack in March, with only three small lodgements across the river. On 6 August Cadorna attacked again; he had considerable artillery superiority, Gorizia was taken, and the Italians gained a limited foothold on the Carso. When Austrian reinforcements arrived, Cadorna faltered, withdrew from the Carso, and launched an attack further north against Tolmino. But neither this, nor the further attacks during

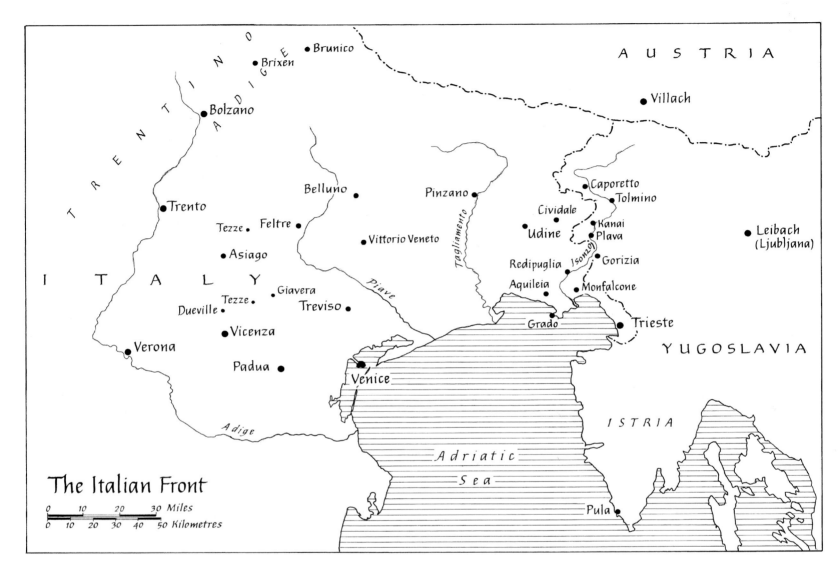

The Italian Front

September and October, did any more than exhaust and decimate the Italian troops in what had become a war of attrition. The total Italian losses during 1916 were about a quarter of a million, and the origins of the demoralization, disillusionment and the defeatism which contributed to the disasters of 1917, lay in those battles of the Isonzo. Had Falkenhayn been free from his commitments at Verdun and on the Somme, German support in the Trentino and on the Isonzo might well have caused Italy to capitulate in 1916.

1917 brought near total disaster to the Italian Army. The war of attrition continued with attacks in May. Despite thirty-eight Italian divisions facing fourteen Austrian, the greatest gains in the Plava and Monfalcone areas were only 5 miles beyond the original line, at a cost of 157,000 Italians and 75,000 Austrians. But in August, with a two to one superiority, the Italians broke through the Austrian line on the Carso, and north of Gorizia the Austrians were forced back beyond the last line of defences. Perhaps because he believed German reinforcements were nearby, Cadorna halted, having sustained losses twice as great as the Austrians. That was the last moment at which the 'Leibach Gap' might have been within his grasp.

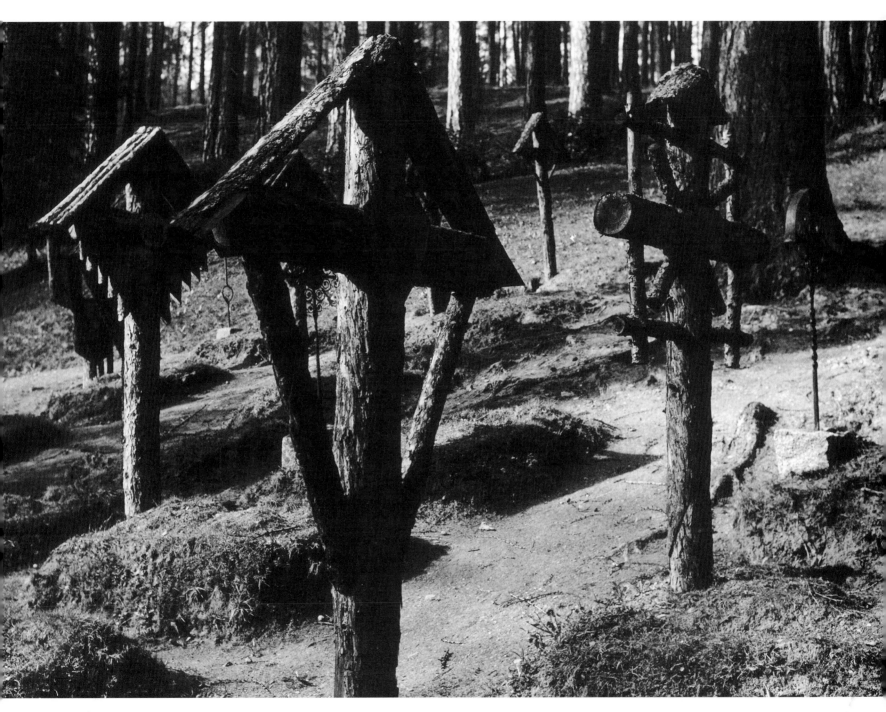

BRUNECK CEMETERY, ITALIAN TYROL. 677 AUSTRO-HUNGARIAN BURIALS.

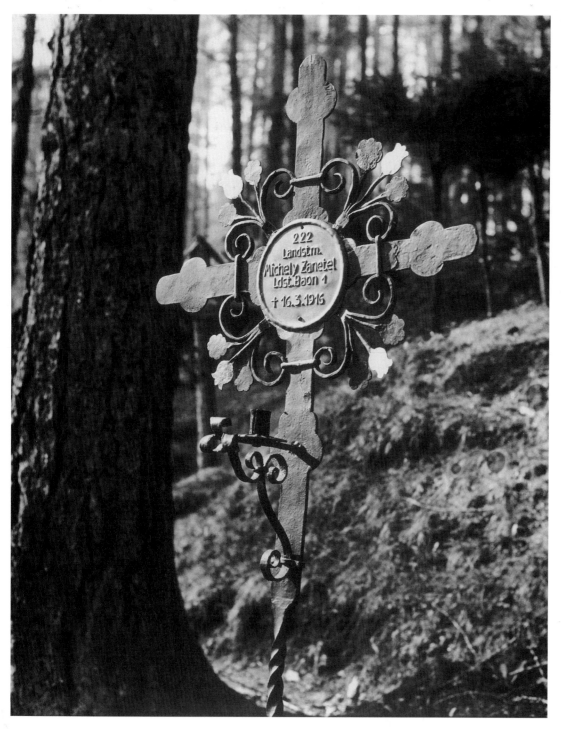

From September, 1917, onwards the great Italian disaster of Caporetto became almost inevitable. Strong German support from General Otto von Below's 14th Army arrived on the upper Isonzo, north of Tolmino, to form a total force of seven German and nine Austrian divisions, including highly-trained mountain troops. On 25 October, after a great bombardment with mortars, heavy artillery and gas shells, the Italian line was breached through its length, the 2nd Battalion Army opposite Caporetto and Tolmino disintegrated and was routed. Further south the Duke of Aosta's 3rd Army retreated. The onslaught was in itself enough to account for the rout and headlong chaotic retreat of an already decimated and demoralized Italian Army to the River Tagliamento, and thence to the Piave. To what extent military morale had been sapped already by a political campaign of the extreme Socialists and the so-called Brotherhood of the Proletariat is a matter for speculation.

At the Tagliamento, some 40 miles from the Isonzo, the rout was temporarily halted on 30 October, but by 1 November the Austrians and Germans were across the river at Cornino and Pinzano. Only by 7 November on the line of the Piave did the retreat finally end, perhaps because von Below's lines were too stretched, or perhaps because he knew that French and British troops had begun to arrive. About a quarter of a million Italians had been taken prisoner. In November the Allies responded to the crisis at the Rapallo Conference. It was attended by Lloyd George, British Prime Minister; Paul Painlevé, French Minister of War; Ferdinand Foch, French Generalissimo, who had reached military retiring age the previous year and had been appointed Director of a new bureau for the study of inter-Allied questions; and Vittorio Orlando, Italian Prime Minister, who had been Professor of Constitutional Law at Palermo, and a member of the Italian Parliament since 1898.

The Conference set up a Supreme War Council, although its effectiveness can be disputed. However, on the Italian front, Armando Diaz replaced Cadorna as Generalissimo, and it was decided to give the Italians greater allied support.

1918 brought the last attack by the Austrians and Germans, and the Allies' final victory. In June, by a pincer movement, Conrad attacked from the north and hoped to reach Vicenza, while an attack across the Piave was aimed at Treviso and even Padua. Conrad's attack fell most heavily upon the British and French on the Asiago Plateau and was repulsed after an initial gain of 1,000 yards. Across the Piave the Austrians advanced 5 miles, but then withdrew, partly because their pontoon bridges were destroyed from the air. Both attacks having failed, Conrad was dismissed.

The final battle, generally known as Vittorio Veneto, was fought in late October when 56 Allied divisions faced 55 Austrian. On 23 October a British Brigade took the Island of Papadopoli on the Piave, and on the 25th the French, British and Italians completed the crossing of the river. Thereafter the defeated Austrians were pursued, Vittorio Veneto was taken on 30 October and the Tagliamento crossed on 2 November. By then the British had broken out northwards from the Asiago Plateau to the Val d'Assa, and into Austria.

The total Italian casualties from the time she entered the war in May, 1915, were 2,197,000, of whom 460,000 died. At Redipuglia alone there are 100,000 graves or plaques, many being of those who died in the battles for Gorizia and the Carso. Others lie in the military cemetery at Aquileia. In the five Commonwealth cemeteries on the Asiago Plateau, and in the cemeteries of Tezza, Giavera, Udine and Dueville there are 2,037 Commonwealth dead. In the cemeteries and memorials in the Tyrol, the Dolomites, and North Italy there are 9,844 names of German, Austrian and Hungarian dead.

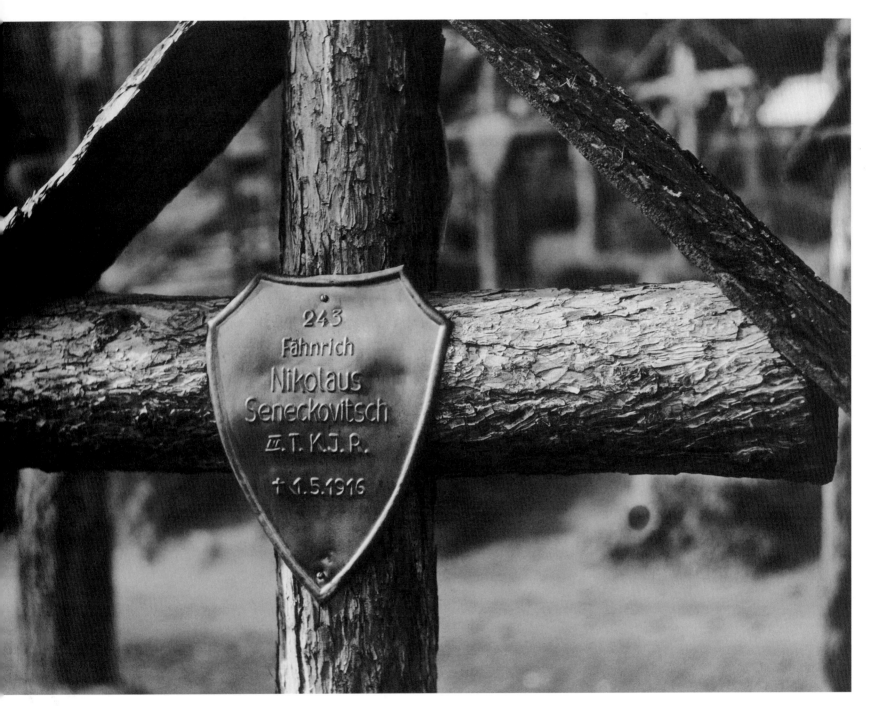

Above and previous pages: *Bruneck Cemetery, Italian Tyrol*

BRIXEN CEMETERY, ITALIAN TYROL. 400 AUSTRO-HUNGARIAN BURIALS.

Left and opposite: *Aquileia*

TEN. COL. BERS. PARIDE RAZZINI
COM.TE DEL 3° CICLISTI
FERITO MORTALMENTE A Q. 144 DEL CARSO
MORI' A PIERIS IL 21 · 9 · 1916
LUMINOSO ESEMPIO DI VIRTÙ MILITARE
DECORATO DI DUE MEDAGLIE D'ARGENTO
E DUE CROCI AL VALOR MILITARE
PROMOSSO TEN. COL. PER MERITO DI GUERRA

S. TENENTE
BARBANCELLO
GIUSEPPE
1° FANTERIA

204

TENENTE MEDICO
BARBANO
CARLO
OSP. 60 CR. ROSS.

SOLDATO
BARBARIN
GIUSEPPE
71° BATT. BOMB.

210

OPERAIO MIL.
BARBARIOL
VALENTINO

REDIPUGLIA ITALIAN MILITARY CEMETERY.
THE RESTING PLACE OF OVER 100,000 WHO DIED IN THE BATTLES OF THE ISONZO AND THE CARSO

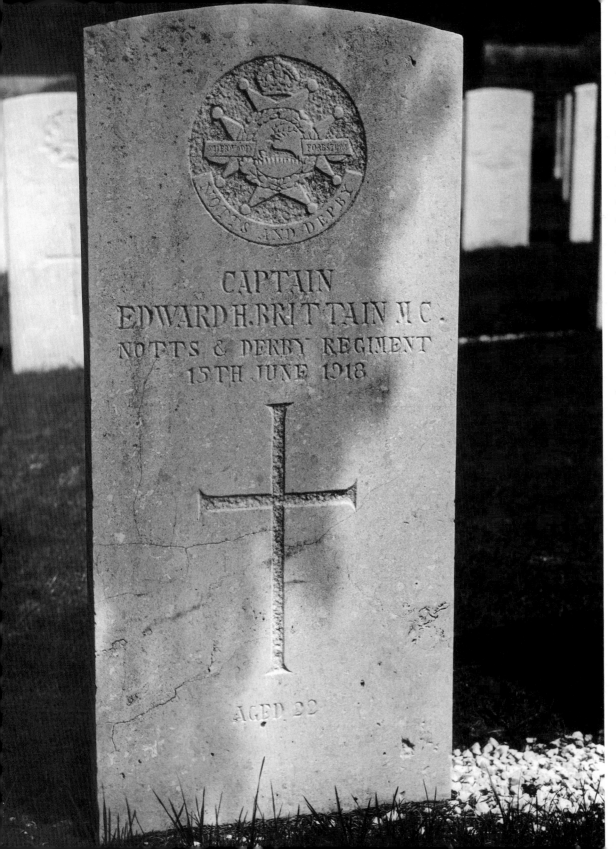

BRUNICO

Those who have mountaineered in the Adanello and Ortler groups know the straight steep valleys, with meadows in the bottoms and woods of fir and pine on the lower slopes, and above them the stony heights studded with green alps, and over all the snows and glaciers of the summits. In such country there was room for only small bodies of troops, and the raising of guns to the lofty reaches was a toil which only the hardiest mountain-bred soldiers could accomplish. The Austrians, mountain-bred also, were not an enemy to be despised, and many desperate encounters took place among screes and rock terraces — campaigning only to be paralleled by the exploits of the Gurkhas in the Lhasa expedition.

JOHN BUCHAN *Episodes of the Great War*

GRANEZZA BRITISH CEMETERY. IDENTIFIED BURIALS 142 INCLUDING CAPTAIN EDWARD BRITTAIN. UNIDENTIFIED 3

Long after the family had gone to bed, and the World had grown silent, I crept into the dining room to be alone with Edward's portrait. He had been through so much — far, far more than those beloved friends who had died at an earlier stage of the interminable War, leaving him alone to mourn their loss. Fate might have allowed him the little sorry compensation of survival, the chance to make his lovely music in honour of their memory. It seemed indeed that last irony, that he should have been killed by the Countrymen of Fritz Kreisler, the violinist whom of all others he had most greatly admired.

VERA BRITTAIN *Testament of Youth*

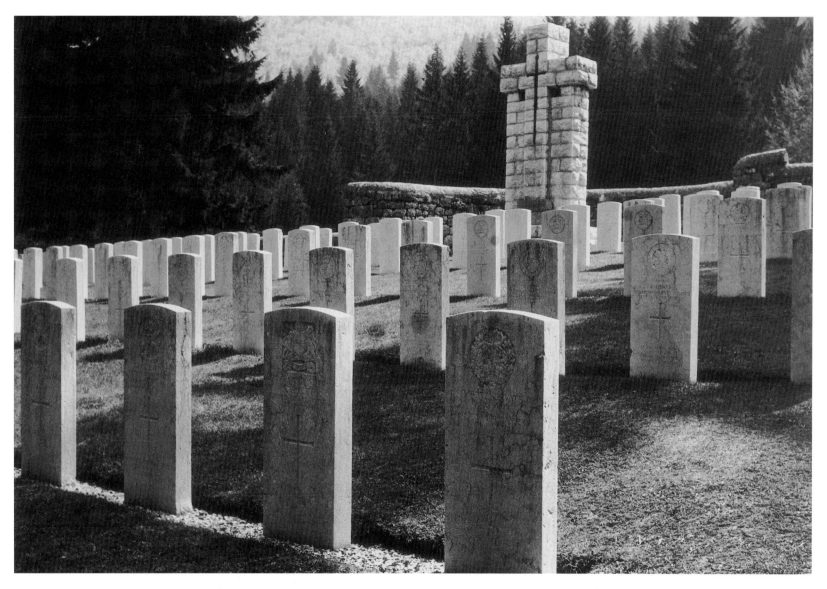

MAGNABOSCHI BRITISH CEMETERY. ASIAGO PLATEAU. IDENTIFIED BURIALS 183

It was imperative that Italy should be rearmed to the utmost possible extent by France and England. On November 18 (1917) I proceeded to Paris to meet in conclave with Luocheur and the Italian Minister of Armaments, General Dallolio. It was a cheerless experience; our margins were so small, our needs so exacting – and the Italian void gaped. In those hard days defeat was not leniently viewed by over-strained Allies. We all went through it in our turn – the politeness which veiled depreciation, the sympathy which scarcely surmounted resentment.

WINSTON CHURCHILL *The World Crisis*

CAVALLETO BRITISH CEMETERY. IDENTIFIED BURIALS 100

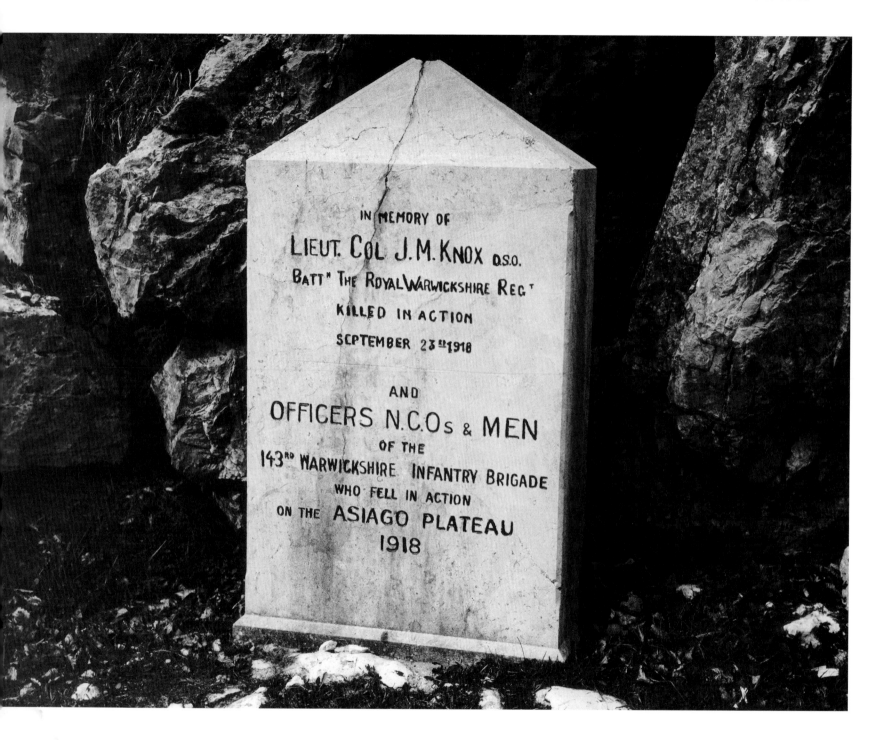

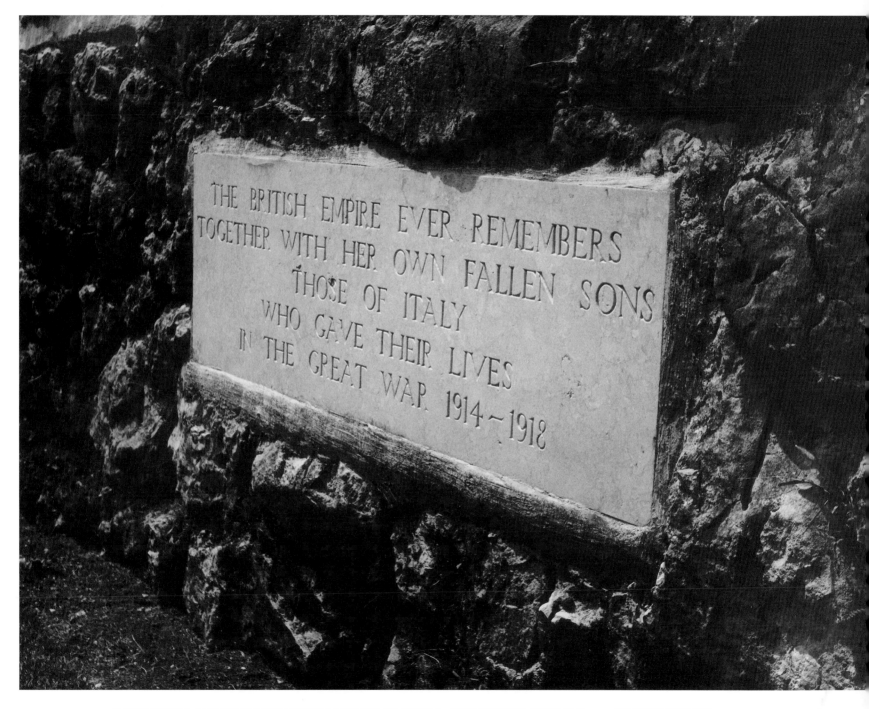

BARENTHAL MILITARY CEMETERY ASIAGO PLATEAU. IDENTIFIED BURIALS 116. UNIDENTIFIED 9

TEZZE

The Bologna Hospital was full of young
and mutilated Italian Officers, some of
whom had lost two and three limbs:
high-hearted boys who accepted their
fate with a jesting grace, and the news
of the final victory, with tuneful voices
and wild rejoicing. From among their
very brave company had gone out those
valiant leaders of Mutilati, the blinded
and the crippled warriors, who had
banded themselves together in a crusade
after the Caporetto disaster, and who
had given new heart to the armies and
to the National morale by their cries of
exaltation.

GEOFFREY WINTHROP YOUNG
The Grace of Forgetting

MACEDONIA

We only went into no-man's-land in the night, so that I never saw what the land looked like in the daylight. Everything had to be done in dead silence, and can you imagine the mystery, when on some pale Macedonian moonlight night, we were told to go into this unknown land, and we do, and with all the feeling and wonder that one might experience in entering a jungle of wild beasts.

STANLEY SPENCER *Stanley Spencer at War*

The Allies' involvement in Macedonia and the Balkans is a curious tale of traditional hate between the peoples of the Balkans, a strategic need to use the area to relieve pressure on the Western Front and an Allied Commander who did not gain the trust of his troops. The Commander's dangerous dabbling in Greek politics, the geographically and politically hostile land which the armies occupied, the reluctant support from the Allied Governments and the lack of military enthusiasm denied the British Army of Salonika much pride in the campaign, despite its final success.

The relationship of Bulgaria to the Central Powers, and to the Allies, played an important part in the development of the conflict in the Balkans and Macedonia. In 1912 Bulgaria, Serbia and Greece claimed, and successfully fought for, autonomy for Macedonia, an essential step in the process of dismembering the Turkish Empire in the Balkans. Inevitably the territorial squabbles between the Balkan States erupted, and in 1913 Bulgaria was denied her Macedonian spoils by Serbia, much to Austria's displeasure. But Bulgarian desire for Serbian territory was deep-rooted, and the antagonism between the two peoples made Bulgaria the object of overtures from both sides, based on current Allied offers of Serbian territory in Macedonia, disregarding Serbian interest. They were designed to prevent Bulgaria attacking Serbia, thereby making the Allied armies of Macedonia less vulnerable. The Central Powers' more overt offer was based upon a successful invasion of Serbia and the acquisition of Serbian territory by the victors. The Bulgarians found the Austrian offer the most attractive and sided with the Central Powers. In the short term this was successful, but it is ironic that in the long term the defeat of the Central Powers in 1918 denied Bulgaria any Serbian territory.

Austria, whose pretext for war was the punishment of Serbia, hoped to deal with the Serbs quickly in 1914, before the Russians mobilized. The initial Austrian forays into Serbia were costly and the fighting often barbaric. Despite an apparent victory in their advance towards the River Drina, their losses of 227,000, general exhaustion and Serbian counter-attacks forced the Austrians to retire behind the Danube and the Sava. The Allied landings in Gallipoli in April, 1915, and the potential weakening of Turkey, caused the Central Powers considerable anxiety. It was essential to maintain Turkey's position as one of the Central Powers, and therefore one objective in attacking Serbia was the safeguarding of the railway line to Constantinople, which formed part of the Berlin to Baghdad railway. In October, 1915, the Serbians were attacked simultaneously from the north by the Germans and Austrians, and from the east by the Bulgarians. The Serbs, though they fought fiercely, could not halt the combined attack; they retired into Albania and suffered greatly in the bitter winter conditions. In January, 1916, the Army of Montenegro collapsed, and the remnants of these armies were eventually evacuated by sea, some to join the Allied forces in Greece. The Allies' need to support the Serbs in 1915 and prevent the total loss of the Balkans led to the Salonika campaign, with all its political intricacies. The Greek position was ambivalent; Venizelos, the Prime Minister, favoured the arrival of a Franco-British force at Salonika, while King Constantine, whose Queen was the Kaiser's sister, favoured the Central Powers. The Allied force, under the command of General Sarrail, landed at Salonika in October, 1915. Maurice Sarrail, born in 1856, was Commander of the French 3rd Army in 1914, when he had disobeyed Joffre's instructions to abandon Verdun, and thereby saved the city and its forts. In August, 1915, he became Commander of the French Army of the Orient at Salonika, and in January, 1916, Commander-in-Chief of the Salonika Expeditionary Force. Venizelos had already resigned, the Allies were not welcome, but Sarrail's international army advanced some 40 miles into Serbia up the valley of the Vardar. The British had considerable reservations, and gave only lukewarm political and military support to Sarrail. His advance was blocked by the Bulgarians who attacked the British line, the Serbs were never reached, and the Army of Salonika retired into what became known as the entrenched camp, on Greek soil.

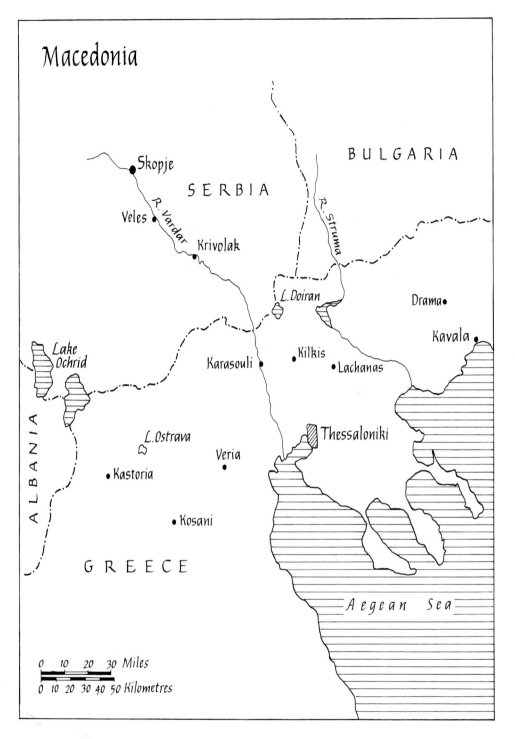

In the spring of 1916 the Allied Army advanced slowly to the Serbian–Bulgarian border. Sarrail's plans to attack from the Struma Valley were thwarted in August, when the Bulgarians drove the French troops back over the Struma; in the west the Serbian troops retreated to Lake Ostrova, but the British line held in the area of Lake Doiran. In the autumn Serbian troops attacked in mountainous country in the west, but despite this and British attacks east of the Vardar with 5,000 casualties, the line did not advance significantly. 1917 was notorious for the Allies' entanglement in Greek politics. This included the abdication of King Constantine, the withdrawal of unfriendly Greek troops to the Peloponnese, the accession of Constantine's son Alexander, the remobilization of a Greek Army sympathetic to the Allied cause, and the recall of Venizelos as Prime Minister. Militarily, the campaigning season was a failure, at times costly. Sarrail's plans for a great spring offensive with his mixed force of six French, six British, six Serbian and one Italian division went astray. The British, under Milne, made a strong diversionary attack west of Lake Doiran on 24 April, as a prelude to Sarrail's own attack. In the heat of summer malaria took its toll. Meanwhile the city of Salonika provided a dangerous escape to the 'fleshpots' for the despondent and bored troops. As if by divine judgement, Salonika was all but destroyed in the great fire of August, 1917.

November, 1917, brought a much-needed change in command which led to the victories of 1918. Georges Clemenceau, then aged 76, became Prime Minister of France and Minister of War in November, 1917, and thenceforward devoted his energies to the pursuit of absolute victory, and the restoration of French national, political and military morale. He recalled Sarrail, who, despite an earlier distinguished military career, had become enmeshed in fruitless and dangerous Greek politics; he had lost the confidence of his army. Guillaumat succeeded Sarrail as Commander-in-Chief in December, and prepared plans for an offensive, for which he gained the support of the Allied Governments. But it was Franchet d'Espèrey, Guillaumat's successor in 1918, who completed the plans, reorganized the Salonika force and refused to accept the British desire to withdraw from a so far

KARASOULI MILITARY CEMETERY. IDENTIFIED BURIALS 1,426

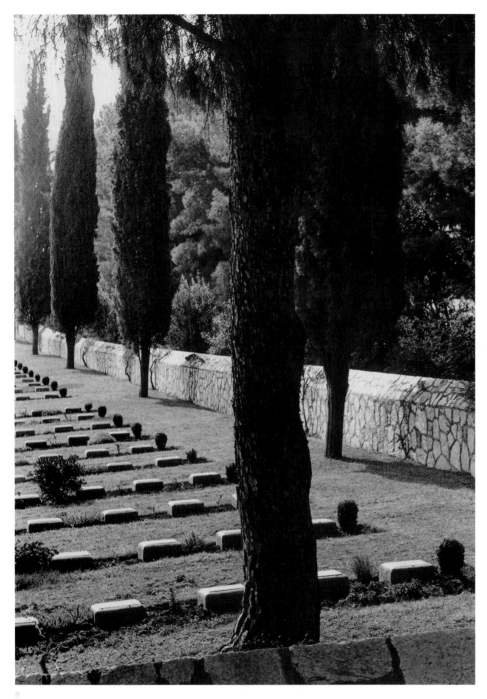

Karasouli Military Cemetery

fruitless and unsavoury campaign. By September, 1918, preparations for the final offensive by this polyglot army were completed, after great diplomatic efforts by Guillaumat in Paris. On 16 September the Serbs and French in the west gained the mountain crests held by the Bulgarians, and by the 21st were at Krivolak in the valley of the Vardar. The British attacks west of Lake Doiran on 18 and 19 September were successful, and the field fortress, which had cost so many lives since 1915, was taken. The Bulgarians were pursued on land, their retreating columns were bombed from the air in the mountain passes, and the retreat became a rout. By 30 September Serbian troops had advanced 80 miles, French troops were in Skopje, and a local armistice was signed. But the Serbs and French drove north. By 10 November they had a bridgehead over the Danube, and 'Desperate Frankie' had visions of entering Budapest.

The place of the Macedonian campaign in the Great War remains enigmatic. Without the presence of the Army of Salonika, Greece, already sympathetic, might have joined the Central Powers. Had the Bulgarians not been held down, her ferocious troops might have turned eastward to deal with Rumania and any remaining Russian forces. That would have released German and Austrian forces, either to complete the annihilation of the Italians after Caporetto, or to change the course of the battles in the west.

For the British, apart from the final battle of Lake Doiran in October, 1918, it was an uncomfortable and unhappy campaign. From October, 1915, to the end of November, 1918, the British Salonika force suffered 2,800 deaths in action, 1,400 from wounds and 4,200 from sickness. In the Great Lembet Road Anglo-French military cemetery in Salonika 1,656 Commonwealth burials are recorded. Close by the British sections are the French, Serbian, Italian and Russian sections, a fitting reminder of the international character of the Army of Salonika. In the eight other Commonwealth cemeteries in Greek Macedonia there are some 7,000 graves, and on the Doiran memorial 2,000 names of those who have no known resting place. In many of the cemeteries there are Serbian and Greek graves with those of the Commonwealth.

You will be driven into the sea, and you will not have time even to cry for mercy.

GENERAL DOUSMANIS *Chief of the General Staff at Athens*

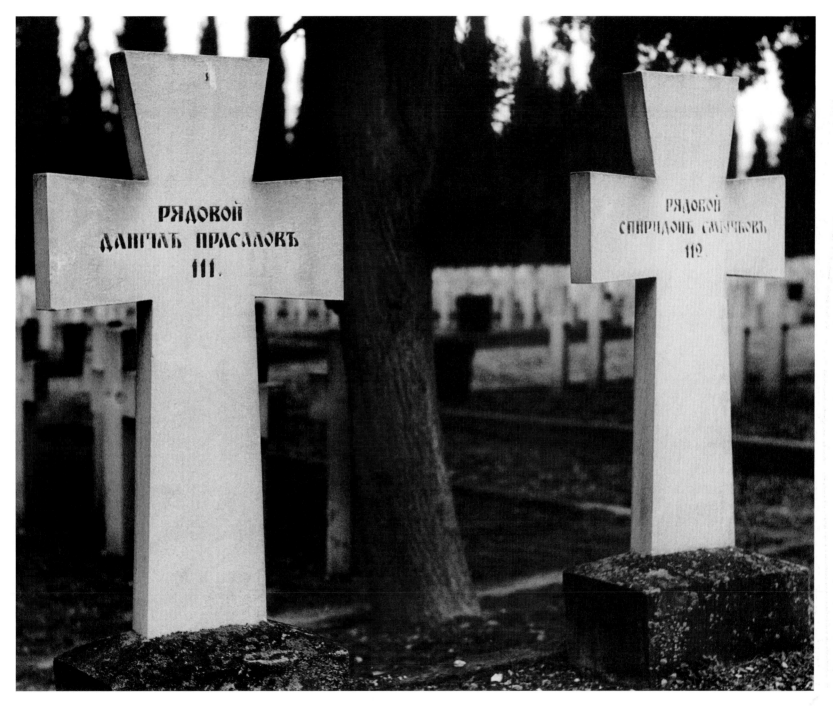

LEMBET ROAD MILITARY CEMETERY, SALONIKA. HEADSTONES OF BULGARIAN PRISONERS

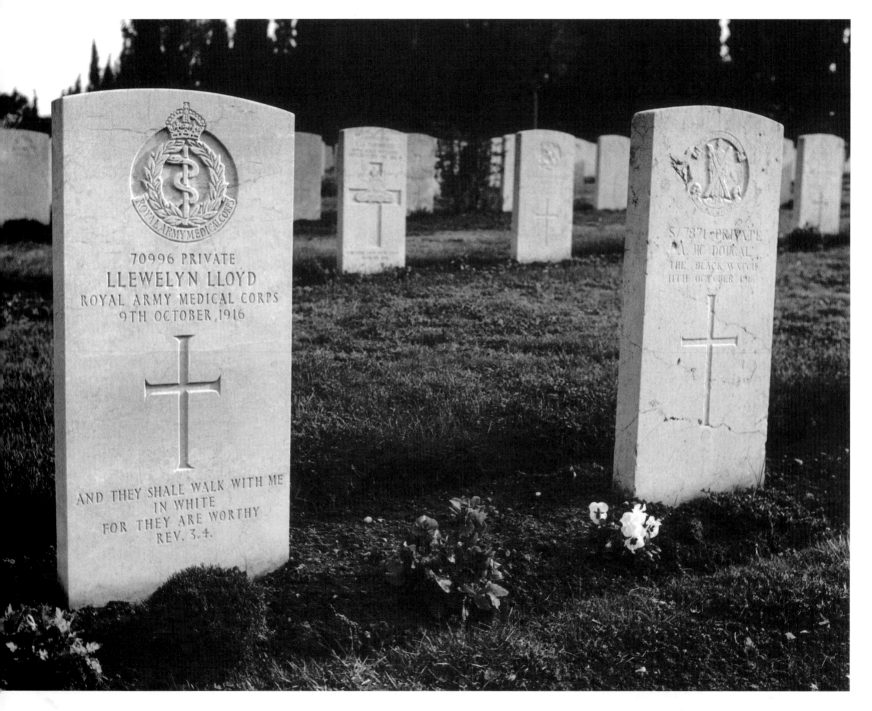

LEMBET ROAD MILITARY CEMETERY SALONIKA. COMMONWEALTH BURIALS 1,644

LAHANA MILITARY CEMETERY. IDENTIFIED BURIALS 279

Up the line again, the sap of life has returned. I would far rather be out in the Infantry than be working as an orderly in a hospital in England. These mountains fill me with eternal joy. I think my period of service is not of degeneration, but of being in the 'refiners' fire'.

STANLEY SPENCER *Stanley Spencer at War*

The Balkans are the hinge and pivot of Germany's schemes of conquest in the War. Northern France, Belgium, perhaps even Alsace-Lorraine, she would abandon with equanimity if only she can keep her hold on the avenue to the east. India, the symbol of World Empire, draws her like a magnet, and the road to it lies through Belgrade, Sofia and Constantinople. Her hand is at the present moment on the door of the unexplored treasure house of Asia Minor and she is desperately anxious to keep it there.

G. WARD PRICE *The Story of the Salonica Army*

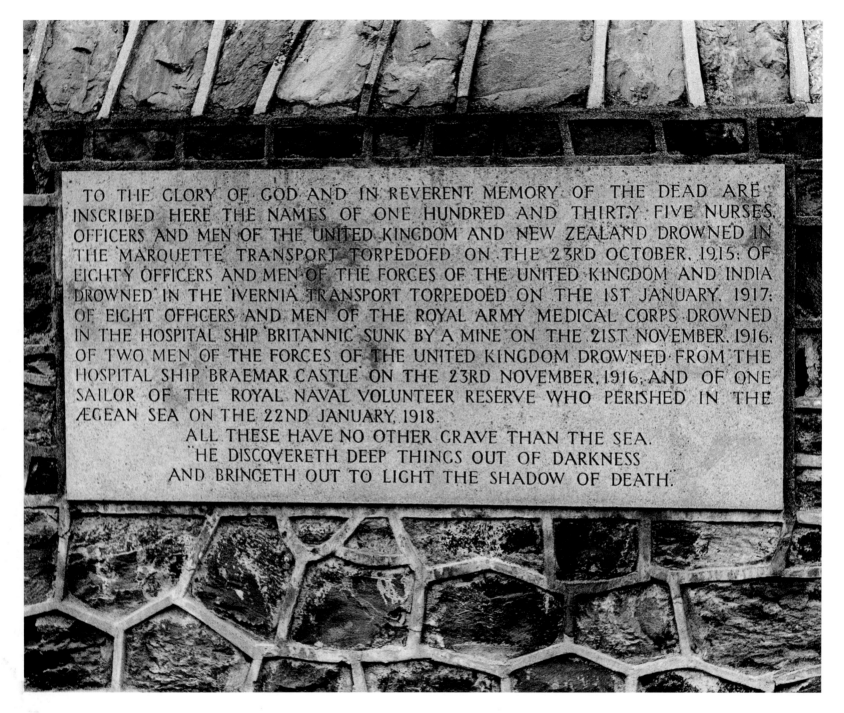

MIKRA BRITISH CEMETERY, SALONIKA. IDENTIFIED BURIALS 1,962

DOIRAN MILITARY CEMETERY. IDENTIFIED BURIALS 1,384

Near 400,000 men of five nations, French, British, Serbian, an Italian division, and a Russian brigade, were now scattered along and behind the front, established at the foot of the Bulgarian mountain wall. Rumania had stipulated that this army should begin a general offensive against the Bulgarians, if possible a fortnight before, and at the worst simultaneously with, her entry into the War. But the opinion was recorded that the Bulgarians were fine fighters in their own country, that the Serbians had not recovered from their disaster, and that not a single British Officer was in favour of the enterprise.

WINSTON CHURCHILL *The World Crisis*

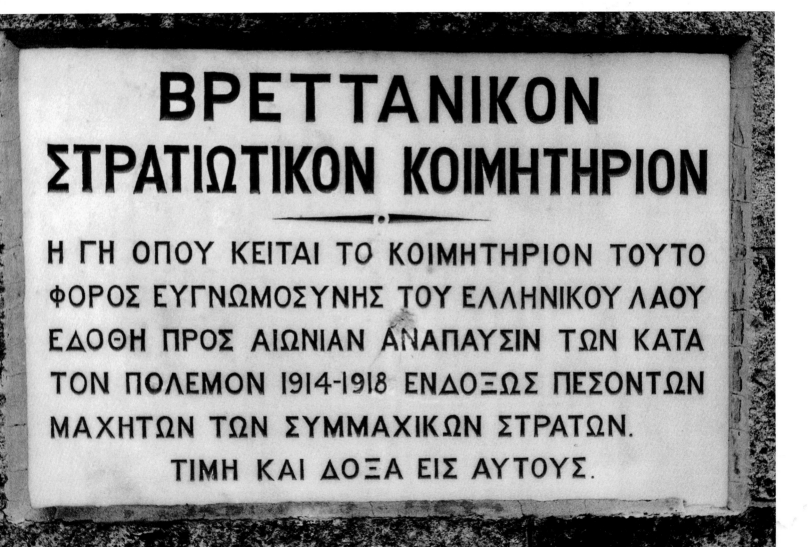

Doiran Greek Cemetery

One satisfactory feature of the fighting was the chivalrous way in which the Bulgarians allowed our stretcher parties to go out in broad daylight between the lines and pick up the wounded who were left lying there after the night attack. So steep are the rocky slopes of the Jumeaux ravine and so completely is it swept by enemy fire, that it would otherwise have been extremely difficult to bring in the unfortunate fellows who had been left behind when we retired from the enemy trenches.

G. WARD PRICE *The Story of the Salonica Army*

Left and Opposite:
Doiran Greek Cemetery

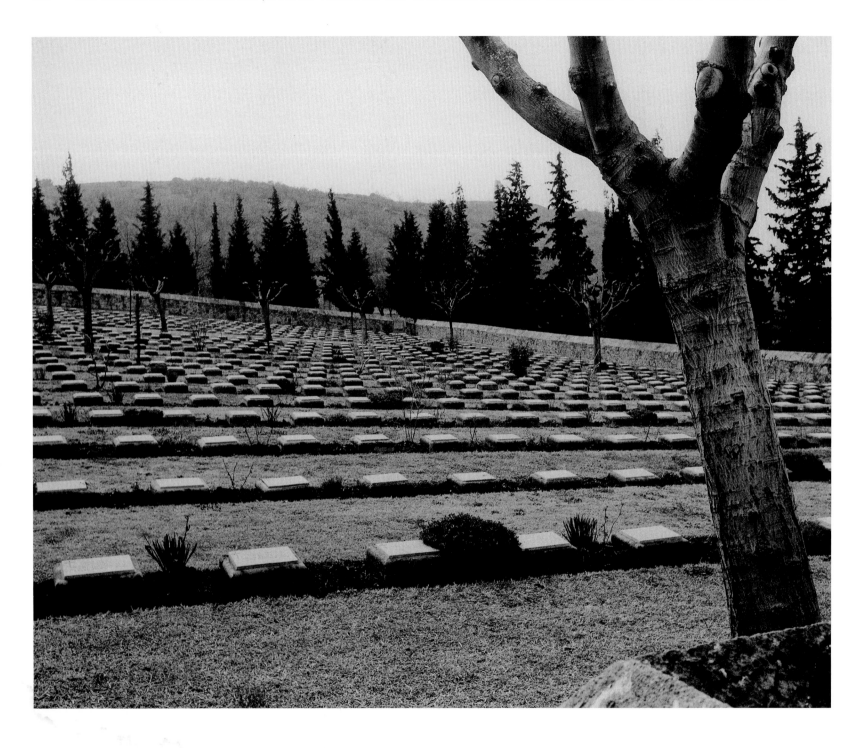

DOIRAN MEMORIAL TO THE BRITISH SALONIKA FORCE. THE NAMES OF 2,160 DEAD ARE RECORDED IN THE REGISTER

MONASTIR ROAD INDIAN CEMETERY, SALONIKA. MONUMENT TO THE CREMATED. THE CEMETERY CONTAINS 325 INDIAN GRAVES, AND 33 UNITED KINGDOM

There were 750 cases of frost bite in one brigade alone during those three fierce days, when it seemed as if the Balkan Winter was showing the worst of which it was capable. Men frozen stiff were carried in scores from the trenches to the First Aid posts to be rubbed back to life again. Warm underclothing reached the division in the very middle of the snow storm, but the cold was too bitter for the men to undress to put it on, and it was added anyhow to the sacks and blankets and other additional garments that each did his best to accumulate, a pair of drawers being used as a muffler or tied round the middle.

It must be remembered too that the men of the 10th division were already in poor physical condition when this severe ordeal came upon them. They looked worse indeed than they had at Suvla. The faces of some of them were yellow and wizened and their bodies thin. The trying climate of the Gallipoli Peninsula had sapped their strength.

G. WARD PRICE *The Story of the Salonica Army*

THE PHOTOGRAPHY AND THE JOURNEYS

Shapes, light, and shade are the elements from which we obtain our visual impressions in life, far more powerfully than we do from colour. The effect of these visual stimuli at conscious level depends upon a series of natural 'filters' or 'analysers' which begin at the eye and end in the brain. The specific areas of the brain concerned are the primary visual cortex, and the visual association areas in the cerebral, occipital and parietal lobes. In the *eye* both conscious and unconscious control of the shape of the lens allows selective focusing and thereby concentration on some part of a scene, and blurring or disregarding of others. The mainly subconscious control of pupil size is coordinated with focusing and with intensity of light, and provides a further method of 'filtration' or 'analysis'. Through this we can concentrate upon or dismiss, usually at will, parts of the scene, while pupillary size allows compensation for great variations in intensity of illumination. This is not simply in order to produce a perfect image, but it allows us to dismiss irrrelevent parts of a scene which had ideal illumination, in favour of those which may have poor illumination.

The interesting arrangement of the visual pathways at the crossing of the optic nerves allows distribution of visual impulses to both sides of the brain. The interpretation of these impulses is complex, impressionistic, and depends upon the 'mind' in the broadest sense. Finally, the effect depends upon the contents of the scene, its composition, and planes (foregrounds/background) and the observer's position in that scene.

Good photography should, as far as possible, use the variables in a camera as a substitute for the natural 'filters' and 'analysers' of the eye. Thereby it may be possible to present through the medium of a flat black and white image of limited dimensions visual stimuli from which the brain will produce impressions which the photographer seeks to present. That is a very different matter from the flat representation of all details falling within the camera's field of view at a particular moment.

By the variation of film speed, which is comparable to retinal sensitivity, focus, depth of field, aperture, shutter speed, composition, and position of the photographer, there can be considerable control over the final impression, albeit well short of the human apparatus. Printing adds further control of composition, contrast and tone.

My interest in the Great War cemeteries and memorials began as a photographic exercise, which led later to an interest in the history and contemporary literature of that War. The sharp lines and whiteness of stone contrasted with a dark green background was the ideal subject for black and white photography. The winter months provided the best light for the subjects, because the sun was always low, the shadows long, there was no heat haze, and the stones and ground glistened with frost.

The contrast and moods of the winter skies and landscapes, and the simplicity of nature, seemed to set off perfectly the headstones. Bare branches, a solitary dying flower, drooping and fallen leaves, added evocative imagery. In the solitude of the cemeteries, it was as if nature and not man preserved the memory of the dead. By accentuating the starkness of the lettering on the headstones, the effect of the words could be heightened.

The technical aspects of the photographic apparatus are simple. A Leica M2 has been the main workhorse with 35 mm (Canada) and 50 mm (Wetzlar) Summicron lenses. An Olympus 35 RC, which fits the pocket, has been used at times; the satisfaction of using the Leica is unrivalled. Films used have been Ilford Pan F and Agfa Pan 25, developed in Mirophen and Rodinal respectively. The choice of the fine-grain slow films (ASA 50 and 25) was partly for purposes of enlargement from 35 mm to 20 x 16 inches for exhibitions; but it was also because slow films make one take full advantage of the Leica lenses, the camera's steadiness at slow shutter speeds, and the effect of a restricted depth of field. For enlarging, an old Leitz Focomat 1 remains as perfect today as when it was built many years ago; a Leitz V35 was used later.

The journeys to photograph the cemeteries have extended over some fifteen years, and had to be fitted into a busy surgical life. They brought much companionship, sadness, and time for reflection. The Western Front, so readily accessible from Southern England, has been covered in short expeditions, concentrating upon small sectors. The guidance provided by friends at the Commonwealth War Graves Commission has been invaluable, with the excellent over-printed Michelin maps showing the position of the cemeteries. The late Rose Coombs' book *Before Endeavours Fade* has been

indispensable, and cannot be praised too highly, because it represents so much of her work at the Imperial War Museum. As a near neighbour she gave me much personal advice.

The journey to the Asiago Plateau, when there was still snow only a short distance from the cemeteries, was the most dramatic and horticulturally interesting. It was as if that isolated plateau was set above the surrounding plain as one very private memorial garden.

The route to the Isonzo, the river over which so much Italian and Austrian blood was shed before and after the Italian disaster of Caporetto, led through the south Tyrol, the Dolomites, and the North Italian plain. At Brunico, on a wooded hillside, was a cemetery of wooden crosses and memorials, Tyrolean in mood, with evidence of the last days of the Austro-Hungarian empire; at Brixen the more severe stone German crosses were suitably Teutonic.

North of Grado on the Gulf of Venice, stands Aquileia, site of an ancient abbey, within whose grounds is an Italian cemetery for some who fell on the Carso, that notorious ridge which is now in Slovenia above Trieste. Further east, near Gorizia, on the Italian border at Redipuglia is the great memorial to the interminable slaughter of Italians. North from Gorizia we traced the course of the River Isonzo towards Caporetto, or Kobarid, as it is today.

Inevitably the expedition by road to Macedonia, and then on to Gallipoli in 1985, was the most moving. The road through former Yugoslavia was long; but the Turkish atmosphere of Sarajevo, within a stone's throw of the plaque to the hapless Gavrilo Princip, assassin of Franz Ferdinand in June, 1914, was a timely reminder of the causes of the war.

In Macedonia, north of Thessaloniki, towards the Bulgarian border, the barren landscape and climate, with its extremes of heat and cold, made us feel the conditions under which men lived and died, and in which Stanley Spencer wrote of his war. From Thessaloniki, after hospitality from a neurosurgical friend, we followed the ancient Via Egnatia, much pot-holed, to Philippi, and stood where St Paul preached. The drive down from the Gallipoli Peninsula, past Geloboulou gave us the first sight of the Dardanelles, the Narrows, Asia Minor and 'The Fatal Hellespont'.

The days at ANZAC Cove, thanks to the Commission's Rest House, were memorable. It was a strange, almost Edwardian, party, with the retired Winchester housemaster, the urologist of girth, humour and Welsh lilt, and the Belgian lady aristocrat tending the gastronomic needs of those with and without a classical education, under the Tilley lamps. And after earnest discussion of ancient Troy and more recent wars, a walk past the garden oases of Canterbury, Beach, Ari Burnu, and Shrapnel Valley, beneath an Aegean moon, brought silence.

THE AFTERMATH

They said it was the soldiers' war to end all wars. The jubilation of 1918 was an unburdening, a momentary relief from sorrow, a hope for a future to which few dared look; reality was put aside. But for some there was no joy, as they stood sombrely with a cynicism which was to prove only too accurate in the future. It was merciful that the dead and the dying never contemplated the true aftermath which followed, a world which they had believed would be a civilisation cleansed by their suffering, a democracy of peace without end.

They had perished, suffered, and were lastingly disabled as soldiers. To come was the suffering of the masses, sometimes with only the flimsiest pretext of war, when bestiality was rife, often for its own sake, an infection which spread from racial hatreds rarely seen in between 1914 and 1918 but which had simmered below the surface for many years.

The headstones and memorials of the Great War are as of children lost in their belief and in innocence, to be surpassed by the gross slaughters of twenty years later, which ended or changed the lives of millions, many of whom bore no arms.

The chief European protagonists were unchanged, indeed had not changed since 1870. Once again on one side were the aggressors, now with an ideology which went far beyond military conquest. On the other were those who looked away, quarrelled amongst themselves often for short-term gain, and denied danger, hoping to avoid another military slaughter. Russia, which failed militarily in 1917, an ideology transformed a vast backward country into a machine which would not halt at the borders of the aggressor of 1941. Ironically within the Third Reich, the fear of Bolshevism strengthened the power and appeal of National Socialism; it was the populace as well as the party machine which acquiesced to this fear. The bitterness of the defeat in 1918, with the seemingly useless sacrifices of the Great War gave added strength to the desire for an all powerful saviour, so that Germany would never again be subservient or inferior to an alliance of capitalism and world empire. In 1936 Victor Klemperer,[*] in Dresden, wrote:

The huge German army is feared and used by every party; perhaps Germany will do a deal with England, perhaps with Italy, but a deal will certainly be done to the advantage of the present government . . . The majority of the people is content, a small group accepts Hitler as the lesser evil, no one really wants to be rid of him, all see in him the liberator in foreign affairs, fear Russian conditions as a child fears the bogey man . . . characteristic of the bourgeois was the fear of Russia. They believe Bolshevism – perhaps rightly – to be the greater evil. They see through Jew-baiting and do not like it, but they put up with everything out of fear of Russia.

The first decades of the aftermath saw France at its lowest ebb, a mockery of the names of a generation of men on the memorials in every village. The politicians squabbled, the army command was irresolute and failed in its demand upon government. A country which had been part occupied by the aggressor in 1914–18, was totally occupied by the same aggressor in 1940. And Pétain, the saviour in 1915 was, controversially, to be a maligned scapegoat in 1945. The slaughter with which Verdun had been saved, marked him too deeply to embark upon another resistance which he believed would fail, collaboration would save lives. But many rose against the occupiers, at great peril, for retribution was harsh and little distinction was made between combattant and non-combattant, a new evil dimension of war. The memorials of 1945 record these cruelties.

The Italians who had lost grievously on the Isonzo and on the Carso, with the disaster at Caporetto in 1917, were captivated and captured by their own somewhat operatic brand of fascism. They wavered as they had done in 1915, seeking their own territorial gains. Perhaps the losses as allies of France and Britain in the Great War played some part in the merry-go-round of treaties in the 1930s, which led to avarice in Abyssinia and the ill-fated military subservience to Germany. The never-ending lines of Italian prisoners of war snaking across the North African desert were almost an apology for a pitiful error of political judgement.

At St Symphorien Military cemetery the headstones of British Christian and British Jew stand side by side; and likewise in Le Cateau German

[*]V. Klemperer, *I Shall Bear Witness. The Diaries of Victor Klemperer, 1933 to 1941*. Abridged and translated from the German edition by M. Chambers. Folio Society, London, 2006

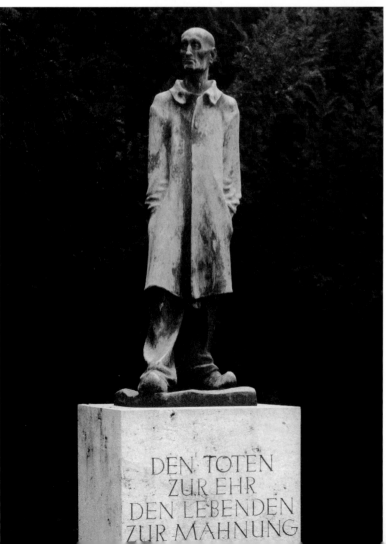

DEN TOTEN
ZUR EHR
DEN LEBENDEN
ZUR MAHNUNG

Military cemetery the headstones of Karl Volkel, a Christian, and Walter Proskauer, a Jew, stand together. They who fought together died together. In desperation the German Jews who had fought in the Great War pleaded that their service for the Fatherland should save them from the persecutions which led to Auschwitz and Dachau. Like baptism, and aryanization through spouse, all failed. The aftermath of a Germany defeated in 1918 and the changes that followed allowed a dormant infection to become rampant. It still has its own living memorials. Will history sustain memory when these living have died, in the way that the memory of 1914–18 remains so strong after so many years?

Europe remained divided for fifty years despite the victory of 1918 which defeated the aggressor of 1870 and of 1914. The later division was more pernicious, and encompassed states that played little part in the aggression that caused the great divide. Irony is everywhere. Without Soviet Russia, Germany would not have been defeated in 1945. Without the German invasion of Russia in 1941 there might not have been the great East–West divide, which was the final military aftermath of two world wars. There was also the third major involvement of the United States in Europe; the men of Belleau on the Marne, were followed by the men of Utah and Omaha in Normandy, and then by the guardians of Berlin. And today, the United States is Europe's nuclear bulwark, the ultimate defence, against potential – some might say mythical – worldwide aggressors. Big Bertha is a pinprick of the past.

In 1989 in Dresden, the statue of Luther stood untouched before the Frauenkirche, still in ruins from the devastation of the British bombing inferno of 13 February, 1945. The moral argument continues to this day. Dresden was far behind the Iron Curtain and the ruins were a stark reminder of the failure, for fifty years, to bring a just society to the aggressor nation of 1914. The Berlin Wall, and Luther at Dresden brought little hope of a lasting peace.

There can never be any war to end all wars; war cannot quell belligerence. Suddenly in November 1989 a seeming miracle occurred. The Wall fell down. The East German guard looks quizzically at us, as if mystified by the events of his own life. So also the men of 1918 could never have foreseen or understood the turbulence of these years. The old enemies may have found a lasting peace, 'Imperial' has gone, a new community has arisen. Can we now say 'these dead shall not have died in vain'?

Above left: *Dunkirk. The memorial to the evacuation in 1940.*
Below left: *Dachau. The concentration camp. 'To honour the dead and warn the living'.*
Opposite: *Dachau. The concentration camp. The screen of skeletons.*

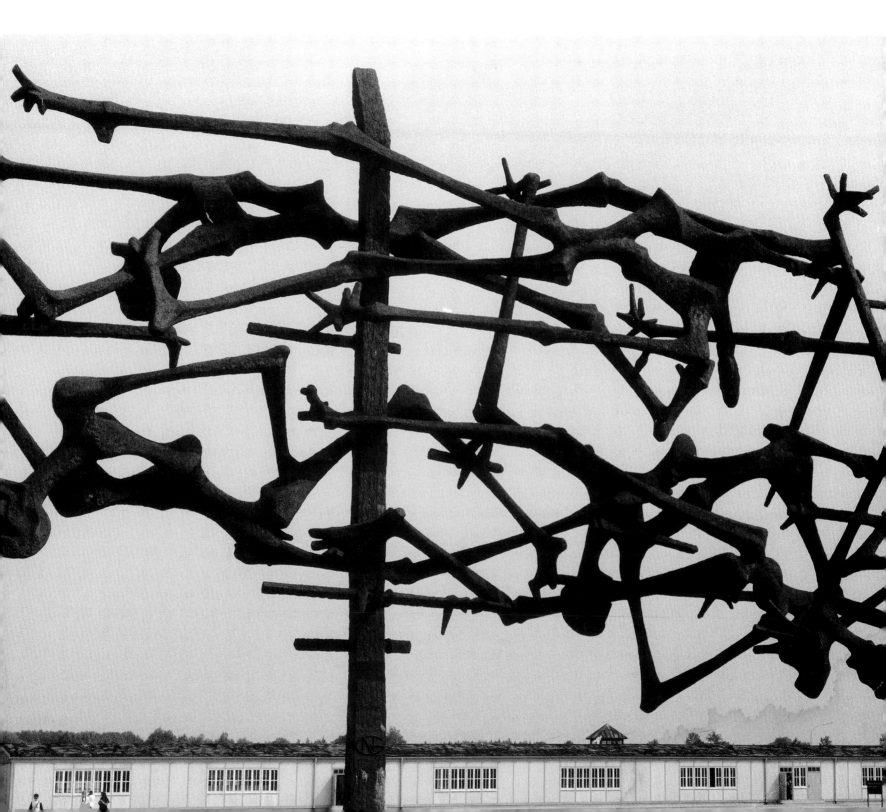

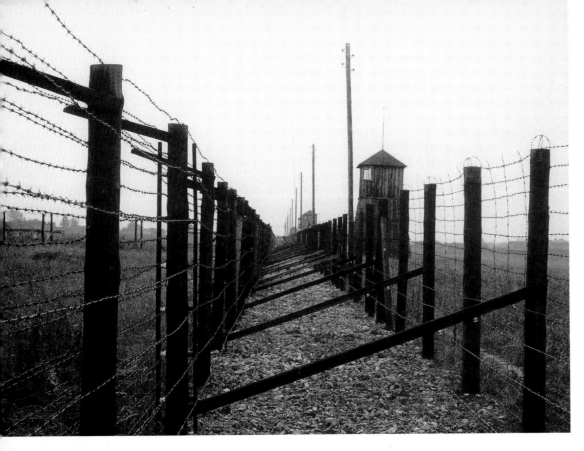

Lublin. The concentration camp.

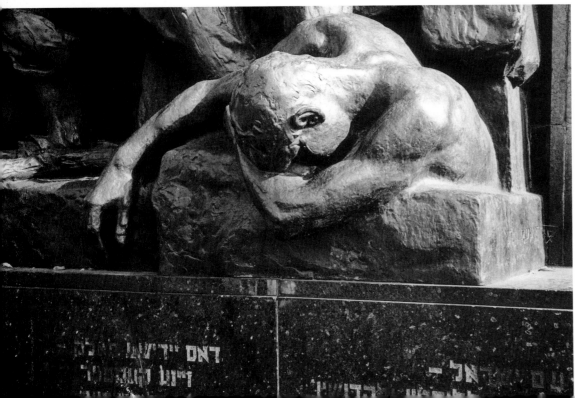

Warsaw. Memorial to the Ghetto.

Right: *Warsaw. Memorial to Polish civilians murdered in the Paiwak prison.*
Below: *Pjuj, Slovenia. Yugoslav patriot killed by the Gestapo in 1942.*

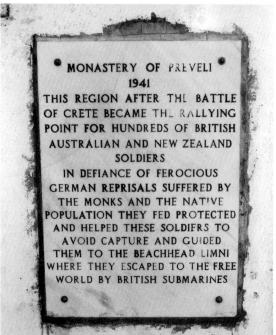

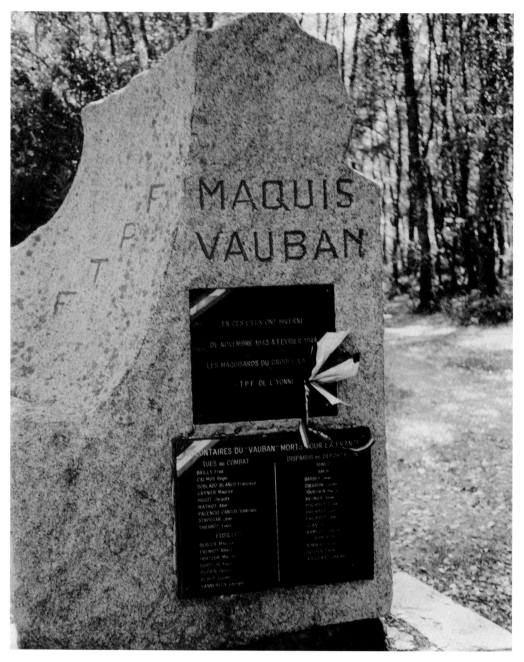

Left, above and below: *Crete, Khora. The evacuation of the Allied forces, 1941.*

Above: *Le Morvan, Burgundy.*

Opposite: *St Agnian. Memorial to the Resistance.*

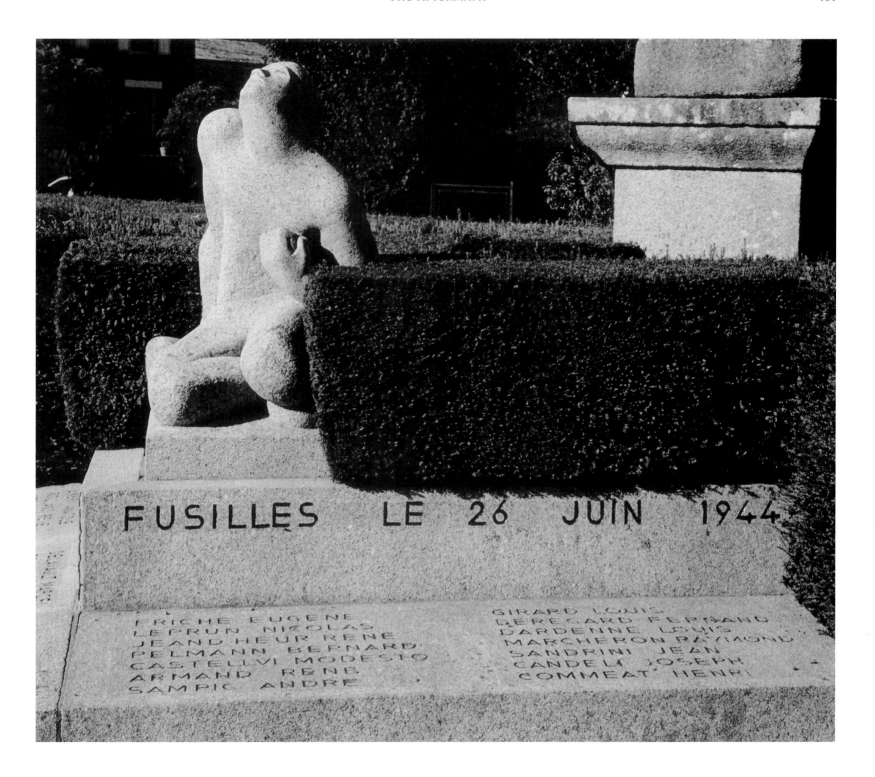

FUSILLES LE 26 JUIN 1944

FRICHE EUGENE GIRARD LOUIS
LEPRUN NICOLAS BERECARD FERNAND
JEANDHEUR RENE DARDENNE LOUIS
PELMANN BERNARD MARCHERON RAYMOND
CASTELLVI MODESTO SANDRINI JEAN
ARMAND RENE CANDELI JOSEPH
SAMPIC ANDRE COMMEAT HENRI

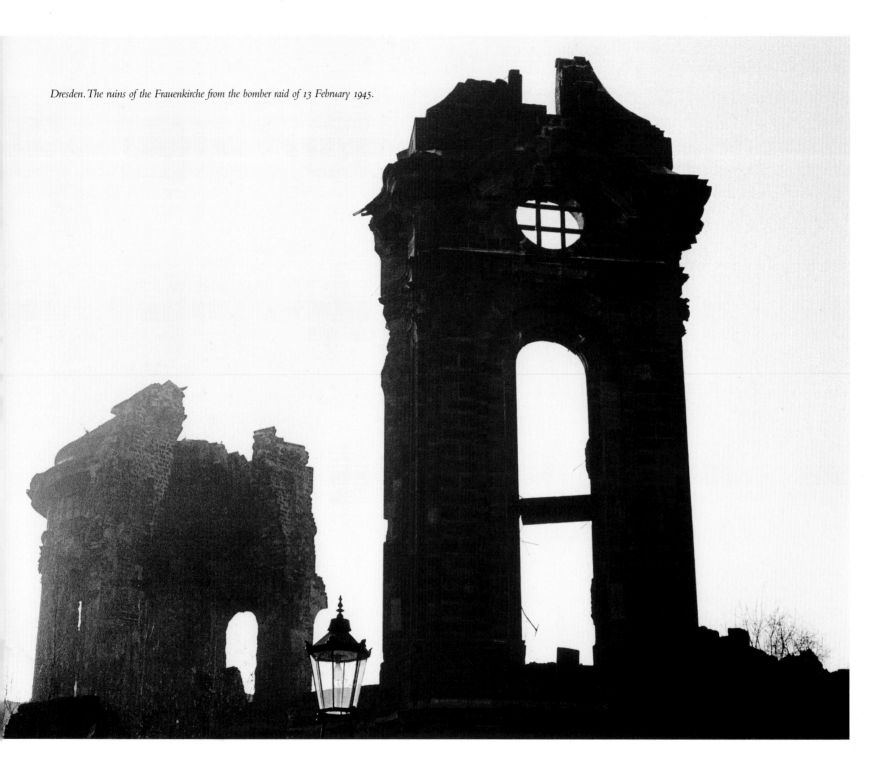

Dresden. The ruins of the Frauenkirche from the bomber raid of 13 February 1945.

Dresden. Christianity in ruins.

MARTIN LUTHER

This page: *Normandy. Utah American Cemetery, 1944.*
Opposite page: *Berlin. The Wall.*

Berlin. Checkpoint Charlie.

Berlin. The Wall opens.

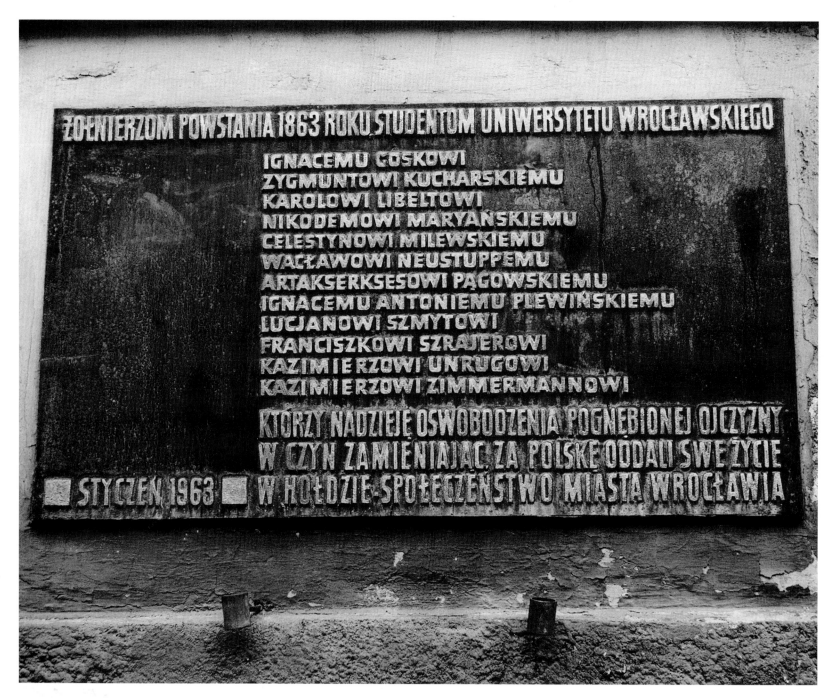

Wroclaw, Poland. 'In memory of the soldiers and university students who in October 1863 fought in Wroclaw hoping to liberate their homeland from occupying forces, and who lost their lives for this ideal. In gratitude from the population of the City of Wroclaw, January 1963'. Wroclaw remained, as did all of Poland, under Soviet domination until 1989.